Fixed.

Also by Amy E. Herman

Visual Intelligence: Sharpen Your Perception, Change Your Life

Fixed.

How to Perfect the Fine Art of Problem-Solving

Amy E. Herman

With best wishes,
Amy Herman

HARPER WAVE

An Imprint of HarperCollins*Publishers*

HarperCollins books may be purchased for educational, business, or sales promotional use. For information, please email the Special Markets Department at SPsales@harpercollins.com.

FIRST EDITION

Designed by Leah Carlson-Stanisic

Library of Congress Cataloging-in-Publication Data has been applied for.

ISBN 978-0-06-300484-9

22 23 24 25 26 TC 10 9 8 7 6 5 4 3 2

To Ian Carter, who fills in all the cracks with gold.

Rejoice! Our times are intolerable.

Take courage, for the worst is a harbinger of the best.

—Jenny Holzer, *Inflammatory Essays*, 1979–1982

Contents

Author's Note

Since many people I interviewed for this book have extremely sensitive jobs, I have changed the names and identifying details of some of them to protect their privacy. Any resulting resemblance to persons living or dead is entirely coincidental and unintentional. All works of art that are included in this book have been reproduced with permission of the artist or the rights-holding institution.

Fixed.

Introduction

I'm going to ask you to do something uncomfortable. It involves nudity, death, and ignoring everyone around you.

Close your door, mute your phone, turn away from your laptop, disregard the million pressing demands and emails and meeting requests for just a moment, and look at the following picture. Really

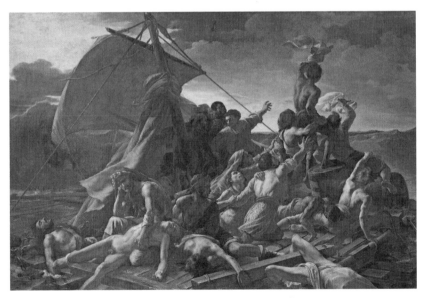

The Raft of the Medusa by Théodore Géricault, 1819, oil on canvas.

look at it. Take in its scope, notice its details, count things, catalog what you think might be going on.

Then, take a breath and let your mind wander.

What did the chaos of the preceding scene bring to mind? A natural disaster? A human-made catastrophe? The current state of your country? Maybe you were reminded of more personal scenarios: office drama, an argument at home that got out of hand, Zoom Thanksgiving. No matter who you are or where you live, chances are you can relate to the desperation depicted above.

The painting, Théodore Géricault's *The Raft of the Medusa,* recalls real-life events when a French frigate, the lead ship in a convoy of four, wandered away from its companions and ran aground thirty miles off the coast of Africa. It may seem like a disaster from long ago (in fact, this painting depicts the events of July 17, 1816). But the failures that led up to it could have just as easily come from some of the disasters of last week, or a disaster that might happen today or tomorrow. For instance, the person responsible for the shipwreck was an inexperienced middle-aged political appointee. He was white, well-off, and so incompetent that he mistook a far-off cluster of clouds for a nearby coastal mountain and, believing he was farther out to sea (despite the appearance of whitecaps around the boat), steered straight into a sandbar. Even after the ship lodged firmly in the sand, he refused to free his ship by throwing its fourteen cannons (weighing forty-two tons) overboard. Being grounded so close to shore shouldn't necessarily have led to tragedy. A plan was drawn up for the other ships in the convoy to save the weapons and gold on board and ferry all the passengers to shore. But when a storm began to tear the *Medusa* apart, the captain panicked, scrapped his plan, and quickly boarded one of the six lifeboats, whose limited seating he reserved exclusively for the ship's officers, the territorial governor, and their families.

In this stunning display of incompetence in a crisis, it's hard not to see parallels to our own day. The captain consigned nearly half of the ship's passengers—civilians and lesser seamen—to the poorly built raft. Although it had originally been built as a place to stow the cargo, instead he loaded it up with people—lots and lots of people.

It was rickety and rode half underwater, and its size—sixty-six feet long and twenty-three feet wide (almost exactly the width of Géricault's painting)—might have been big enough for a roomful of ravers on spring break, but not for 146 men, an unfortunate woman, and a twelve-year-old boy. Under the new plan, they all headed out to sea, with the raft pulled on tow ropes behind the lifeboats. For all the haste, for the first mile or so, this jerry-rigged setup worked fine.

Until it didn't.

The oarsmen in the lifeboats quickly realized that the lifeboats would be going nowhere if they had to pull so much more dead weight to safety. The captain, fearing that the instability of the arrangement would endanger the passengers in the sturdier craft, ordered the ropes to be cut, leaving their compatriots on the raft to fend for themselves, with no steering, no sails, and only a barrel of wine and a tin of biscuits by way of supplies. Alone on the open sea, the crowd on the raft—young and old, Black and white, male and female, experienced and not—fought viciously and descended, with astonishing speed, into cannibalism. After eating their hats and belts, they started eating each other. When the raft was rescued *just thirteen days later*, only fifteen people were left alive, five of them barely. One of the crew who rescued those on the raft wrote, "Those I saved had eaten human flesh for several days, and when I found them, the ropes that served as stays were covered with pieces of meat they had hung up to dry."

This horror story rocked France, and the harsh light it cast on the regime threatened the newly restored monarchy. Royalist forces covered up the atrocity, publishing a notice that the 148 had been lost at sea, until 2 of the survivors (the ship's surgeon and an engineer, who can be seen in the painting conferring by the mast) wrote up an eyewitness account of life on the raft (later expanded into a book) that contradicted the official version of events. The book became a bestseller in France, which kept the callousness of the aristocracy in the headlines. As a result of this notoriety, the captain was put on trial and his light sentence at the end of the proceedings—only three years in prison, and not death—set off a furor.

So did the nearly life-sized *The Raft of the Medusa* when it first ap-

peared in Paris three years after the wreck, as part of the Salon of 1819. In a reflection of the divided political landscape of the day, critics battled over its value, praising its timeliness, ridiculing its inaccuracies (the starving survivors look more like refugees from a weightlifting competition). One even blamed the artist for starting a race riot, since a Black man was featured in the painting's focal point. On seeing the work, Louis XVIII chose to ignore the political implications and graciously focused instead on the great accomplishment, telling the artist, "Monsieur Géricault, you've painted a shipwreck"—and here the king paused, as if in anger, before wittily concluding—"which is not one for you!" But a discouraged Géricault, who felt the reception hadn't met his own high expectations for the work, cut the painting from its frame and lamented, "It's not worth looking at."

The Louvre and its millions of visitors would likely disagree. Today, *The Raft of the Medusa* (although not acquired until 1824, after the painter's death) currently occupies an entire wall in the illustrious museum. The painting is raw, complicated, and gruesome. It covers contemporary politics and history (both of painting and of France), and it took years of meticulous study followed by feverish concentration in a remote studio to finish, and later to navigate its public reception. As such, I believe it's a perfect primer for solving complex problems.

Problem-solving is a critical survival skill because things go wrong for all of us all the time. Working through problems is critical for productivity, profit, and peace. Our problem-solving skills, however, have been short-circuited by our complicated, technology-reliant world. For the first time in human history, many of us share the same best friends: Siri and Alexa. We've become increasingly reliant on artificial intelligence, even to fuel our imaginations. The downside to the internet's speed at spitting up answers, however, is that we have allowed our own reasoning skills to be dulled or underdeveloped. Why learn how to fix something when Google can do it?

Unfortunately, calamity doesn't always fit in a search bar. As Murphy's Law and even the Bible assure us, things will go wrong. And increasingly in our modern, perilous world, the issues that emerge are subtle, laced in subtext, or teeter on the tip of a slippery slope—all

attributes that require a human touch to solve. As said humans, we must not only be able to address the problems that arise across all professions and walks of life, we must also be able to solve them. Before they drown, damn, or destroy us. Thankfully, problem-solving is a skill that can be learned. Unfortunately, it's not often taught.

I was recently having lunch with a college professor who lamented the lack of solutions for this very problem.

"Every semester I have students who are so used to relying on their phones for answers, that when they're faced with a situation they have to solve themselves, they can't," she said. "The problem is, *I* don't know how to teach them problem-solving skills."

As a leadership consultant who has crisscrossed the globe for eighteen years teaching professional development courses to everyone from Silicon Valley executives to Navy SEALs, I know a few things about the power of good training materials. I knew there were plenty of great books about how to adjust our attitude or approach when things go sideways, as I enjoyed all of them, but I couldn't find one that walked readers through exactly how to get out from between that rock and hard place. So, I decided to write one.

In my work with homicide detectives and hostage negotiators, I've learned that sometimes you have to look behind, below, or away from the obvious answer to find the right one, so I decided to start with the most recognizable wisdom on problem-solving, the well-known adage about the inevitability of catastrophe: "If something can go wrong, it will go wrong."

It's an age-old idea that's believed to have been repackaged and popularized in the 1950s thanks to a comment from an actual person, Captain Edward A. Murphy, an air force engineer. Murphy was working on Air Force Project MX981, an experiment designed to test the limits of the human body in situations of sudden deceleration, when he discovered a technician had wired a transducer incorrectly. Murphy, referring to the ineptitude of the technician, groused, "If there is any way to do it wrong, he'll find it." A project manager jotted the sentiment down and named it "Murphy's Law." Other engineers adopted the phrase but used it as inspiration to find potential prob-

lems ahead of time and circumvent them. When the project's lead, Dr. John Paul Stapp, held a press conference touting its safety record—after strapping chimpanzees and bears into his high-speed rocket sled, Stapp himself volunteered to be the human guinea pig, suffering only bruised eyes as gravity sucked the blood from his capillaries—he credited his team's belief in Murphy's Law, and a phenomenon was born.

If the most famous problem-solving proverb originated with military scientists, I thought a solution set might be found in the opposite direction—from a group of people who rely on the other side of the brain: artists.

It seemed a good fit. After all, German filmmaker Wim Wenders defined creativity as "obsessive problem-solving," so I wondered if methodically walking through the myriad obstacles artists overcome would produce the step-by-step instruction manual for concrete problem-solving that I craved. As I explored the creative ways artistic minds sort and solve problems—from conceptualization to actualization, while facing obstacles from deadlines to a dearth of resources including money, materials, and motivation—an easy-to-follow primer emerged, a paint-by-numbers for problem-solving, if you will.

I organized this book to follow the artistic process, from approach and execution to distribution and reception. It's divided into sections—Prep, Draft, and Exhibit—that include both straightforward steps like "Change Your Shoes" and "Set a Deadline" and more outside-the-box instruction on how to "Recognize Relationships and Red Herrings" and "Manage Contradictions."

The result is a journey you can see and *instantly feel* featuring startling, sumptuous, and oftentimes unnerving works of art—severed heads and naked breasts, graffiti, photography, old masters, and trash art—that ultimately serve as a tangible and reliable road map to better decision-making, problem-solving, and creative thinking. No GPS required.

Art, and artists themselves, often get a bad rap for being complicated, obtuse, even obscene, but that is exactly why they provide the perfect backdrop for problem-solving, since our issues today are similarly convoluted.

Rest assured, you don't need any art history training or previous knowledge to benefit from this process. Just open eyes and an open mind. This isn't about the study of art; it's about using art to study ourselves and the problems we face every single day.

Art can help anyone anywhere fix things because it is a universal language. Two people from completely different backgrounds with opposing viewpoints on everything can stand in front of the same image and discuss what they see. Art provides a safe space outside of ourselves to analyze our observations and convert those observable details into actionable knowledge. Doing so can help us understand how and why things go wrong and, more important, how to fix them.

Art also facilitates problem-solving because it exposes deep-seated truths about ourselves that might otherwise stand in the way of our escape—even the truths we've hidden from ourselves.

Allow me to illustrate.

I show the following pair of pictures in my The Art of Perception® live presentations. I tell my audience, no matter who they are, that I'm

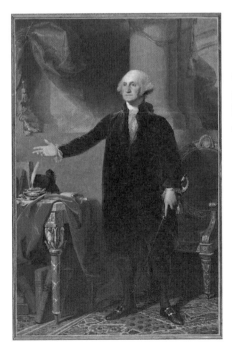

*George Washington
(Lansdowne Portrait)*
by Gilbert Stuart, 1796,
oil on canvas.

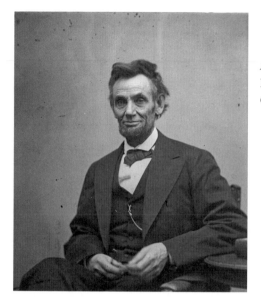

Abraham Lincoln seated.
Photograph by Alexander
Gardner, February 5, 1865.

confident they have never lived under the rule of either #1 or #16, as I like to call them.

I ask participants to spot the differences and likenesses between the two. We talk about posture and stance, Lincoln's disheveled tie, the rainbow behind Washington, and the fact that sometimes you need to state the obvious: one is a painting while the other is a photograph.

Take a moment to look at both images and see if you can come up with a list of at least five more similarities and differences between the two.

Now study the two likenesses in the next two images.

If you're old enough to read, you've lived through at least one term, if not two terms, of the president in this first image. And your mind is now going a mile a minute. Whether you loved, hated, or were indifferent to Obama, your mind switched gears when I switched images. Now it is personal. You thought of things you liked and things you didn't. You might have compared Obama to Lincoln in terms of oratory flair or perhaps race. Whether you thought about health care and

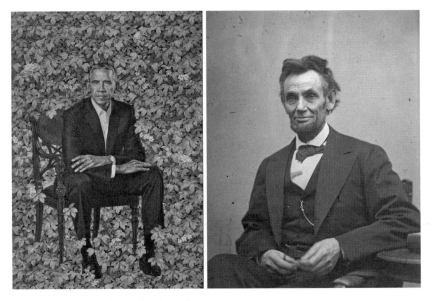

Left: Barack Obama by Kehinde Wiley, 2018, oil on canvas.

Right: Abraham Lincoln seated. Photograph by Alexander Gardner, February 5, 1865.

jobs, the election, slavery, sadness, anger, or glory, you thought about something other than just these images.

This is what bias feels like.

When you looked at the first set of presidents, you were able to analyze the images objectively. You didn't vote for or against either. And unless you were instructed to in an American history class, you probably didn't text or tweet or opine for or against either. The same cannot be said of your analytical process of the second two portraits. Suddenly a filter came down over your perception and colored what you saw: good or bad.

Despite all the warnings we have heard about them, biases are not inherently bad. We all have them. Some biases are actually beneficial to us and our survival, like an innate wariness of a growling tiger. Not having that built-in hesitation could mean we end up as a

large cat's lunch. On the other hand, an unwarranted guardedness against another person because of their physical appearance could lead us to misjudge and hurt someone or miss out on what could be a meaningful relationship. It could cause us to overlook our star pupil, not see the prodigy we could mentor or the elder whose wisdom we desperately need. Professionally, it could hinder our ability to prosper, profit, or even get promoted. We need to learn how to recognize our own biases if we're going to problem-solve successfully, especially when we're dealing with issues that involve "the other" side.

Like *Medusa's* raft, I believe that art can help lift us out of the confusion and chaos that usually accompany conflict—hopefully before we fully consume each other. And in the process, we might just learn to see problems not as disasters, but as opportunities. Problems are opportunities in that they highlight flaws in the system, weaknesses in our organization, and issues within ourselves that, once identified, can be overcome, making us, our work, and our relationships stronger. In the words of Winston Churchill, never let a good crisis go to waste.

Embracing the Unfamiliar (Part One)

Shortly after the COVID-19 pandemic shut down all in-person travel, I received a call from the leader of an unidentified military squad who was hoping to schedule a specially tailored Art of Perception course. She introduced herself by her first name only—I'll call her "Caroline," although that was not the name she gave me and I don't think the one she did give me was the one on her government ID. I didn't even know for sure that she was a woman, although her voice did match certain characteristics I associate with women and she did choose to give me a woman's name as her alias—not something I'd expect from a male in the military.

This particular team, Caroline explained in suggestive but purposely vague terms, was highly trained to excel in "cognitive performance in high stress environments," but in recent training sessions team members had started to exhibit potentially dangerous lapses in their perception. In their own debrief sessions after training, they agreed that these failures were both individual and collective, and the group's leader, who'd heard of our program from a contact in the Department of Defense, hoped that I could tailor an interactive presentation that would help them address the lapses in perception *and* provide tools to better assess situational awareness in future missions.

In better times, I'd travel somewhere and lead the program in person. In most cases, the travel is not exactly glamorous: often we're meeting in nondescript government buildings or off-site conference rooms. When it's possible, I try to arrange to hold the sessions at an art museum located near the town I'm traveling to, so that we can, in breaks from my combination lecture and PowerPoint presentation, see actual works of art in person. But one thing I get from traveling: I meet the audience. Even when, like my current caller and her team, they wanted to remain officially unidentified, I can gather information from their body language. I can usually tell by watching them interact if there's a hierarchy and if that hierarchy is loosely observed or strictly maintained. I can see who plays what role in the group, who relaxes people when they speak, and who is the person who starts to talk and suddenly everybody sits up straighter.

But in this case, I wouldn't have access to any of these clues. Owing to the pandemic, we'd meet electronically. My students or trainees would appear as black boxes identified by first name only. Caroline didn't give me much more information about the makeup of the group or their mission other than to say the participating members engaged in "continual risk assessment in drastically changing and often hostile environments." Did they operate here? Abroad? In person? Remotely? Alone? In teams? Briefly? For long engagements? Every time I tried to gather one small clue more than I had, Caroline made it clear that she had told me all that she could without compro-

mising their security. "I can tell you in their work, failure is not an option," Caroline said.

Without thinking, I said, "That's true of almost all of us!"

That was when she finally let something slip that I thought I could use: "Yes, but with this team, failure is not an option because it would lead to catastrophic loss of life." So, now I had my parameters. I didn't need to start from scratch, but I needed to think this through.

Prep

According to the publishers of *Artists Magazine*, one of the most common mistakes beginner artists can make is to neglect adequately preparing for their project before diving in. For example, if a canvas isn't properly primed, paint can flake off or seep into the fibers, ruining the composition or leaving the work itself susceptible to accelerated deterioration, in which case the time, resources, and creative output of the artist would be for naught.

In the same way, jumping right into solve-it mode without proper consideration of the scope, depth, and delicacy of a sticky situation can sabotage the final results. In this first section, we'll explore the three steps needed to prepare for problem-solving, the majority of which can be done preventively before a problem even arises. We'll start with getting to know the most important player in problem-solving: ourselves.

We can't effectively problem-solve if we don't know ourselves and our minds. Learning to recognize the filters with which we see the world will help us overcome them and, in turn, the challenges we face daily. We'll create a self-portrait to help us identify how we truly feel about problematic issues like race, power, and privilege so we can come to the table with a better understanding of our and others' biases.

Clean Your Lenses

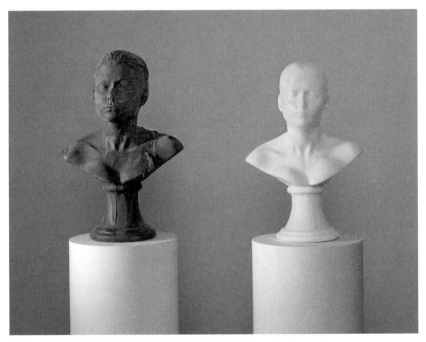

Janine Antoni, *Lick and Lather*, 1993.

In 1569, doctor Alfonso Ponce de Santa Cruz, the personal physician of Spain's King Philip II, wrote of how one of his other royal patients had developed a peculiar delusion. Courtiers had become alarmed

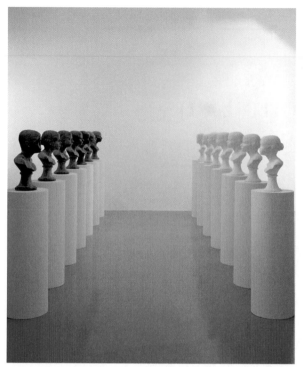

Janine Antoni, *Lick and Lather,* 1993.

when this nobleman, seemingly overnight, began carrying himself differently, walking stiffly and carefully, sliding sideways through doorways, and insisting no one, not even his valets, touch him.

Intelligent and intelligible in all other ways, the patient was convinced he had woken up a changed man. He believed that instead of bone, he was made of glass.

The man stopped going out for any reason and demanded his bed be cushioned in heavy blankets and straw, where he lay inert for days. None of his advisors could convince him of his fallacy, but the doctor had a plan. Ponce de Santa Cruz ordered the noble's room to be completely covered in straw for extra padding and protection. The room was emptied save for the patient, the door locked, and the straw set on fire.

The nobleman immediately began banging on the door, frantically throwing himself against it in a desperate bid to escape. As he begged for help, the doctor on the other side calmly asked him to reflect upon

his situation: If he really was made of glass, why hadn't his violent movements broken him?

The lesson was swiftly learned. The nobleman conceded that he wasn't made of glass and was instantly saved . . . in more ways than one.

The fear of being made of glass was so prevalent from the Middle Ages through the nineteenth century that it had an official psychological name—the "glass delusion"—and quite famous sufferers, including King Charles VI of France and Princess Alexandra Amelie of Bavaria. Although science has helped us evolve past believing in crystal skeletons, we still suffer from widespread delusions today. People have delusions of grandeur, think they're better/smarter/more generous than they really are, and have no idea how others really see them. A 2013 study of prisoners found violent criminals rated themselves as not only kinder and more trustworthy than the average citizen, but also no less law-abiding.

Delusions are simply disconnects between what a person thinks about themselves and reality. In other words, a lack of self-awareness. And the majority of us are afflicted.

Psychologist Tasha Eurich reports that 95 percent of the general population thinks they are self-aware, but only 10 to 15 percent really are. The stats for leaders are even worse. After studying the behavioral competencies of seventeen thousand executives at a general management level and up, Hay Group found that only 4 percent of them truly possessed self-awareness.

In an age of unprecedented information, why are we so in the dark about ourselves? The simple answer is: because we want to be.

Back in 2009, while mourning the death of yet another print newspaper, *New York Times* columnist Nicholas Kristof noted a study from MIT that suggested in the future, instead of getting news from carefully curated, traditional sources like newspapers and mainstream news programs, people would instead "graze" online. While the ability to search the World Wide Web offered the ultimate democratization of information, it also gave users a special power: each would become his or her own editor. The worry was that with this total con-

trol, people would naturally gravitate toward opinions that reinforced their own, and eventually only consume like-minded reports.

"If that's the trend," Kristof wrote, "God save us from ourselves."

The feeling of shock and awe that followed the election of Donald Trump to the office of President of the United States seven years later suggests the prediction was indeed accurate. The surprise at the outcome of the Brexit vote in 2016 and the landslide victory for the Bharatiya Janata Party in India's Uttar Pradesh Legislative Assembly election in 2017 further proved that the trend is an international one. In all three cases, the pollsters, pundits, and mainstream media, whose very job is to know what people think, completely miscalculated the outcome. Why? Did they just not read the situation accurately? Or were they blinded by their own hopes and opinions? Did they see only what they wanted to see?

I believe the answer is all of the above. And if professionals so completely missed the mark, how much more do we nonprofessional information-gatherers miss on a daily basis?

According to behavioral scientists, we all engage in selective truth-seeking because it makes us feel good. We like to be surrounded by people who cosign our beliefs and lifestyles. Researchers at the University of Kansas recently concluded that the desire for similarity is more than just a choice to seek out the comforting and comfortable; it's our hardwired psychological default. However, it can lead to chaos—both personally and professionally.

Complacency and Confirmation Bias

From the outset, the Viscount de Chaumareys spent his time below-decks with his mistress. It might not have mattered if he'd just allowed his experienced crew to follow the other ships in the convoy, all of which were captained by savvy veterans of the dangerous coastal waters. Almost immediately tensions surfaced between the crew, many of whom had fought with Napoleon against the British, and

the captain, who had joined the British during the French Revolution to fight for the monarchy. On top of that, the governor designate of Senegal, Julien-Désiré Schmaltz, browbeat the captain into taking the speediest route. Schmaltz, too, had bet on the royalist side. In fact, had Napoleon won at Waterloo, Schmaltz would have stood trial as a traitor for his support of the king. Instead, his bet paid off, and like the captain, he saw his star ascending as Louix XVIII took the throne.

This deeply divided ship steered recklessly by the reefs, even when his worried crew warned of the suddenly lighter water that signaled the approaching shallows where the sands of the Sahara emptied into the Gulf of Arguin. The captain, in his ignorance, discounted the warnings. As late as one hour before the ship ran aground, de Chaumareys refused to stop to measure the depth of the sea because it would have slowed them down.

When the storm came and the foundering *Medusa* began to fall apart, did he suddenly rise to the occasion? No, even then, de Chaumareys continued to favor his high-ranking friends over his responsibilities to the ship and its inhabitants. He allowed the governor on board to be lowered into a lifeboat on a padded armchair while hundreds of other passengers were herded onto the makeshift raft at gunpoint. He all but ensured that the rowboats could not tow the raft by understaffing these boats—so that the aristocracy aboard would have more than enough rations to enjoy the voyage to safety. Most damning of all: fearing attacks from the hordes on the crowded raft, he had the tow ropes cut. Back at home, a deeply class-conscious France seethed as details like this leaked to the public as the king's preferred choice of captain stood trial. Not surprisingly, when the verdict was read, the captain had been found guilty of incompetent and complacent navigation. But even here, the captain received preferential treatment; the judge spared him the death sentence and instead sent him to prison for only three years.

Unfortuntately, dangerous complacency did not die with the Bourbon kings of France. Harry Kraemer, Professor of Management and Strategy at the Kellogg School of Management, cites comfort as the downfall of many companies. He notes that all too often once a com-

pany establishes a market lead, its leaders begin to think that everything great will always stay that way. They read, and believe, their own press.

"Complacency sets in, which undermines the continuous improvement necessary for growth," Kraemer warns. "The inevitable result is mediocrity. In the worst cases, the company completely loses sight of its vision." Sensing that the ship is about to run aground, the most talented people begin to leave, and in the panic to turn things around, leaders make bad decisions and compromises.

Psychologists call our willingness to welcome information that supports our positions and dismiss or even deny that which contradicts them "confirmation" or "myside bias." In his prescient book, published in 2009, *The Big Sort: Why the Clustering of Like-Minded America Is Tearing Us Apart*, author Bill Bishop argues that shielding ourselves from opinions and perspectives that don't align with our own leads not just to us segregating ourselves, but to righteousness, entitlement, and, eventually, polarization and intolerance.

While we can easily see this being the case for the uneducated and uninformed—those ignorant trolls who lurk on the internet!—studies have shown that this phenomenon is actually more prevalent among the more educated.

I'll admit, I was shocked to learn this, as I inherently believed "smarter" people would naturally be more open-minded. This revelation, in turn, exposed my own biases to myself, and underscored the idea that even our leaders not just can, but are more likely to, insulate themselves in a cocoon of like-mindedness.

A study of Yale students and toilets exposed another problem in our inherent bias: we think we know more than we do. Students were shown eight items, including a flush toilet, a zipper, and a watch, and asked to rank their level of understanding of how the objects worked. When asked to explain the mechanics behind the things they professed to understand, most students found they had overestimated their knowledge and expressed surprise at their own ignorance. This "illusion of explanatory depth" doesn't matter when it comes to toilets—they'll work the same regardless of our intimate knowledge

of how—but it does in matters of business, political, social, and military importance, navigating the shoals of Western Africa . . .

For instance, in their book *The Knowledge Illusion: Why We Never Think Alone*, cognitive scientists Steven Sloman and Philip Fernbach cite a 2014 survey that asked Americans how the United States should respond to Russia annexing the Ukrainian territory of Crimea . . . and also if they could find Ukraine on a map. So you can play along, cover the bottom map below with your hand, and look at the top unmarked map of the world, with all current countries outlined. See if you can correctly identify Ukraine.

Did you? If you aren't sure, and are looking for an answer key, then you didn't. If you are as confident in the location of Ukraine as you are about recognizing Italy or Australia, then congratulations, you're in the minority. Most respondents couldn't find Ukraine; in fact, the average guess was off by 1,800 miles.

More surprising than Americans' lack of geographical knowledge, though, was the survey's finding that the more mistaken respondents

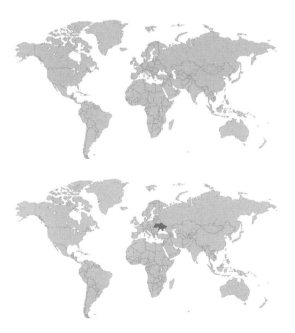

World Maps, by
Andrei Minsk.

were about where Ukraine was located, the more likely they were to approve of military intervention in the situation. Let that sink in for a moment: the less people knew about the country, the more likely they were to favor it being invaded. What if the US response had been put to a popular vote? Would we have raided a country we can't even find on a map?

The United States did not intervene militarily in this particular situation, but it did impose sanctions on Russia for the annexation of Ukraine, which can be seen highlighted in the second map (Crimea is the southernmost peninsula jutting out into the Black Sea).

It's perfectly natural that we're more likely to believe things that reinforce our worldview, that we align ourselves with people who share our views, that we have inbred biases and a distorted idea of how much we know. The real danger comes when these logical fallacies are exacerbated by our modern media habits. As of January 2020, more than half of the world's population, a full 59 percent, was online, with the average person spending six hours and forty-three minutes each day using the internet—roughly one-third of their waking lives. And, thanks to technology companies like Google using computer algorithms and filters enacted by our own discourse and preferences to show us more of what they anticipate we'll like, we are seeing less of the other side than ever before. Instead, we see only ourselves. And clones of ourselves.

The first step to remedying any problem is to acknowledge it. Now that we know how centuries of human evolution and modern communication companies conspire to keep us in a one-sided coma, we can and should balance the scales. To counteract our own biases in information gathering, we need to purposefully look at things we don't normally gravitate toward, find and read opposing views, and put ourselves in situations that make us uncomfortable.

Problem-Solving with Nurses

Museums always want to bring in more people to see art, and the education department plays a big role in accomplishing that goal. That's how

The Art of Perception started, as a modest program for premeds and medical students. Science types could get fun (and presumably easy) humanities credits, and in the process the museum—specifically, the Frick Collection, where I ran the education department—could hook a whole new generation of young, savvy, and excited museum-goers on art. But almost from the first session, the mission began to expand, as I saw firsthand how looking at art could open new avenues, beyond art appreciation, as the students, many of whom had never been to a museum in their life, experienced new ways of looking and discovered new habits of mind in the process. From the beginning it was a two-way street: as I saw new groups of students and tried to expand the library of images I could draw from, I had my own set of eureka moments. For every new audience, I had to come up with new applications and more targeted ways that challenging images could be repurposed to help solve increasingly more specific problems. That's true to this day.

While I was still in these early stages of discovery, I got a call from a woman named Rachel, who'd heard about the program from one of her residents. She wondered if I could come to the hospital where she worked to lead a program for her nurses. I said yes, and almost immediately I made my first mistake. Since doctors and nurses were both in the medical field, I assumed I could teach groups of either of them in sessions that were substantially similar. Wrong. Even though doctors and nurses work together, they have entirely different jobs. Doctors diagnose illness and prescribe cures; nurses provide safe and compassionate care. This means that doctors and nurses see patients in vastly different ways. A doctor, even a compassionate one with a great bedside manner, reviews evidence, trying to arrive at a diagnosis and recommend a treatment. But to administer care, nurses have to really look at patients, their immediate situation, their family and friends, their body language and mood, their habits, their fears, everything they say and anything they're trying to hide. Nurses spend more time one-on-one with patients, so they get to know them better than a doctor ever could. It bothers nurses that more people don't understand this crucial difference. I quickly

learned there is one question you should never ask a nurse: "Why didn't you become a doctor?"

I spent many hours with Rachel and her nurses, both in preparation for their sessions and, later, as the courses took off, in the museum looking at art together. In the process, I learned something I never would have suspected—that the empathy and kindness nurses extend to patients don't always translate to other nurses. In fact, they have the opposite problem. Bullying and aggression, usually by senior nurses directed at their younger, less experienced counterparts, have turned health-care facilities all over into hostile workplaces. It's a leading cause of turnover in the profession, so it's an economic drain and an administrative headache as well. This cruel and pervasive problem— often minimized or ignored as an inevitable "rite of passage"—has a name: lateral violence. And it can get ugly.

Soon after our first call, Rachel wondered if I could help her deal with this "toxic problem." She explained it this way: "The nurses are eating their young." The seasoned nurses often were openly hostile and aggressive to new or junior nurses, making an already stressful work environment even more fraught. Usually this hostility is based on a mutual sense of inadequacy: the younger nurses are well-trained in all the newer, sophisticated technology, and older nurses, with their years of experience, know things that their juniors don't even suspect. As one forty-year veteran said to me, "A good nurse knows the smell of infection as soon as she walks into a room." New nurses won't pick up that instinct for years.

A related worry: new nurses don't file reports when they're bullied for fear of retaliation. So, the resentments simmer just under the surface until an explosion occurs. Since the workplace is already a pressure cooker, these regular explosions are on a very short timer. But instead of solving the underlying problem, everyone cleans up the mess, dries their tears, and gets back to the patients. The timer resets. Rachel wanted to stop the cycle by teaching the newest nurses, known as residents, just like new doctors, to resist and report instances of bullying. But that wasn't enough. The nurses needed a place

to talk openly, not about nursing protocol, but about seeing and observational style and effective communication. They needed to know how to handle confrontations without letting emotion take over. So, the new nurses gathered in groups of ten to fifteen and talked about works of art, including many photographs of real life. Sessions took about three hours, and they were mandatory for all residents. In this neutral setting, they had permission to laugh, cry, and make connections between the art and what was going on every day on the floor and in the operating room. Because they were looking at art, they could ask tough questions in a nonthreatening atmosphere and learn to raise objections to a settled opinion without fear of being criticized or, even worse, ostracized.

The next step was to work with the senior nurses because every story has two sides. While the latter program would focus on biases commonly found in seasoned practitioners, the works of art also stressed being open to new ways of thinking. I remembered that you can bring a horse to water but can't make him drink, but my hope was to splash the water on them to get them to reconsider their relationships with other nurses. Two works of art that I discussed with these nurses seemed to address the problem better than words ever could. In the first, the Hawaiian artist Paul Pfeiffer took a series of video stills of a boxing match. He digitally altered each image to eliminate the fighter throwing the punches so the picture shows only a lone boxer being hit over and over again and crouching in a defensive posture. Without the attacker in the image, it looks like the figure receiving the blows has no idea where the next hit would be coming from. I asked the nurses if they ever had days like this, where they get hit over and over again from every angle. Like the fighters in the video, they, too, stay in the ring and never go down for the count. They would nod in recognition, and I could see their expressions of sadness combined with exhaustion, as if they were all too familiar with this situation. Ironically, Pfeiffer titled this series *Caryatids*, which, as I explained to the nurses, is the name of a sculpture, in the form of a female figure, that takes the place of columns

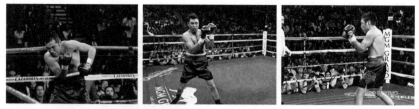

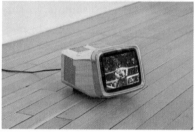

Caryatid (De La Hoya)
by Paul Pfeiffer, 2016, digital video loop,
chromed 12-inch color television with
embedded media player.

in supporting the roof of a building in classical Greek architecture. The figures are stoic and solid, and will continue to hold up the world around them, no matter what happens. That's what nurses do.

The second work of art that I show the nurses is actually a group of photographs, known collectively as *The Brown Sisters*. The photographer, Nicholas Nixon, took a series of portraits of four sisters (one of whom, Bebe, was his wife) in the same order, over the course of thirty-five years. Seeing the portraits together shows the viewer both the toll of time and the rewards of age, as their appearance (and even the emotional dynamic between the women) change subtly as the women live their lives. From young and idealistic sisters with attitude to spare, we watch the women mature into more confident and stalwart versions of their younger selves. Their hair grays, their bodies change, but their facial expressions belie a strength and compassion that only experience manifests.

When I showed the photographs to the older group of nurses, they could see reflections of themselves in all the portraits, but especially the later ones. I encouraged them to look carefully at the younger portraits to remind themselves that they, too, were once starter versions of themselves, inexperienced and even intimidated, as beginning nurses. If they take the time to focus on the younger nurses as people

and professionals, not just neophyte colleagues needing to be "broken in," they might find safety in their own empathy and, hopefully, see the folly in their misdirected aggression.

There was laughter and tears in this session, too, and without mentioning the term "lateral violence," I then posed a question about new technology. That's when the mood darkened. When I asked about this negative response, their answers were couched in anger, fear, and distrust. They were afraid that the technology would leave them behind and that the younger nurses would use the tech to make them irrelevant before they were ready to retire. By first showing works of art to establish where I knew they were coming from, I was able to probe more deeply to get to the root of the problem. The art enabled them to go out of their comfort zone and to see, in a nonthreatening environment free of judgment, that 1) they really didn't know everything and 2) seeing others' perspectives actually augmented their own. I ended their session by saying that really they were in the same position as the new nurses: both groups were ready to learn and to teach. It might take years to undo the damage lateral violence inflicted on this hospital. But if they could start the healing by finding common ground in art, we were well on the way.

In the years since, I've had the chance to do many similar sessions with nurses across the country. When I'm arranging the session, I always ask the supervising nurse if there are any specific problems they'd like to work on. And nearly everywhere the answer is yes, and the problem is the same one, lateral violence, or whatever name they have for it. The sessions now often include both new and senior nurses, and I nearly always hear back from them afterward how much the sessions helped solve some problem, *even if it is one that we didn't address.* I have some theories about why that happens. First, looking at art and talking about your reactions to it provides a neutral ground to express your feelings and personality. It allows factions that had gotten in the bad habit of looking at each other as enemies or combatants to appreciate each other in a new light, as they each reveal insights and aspects of their personality that have no chance to see the light at work. Second, art poses puzzles and problems, while present-

ing a viewer with fresh mysteries. Too often, the problems one faces in the workplace are entrenched, fraught, entangled with emotional history. Or they simply have no solution. None of this is a comfort for the mind, which continues to gnaw at these problems, whether or not there is any likely chance of solving them. Art provides a way for the mind to make new connections, to make leaps and engage in a

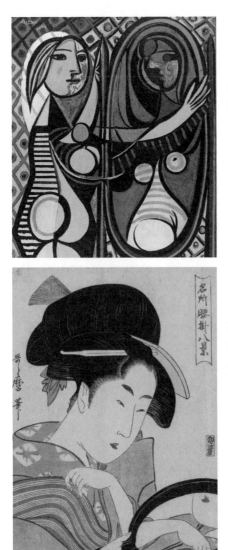

Girl before a Mirror by
Pablo Picasso, 1932, oil on canvas.

*Eight Famous Views of Women
(Meisho koshikake hakkei): Woman
Holding a Mirror* by Kitagawa
Utamaro, 1795–1796.

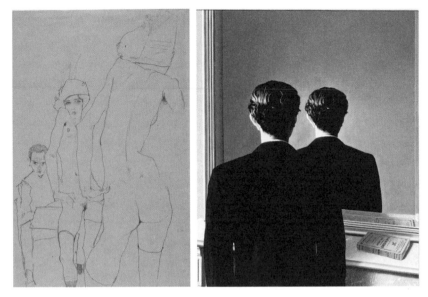

Schiele with Nude Model before the Mirror by Egon Schiele, 1910.

La reproduction interdite (Not to Be Reproduced) by René Magritte, 1937.

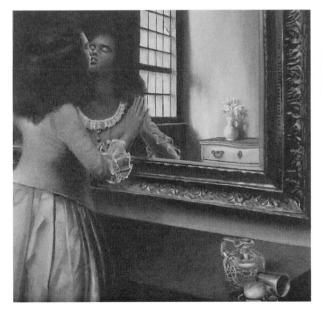

Narcissus by Elizabeth Colomba, 2008.

different kind of thinking, both individually and collaboratively, that is new, revitalizing, and refreshing.

This is a valuable exercise in itself. But there seems to be some property of the mind that profits from this brand of thinking, maybe because it is new, or neutral, or outside of the normal habits and customary stresses. I often will hear a certain sound coming from participants in these sessions: a kind of sigh, or quick breath, or exclamation. It is very gratifying and reassuring to hear while I'm up there with my pointer on the stage, even though I now know to let it pass by without remark. I think of it as the sound of insight. Sometimes a nurse (or, in other groups, a police officer, or an FBI field agent, or a disaster preparedness specialist) will approach me afterward to apologize for the sudden noise they made halfway through. "But while you were showing"—and they'll name the artwork—"I suddenly figured out a problem that's been on my mind for weeks." Sometimes they'll email or write an actual letter weeks later. Art enters the mind on a different kind of timetable. As the saying goes, "Life is short, art is long."

Learning from Our Dislikes

Let's start here with something simple that can help us solve problems: just looking at art. Look at the preceding five images that feature figures in front of mirrors.

Which image do you like the most?

Describe it in one sentence for someone who can't see it.

Perhaps you were drawn to that particular image because it reminds you of yourself or someone you know. Maybe you can relate to the expression or age or body type of the subject. Or maybe you just enjoy the composition and colors.

Now, pick the image you like the *least*, the one you'd breeze past in a museum, the one for which you'd never buy the postcard.

Which image do you dislike the most?

Describe it in one sentence for someone who can't see it.

Rather than just asking yourself why you dislike the image you chose, I want you to really reflect on it. Give yourself a full two minutes—set the timer on your phone—and study that image with an eye toward what exactly you don't like.

Note everything you dislike about the image.

What we like and dislike or believe and disbelieve is unique to each of us and our experiences. Many people don't like Picasso, some because they don't find his work all that inspiring—author Russell Smith confesses he doesn't "get any aesthetic frisson looking at his paintings"—others because they can't get past the artist's renowned misogyny. Some people love modern art; others find surrealism off-putting. A person with a history of abuse or body image issues might avoid depictions of nudity, while someone else might be magnetically drawn to them. The important thing is knowing which type of person you are, what makes you tick, what you like, and, maybe even more important, what you don't like.

Psychologist Carl Jung believed that knowing the things that "irritate" us can lead to better self-realization because often what we dislike outside of ourselves is a secret reflection of what we dislike in ourselves. This habit, which is known as "psychological projection," is believed to be an intrinsic form of self-defense. Actively judging someone as selfish or irritating, for instance, allows us to avoid confronting those same attributes in ourselves.

According to Jung, these negative feelings and opinions and biases often live in the "shadow" of our personality, in the darkness of the unconscious mind. The more we suppress, ignore, and avoid them,

the more likely we are to project them onto others. Hidden in the shadows next to them, though, Jung believes is a "source of creativity and insight." When we understand one, we unlock the other. Doing so is known as "individuation," a process Jung described as "divesting the self of the false wrapping of persona" and "the suggestive power of primordial images." Many believe individuation is vital for a healthy psyche and how we can fulfill our greatest potential as humans.

The echo chamber we find ourselves technologically trapped in leaves little room for individuation. To escape that entrapment, we have to make a conscious decision to seek and understand what we dislike. And to do that, we can't only spend time with the familiar. Instead, we must seek out the unfamiliar. This is how we grow.

Practice leaving your comfort zone. Actively seek out things and people you normally wouldn't. Find and spend time with the other side. Figure out what you are drawn to and what repulses you, what you stand for, and what you won't abide so that you can start to draw a more accurate picture of yourself.

The Self-Portrait

While ours is a selfie culture, the autobiographical images we publish are not always very accurate. We edit what we want others to see. We filter out the imperfections. This practice might be good for our "brand," but it's not going to help us grow or understand or be able to problem-solve successfully. To do that, we need to take a good, honest, hard look at ourselves. From all angles, even the unflattering ones.

Alice Neel was an American painter known for her portraiture. She convinced Andy Warhol, master of the carefully cultivated celebrity image, to pose for her shirtless and vulnerable, exposing his assassination attempt surgical scars and the medical corset he had to wear forever after. An attractive woman her entire life, Neel embraced the same vulnerability when she stripped away all her own vanity and pretense and painted her own self-portrait at the age of eighty. Completely nude.

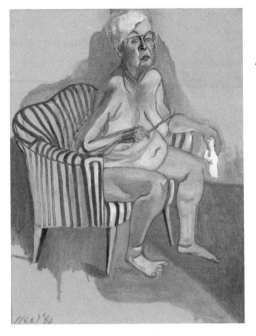

Self-Portrait by Alice Neel,
1980, oil on canvas.

In the image, Neel sits upright, almost regally, engaging the viewer with a direct, perhaps defiant gaze, even though her aging breasts sag toward her protruding stomach. This is the kind of unflinching, honest self-analysis we must do if we are to understand ourselves.

If we are to become problem-solving experts, we need to first know our own internal strengths and weaknesses so we can account for them ahead of time, using or discarding what will and won't help us get to a resolution. Only after recognizing and confronting our biases can we overcome them. To do this, we're going to use art to study ourselves outside of ourselves.

Do you remember the first image at the beginning of this section, just eighteen pages ago, the dark and light busts of a human head?

Without looking back, what do you remember about it?

What did you think about when you first saw it?

If you don't remember the image, why do you think that is?

Go back to the photo on page 15, and study it for a full minute. Set the timer on your phone, and look at the image, noting your thoughts as you do. Ask yourself what you are looking at and why it might have been created. Mark this page and come back when you're done.

What did you see?

What did you think about while you were looking?

Did you see two people or one?

Were the statues male or female?

Did you think about gender—in art or anywhere else?

Did you think about the race of the individual(s) portrayed in the busts?

Did you see color: black or brown or white?

Did you think about racism or identity?

Did you think about what the statues were made of or how they were created?

Do you know who made them?

Their creator is a contemporary artist named Janine Antoni. They are two in a series of fourteen busts she created of herself in 1993. The busts are both representations of Antoni. Take a quick peek back at the photo to confirm this.

Antoni wanted to explore the idea of self-portraiture and the classical bust. When we think of a bust in a museum, the sculpted representation of a person's head and shoulders, we generally picture famous, austere, white men and women carved in marble or cast in

bronze, such as Roman emperors, European explorers, or famous literary figures, even though the art form existed in other cultures, too, as evidenced by the fourteenth-century limestone bust of Queen Nefertiti and the sixteenth-century *Head of a Dignitary* carved of clay in the Kingdom of Benin, Nigeria. Antoni wanted to, in essence, turn the classical Western idea of a bust on its head by sculpting herself, an ordinary woman, out of ordinary material.

Antoni made a mold of her head that captured every detail, every pore, every strand of hair. She then filled the mold with thirty-five pounds of melted chocolate. Yes, chocolate. Antoni took her chocolate bust and resculpted it with her tongue. She repeated the process seven times. She then filled the mold with soap. She brought her soap bust into the bath with her and slowly washed it down. She did this seven times as well. Each resulting bust is both an authentic and unique representation of her.

"I was thinking about how one describes the self and feeling a little uncomfortable with my outer surface as the description of myself," Antoni says. "This piece very much is about trying to be on the outside of myself and have a relationship with my image."

Antoni's exhibit, titled *Lick and Lather*, is on display at the National Gallery of Art. It's a powerful, multisensory piece, as you can smell it before you see it. Antoni won't allow museum curators to protect the pieces behind glass, as she wants visitors to immerse themselves in the experience, as she did when creating them. She's aware of the risks, since many of the busts have been bitten.

"There's not a lot of time between smelling and biting," she concedes. "It's a funny thing when you make pieces about desire and people succumb to their desire."

Like Antoni, to really know ourselves, we need to deconstruct our "self" with a process of discovery and erasure. We need to look at what we're made of, what we think, and question why. Stepping outside of ourselves and really seeing how we look, how we act, how we might appear to others, can help us strip away the things that don't help us in this complex, modern, multinational world, and reinforce those that do.

Let's start with our own internal biases. Who did you think created the busts? Did you think they were made by a woman? Why or why not?

What race do you think Antoni is? Black or white? (You can flip back and look at the image at any time.) Why do you suppose you think that?

What if I told you Antoni was born in Freeport, Bahamas? What do you think of her racial identity now? Again, feel free to look at the busts.

Although she was born in the Caribbean, Janine Antoni is a white woman born to white parents. Most people I show this image to are convinced she is Black. They cite her hair as evidence, or her nose, even the tilt of her head or the fact that her eyes are closed. Knowing her racial background now, why do you think she chose the materials she did? Many people tell me the busts are a statement about racial identity, that she chose the materials because of the colors. One even suggested the piece was about Antoni's struggle growing up in a predominantly Black country as a white girl.

The truth is Janine didn't create the self-portraits to have anything to do with race. She chose to make the busts of chocolate and soap to express the idealized states of a woman: the contrast of being an object of desire and purity. "The brown and white—really, with all my work—it comes from the material," Antoni says. "So, I'm not so much thinking of myself in a dark color and myself in a white color. I'm thinking of myself in chocolate and myself in soap."

Every person who looks at *Lick and Lather* comes to it, like all art, from a different perspective. Some see a racial struggle, some see gender identity, and some see an example of modern art that they may or may not appreciate. To better know ourselves, we need to not only acknowledge our own personal perspective, but also recognize how our experience filters what we see and believe.

In 1770, future American president John Adams, then an attorney defending British soldiers for their shooting of Bostonian Crispus Attucks, an escaped slave and seaman who is thought to be the first colonist killed in the American Revolution, noted that "facts are

stubborn things." His goal was to prove the soldiers were intimidated by Attucks, a "stout" man who stood six inches taller than most, had allegedly grabbed a bayonet, pushed soldiers down, and, according to Adams, "tried to knock their brains out." Adams's account was meant to show that the soldiers acted lawfully, in self-defense, the law being the fact that cannot be changed. Facts, however, can indeed be changed by that most stubborn of all creations: the human brain.

The brain regularly sorts and prioritizes information for the ultimate benefit of its owner. And it doesn't always do so correctly. In the 2018 policy report *Fake News: National Security in the Post-truth Era*, researchers noted that the human brain, especially regarding memory, is a "fallible system, prone to error and distraction: The brain remembers information regardless of whether it is true or false." The report concluded that while our human fallibility has been "exacerbated" by our current technological landscape, it is and always has been most influenced by our cognitive predispositions.

Consider the differences in opinion about the facts of the May 2020 killing of George Floyd by Milwaukee police officers. Similar narratives were conjured up in the officers' defense; like Attucks's, Floyd's height and size was used against him. As in Attucks's case, where five of the seven officers present were acquitted of guilt and two were charged with the lesser crime of manslaughter, in Floyd's case, most of the officers involved were charged with aiding and abetting unintentional second-degree murder and second-degree manslaughter. Opinions of the victim varied wildly, as Floyd, like Attucks, was believed to be a troublemaker by some and a martyr by others. Even the facts were disputed. While almost everyone agreed that Floyd was deceased, a "fake death" rumor still swirled. Others wondered what had actually killed Floyd: police brutality, a heart condition, or drugs. Even the official autopsy report left room for dispute. The medical examiner declared that Floyd, who suffered from heart disease, had "experienced a cardiopulmonary arrest while being restrained by law enforcement officer(s)." The word "while" was seized upon, as, to some, it defied the blame of a "because." While everyone could agree

that the George Floyd situation was terrible, not everyone agreed on for whom: the poor man or the poor police officers.

It might be useful to pause a moment in reading to reflect on these two cases:

How did you feel when you read about Crispus Attucks? Did your thoughts change when you read that he might have been aggressive? How did you feel about George Floyd? Did your opinion on the George Floyd case ever change? What precipitated that shift? Be honest with yourself. The point isn't to judge yourself, but to discover what you think and why so that you can change what needs to be changed to be the best teacher or student or parent or boss or friend or human you can be.

Two summers ago, during a business trip to London, all of my jewelry was stolen from my hotel room while I was at a meeting. While the general manager apologized profusely and called Scotland Yard immediately to investigate, word got out to the small staff of the exquisite hotel that the guest in room 3A had been a victim of theft. For the remainder of my stay, the staff members averted their gazes whenever they encountered me, and over drinks, the hotel bartender lamented that "outsiders" who worked at the hotel were not vetted as carefully as they used to be. The case was never resolved, but I detested my own internal suspicions of everyone I encountered who worked at the hotel. Issues of entitlement, economic disparity, and bias abounded in my own head, and the experience laid bare my own shortcomings in judgment and objectivity. We are all subject to negative or discriminatory thoughts, but we cannot know what we are predisposed to—blaming staff workers, for example, without proof; or even blaming yourself for your entitlement and privilege—if we do not seek out the likes and dislikes in the shadows of our subconscious. To do so, pay close attention to what personal filters might be obstructing your view.

Uncovering the Why behind Like and Dislike

One more question about Antoni's work: Do you like it?

Some people in my class adore Antoni's work, others, not so much. Some see it as a brilliant commentary, others as an unnecessary art project, and still others don't say a word but make a face and do not want to discuss it at all. From their body language, I can tell that most just think it is weird. At one of the presentations where I showed this image, I asked the audience to raise their hands if they didn't enjoy Antoni's busts, and I called on a young woman in the front row.

"Why?" I asked her. "Why don't you like them?"

"I don't know. I just don't." She shrugged.

As our likes and dislikes are personal to us, forged by both our nature and nurture, there will always be differences in opinion between us. To bridge the gap and to successfully live and work and engage with others, we must be able to not only identify our own beliefs and biases, but also know why we feel the way we do. And not just know it, but articulate it. Too often, though, we skip this step and fall back on the too-easy "I don't know."

Nutrition and wellness coach Rebecca Clements successfully guides her clients to better health by teaching them to "reframe the way they think, speak, and act." One of her strategies is helping them see "I don't know" as the path of least resistance.

"The phrase is a cop-out, an excuse, a reason to not try to know," she explains. She doesn't expect her clients to have a ready answer to everything, but she wants them to avoid taking an automatic shortcut because it inhibits their potential.

"Do you know what happens when the three-word phrase 'I don't know' passes your lips?" she asks. "The brain stops trying to know. We are wired to notice, adapt, act, repeat. When we are directed to notice something and we *don't* try to answer, we just stopped ourselves from some potentially epic and life-altering moments."

To keep yourself open to those moments, make it a habit to notice whenever you use the phrase, and immediately substitute it with something different. Instead of saying "I don't know" to guests, new

employees at Disneyland are trained instead to say, "Let me find that out for you," and then do just that. Similarly, the three-word reply is discouraged at the US Naval Academy. Cadets are instructed in their first year that there are only five acceptable answers to a direct question: 1) Yes, Sir/Ma'am; 2) No, Sir/Ma'am; 3) No excuse, Sir/Ma'am; 4) Aye, aye, Sir/Ma'am; and 5) I'll find out, Sir/Ma'am. The Navy's Five Basic Responses brilliantly cover all the bases: affirmation and denial, acceptance of responsibility, acknowledgment of instruction, and a promise to seek out the answer.

Clements offers a few more alternatives:

- I'd love to find out.
- Let me think about that for a moment.
- Great question!
- Nothing immediately comes to mind—give me a second.
- I'll get back to you.
- Hold on, let me decide.

Replacing "I don't know" isn't meant to pressure you into always having an answer. In truth, sometimes we use the phrase when we *do* have the answer. We use it to divert or dismiss a discussion. We use it to cover up our own discomfort at the subject or our honest feelings about it.

Our reason for reticence might be something benign, like shyness, or something more sinister, like collective societal, familial, or personal norms we've subconsciously inherited, or that might work to silence us. In any case, if the reticence stops us from fully exploring the depths of our own minds, we don't fully honor our instincts or give ourselves the opportunity to examine a situation with our own mind. It then lets others do it for us. "The point is to give yourself permission to think deeper, be curious, and get in the habit of making decisions," Clements notes.

To help the woman in my class better analyze her own response to *Lick and Lather*, I asked her to dig deeper: "I really want to understand

your point of view on the piece and why you don't like it. Take a moment and ask yourself why."

She thought for a minute, then answered, "There doesn't seem to be any artistic skill involved. I mean, are you kidding me, she licked a giant chocolate head and took a bath with a soap one? That's art?"

"Why does this bother you?" I pressed.

"Because it's just so silly," she answered.

"What do you find silly about it?" I asked. "The subject matter? The head of a woman?"

"No," she said. "It's actually quite pretty. I think it's the material. Chocolate and soap just don't seem like serious artistic components."

"Why do you think that?" I asked. "Is there a rule about what's allowed to be used to make art and what isn't?"

"No," she said.

"Could it be that you're just not used to seeing art made out of such common materials?"

"Maybe," she said.

"Do you think the artist thought it was silly to sculpt using chocolate and soap?"

"Well, no, of course not."

"Do you do anything at your job that others might find silly? How do you suppose a sculptor would view a PowerPoint, for example?"

"Probably not very highly," she said.

"Is it safe to say that an artist might not love seeing a PowerPoint in an office, just like a businessperson might not love seeing contemporary art in a museum?"

"Yes, that's fair."

"So, having really delved into this more, could you fill in the following for me: I don't really enjoy this piece because . . ."

"Because I'm not used to seeing art made of regular materials, I'm not a huge fan of modern art, but I can see how others would like it," she concluded.

In just a few minutes, by answering a few "why" questions, the woman was able to transform a simple "I don't like it" statement into a more thoughtful, hopeful, inclusive answer.

We know that we won't always like everything we see or everything other people do. What's important is that we're able to articulate why we like something or don't, why we agree with it or not. If we are to successfully navigate the problems life throws at us every day, we need to be able to talk openly and honestly about what we feel and why we feel that way. Simply saying "I don't know"—or "I don't like it" or "I don't agree"—is often a conversation stopper that doesn't help anyone. Explaining why instead turns the period at the end of the sentence into an ellipsis . . . an invitation to more.

Problem-Solving with the FBI

In 2004, when I was just starting The Art of Perception, I was contacted by a supervisory special agent from an FBI field office from out of state who'd read about my course and wanted his agents in Violent Crimes and Organized Crime to have the training. I was still the head of education at the Frick Collection then, so I invited them all to the museum for a full morning of looking at art followed by a lunch with all the participants to debrief. I was excited to have FBI agents coming in person, and I spent days thinking about works in the Frick Collection that could help them and lining up questions about art that an FBI agent would find useful. Both violent and organized crime investigations rely on visual acuity and pattern recognition. While both crimes and criminals can fall into patterns—just as agents and investigations can—I learned early on that no two crimes, suspects, victims, or investigators could *ever* be exactly the same. My training had to underscore that crucial uniqueness for the participants. Patterns of recognition should never fall into reflex patterns of either expectation or response.

On the day of our meeting, the FBI teams showed up to the museum early—something I would come to learn is an almost universal trait in law enforcement. Unfortunately, it was not a trait of the then head of education at the Frick. I apologized for my tardy arrival and

shepherded them up to the boardroom on the second floor, where normal museumgoers are not permitted. The museum used to be a private home, one of the last of the Gilded Age mansions in New York City, and I could see their awe at the surroundings. As they took their seats, I told them that this was not going to be a day to enjoy art leisurely in an opulent setting. They were in for a highly structured session designed to make them question their habits of critical inquiry in investigation and, specifically, their assumptions when it came to assessing evidence. Each work of art we would analyze should be considered as a new case and approached with fresh eyes. Whether they liked the work was as irrelevant as whether they liked the victim of a crime. However, I did want to know if any of the works we discussed evoked a "gut reaction" and what that reaction was. Their instinctive reactions are important to acknowledge, I told them. Whether you can rely on them will vary from case to case, but you must make the effort to articulate the gut reaction and see if that feeling correlates to any observable data. It takes work—which is almost the opposite of a gut reaction—but it can be valuable. We spent time in the galleries followed by individual and team analysis of a carefully selected group of artworks that included both paintings and sculptures. I can't imagine that Henry Clay Frick ever dreamed that one day FBI agents would study his treasures to improve their abilities to conduct criminal investigations.

We returned to the boardroom, where I showed a series of slides—some of crime scenes, some of more contemporary art—to expand the elasticity of their observations and test their agility. Three hours elapsed in about fifteen minutes and we were off to lunch in less upscale surroundings. We traded crime stories and art gossip over lots of burgers and fries. When it was all over and I dropped them at the subway, the agent pulled me aside to say that we'd never discussed a fee for the day. I went into my spiel—how it was my honor to welcome them to the museum and how I appreciated their candor and willingness to engage in this unusual style of training and how I hoped we could continue the collaboration. He gave me a look that I have come to recognize as the law enforcement stare. It can be unsettling, and

I hadn't even committed a crime! When he reached out his hand to shake mine, I felt the wad of bills between our palms. Then he said the words that I will never forget: "We are going to use this training to catch killers. Do not give it away for free. It has real value." And with that, he disappeared into the subway. I'd been doing the sessions for a while by that point, but that day marked a new start—the first mark, really, in a canvas I've been working on ever since. Sometimes I do donate training to professionals who need it and cannot afford it, but the advice of that agent stuck with me and has guided my new business. The Art of Perception has a quantifiable value, and real pros could use it to solve real problems.

Review Your Assumptions

Neurologist and psychoanalyst Sigmund Freud believed that human behavior is driven primarily by two unconscious forces: fear and desire. To begin analyzing your thoughts and examining your own psyche, ask yourself: *Do I believe this/feel this way because of something I fear or desire?*

Look back at an Antoni bust on pages 15 and 16 and ask yourself if your visceral reaction to it might be grounded in fear or desire. If you like it, could it be because it reminds you of someone you love? Do you like it because it's playful, powerful, or peaceful—qualities with which you identify? Perhaps it appeals to you because you desire a career that allows you more freedom of expression, such as Antoni's, which allows her to sculpt from chocolate and get money and praise for doing so? Maybe you like it because chocolate is your favorite food or you love taking baths to relax?

If you don't like it, could it be because you see pain in the face? Perhaps the erased features tap into a fear of anonymity or loss? Maybe the chocolate reminds you of a health struggle or the soap of a poverty issue in your own background? Perhaps there is a sexual element to the materials' relationship to the body that makes you uneasy? Perhaps you just don't like the smells of chocoloate and soap in one room?

Do the same thing with issues that engage you. Did the election result or new human resources policy or announcement from the UN fill you with excitement or angst? Could the reason be anchored in fear or desire?

Suppose I asked you to re-create Antoni's experiment by creating a self-portrait using two different materials: one that represents your deepest desire and the other your greatest fear.

Off the top of your head right now, what material(s) would you use to represent your deepest desire?

What material(s) would you use to represent your deepest fear?

Spend the next few days contemplating your desires and fears. What initiated them? What triggers them? How do they color how you see the world? Then go back and answer the above questions again. In all likelihood, your answers will change the more time and attention you devote to considering the questions, as the longer we spend reflecting on our own character, the more we will uncover about ourselves, writ large.

Change Your Mind

Due to the nature of the materials Antoni used, her busts of chocolate and soap have changed in the last twenty years and will continue to change over time. Parts of the sculptures have flaked away, many are now adorned with peeling layers, and the chocolate ones have discolored with a natural white bloom.

In the same way, our self-portraits will, and should, change over time.

What would your ten-year-old self have chosen as the two materials that best represented your desires and fears at that time in your life?

How different are those choices from the materials you picked today?

What do you suppose your ninety-five-year-old self would choose?

A final way Antoni's sculptures have changed since she created them is that they have been affected by those who have viewed them. The busts have been changed by the humidity and heat of visitors in the gallery, by their curious touching and even nibbling. The idea that viewers in a museum feel compelled to touch or taste an object speaks to their willingness to take chances and break rules, revealing more about their own boundaries. Over the years, three of the busts' noses have even been bitten off.

Likewise, we are formed and reformed by those around us. For your next self-portrait exercise, reflect on how the people around you—in your neighborhood, at your place of worship, at your school or work, in your family, and in your friend group—have shaped you. Note which influences have been positive and which might have been negative.

How have the people closest to you influenced you in positive ways?

How have the people closest to you influenced you in negative ways?

No matter how well-read, well-traveled, or well-educated we are, our environments affect us. We all, to some extent, exist in a bubble of our own making.

A college student from Colgate University recently taught me that I was overzealous and perhaps perpetuating negative stereotypes by describing people using their skin color. As a former attorney who has worked with law enforcement for the last twenty years, I'm committed to coaching people to gather and relay the facts as objectively as possible. In *Visual Intelligence,* I discuss the importance of using concrete, descriptive language. Too often in critical situations, fearful of not being politically correct, we leave out important facts. As an example, I talk about skin color, and how describing someone as "African American" isn't factual unless you know that their ancestors

hail from Africa. It would be an incorrect description for someone from a Caribbean nation. Instead, I counsel that we should use factual adjectives that cannot be denied, such as skin color: a "Black male" or a "white female."

This college student, however, showed me the importance of using our visual intelligence wisely to make better decisions.

I was telling a story about an encounter I had at an airport. "After the ticket agent said the plane was full, this Black man standing behind me—," I began.

"Why do you say he was Black?" she interrupted.

"Because that was the color of his skin, and I'm describing him," I said, ready to launch into my lesson about how "Black" is a description, not an insult.

"Yes, I got that," she answered, "but is that detail important to the story?"

"I guess not," I said, "but I wanted you to be able to picture him."

"If you're painting a perfectly detailed picture, why didn't you describe the skin color of the ticket agent?" she asked.

She gave me pause and made me really think about why. I realized that I didn't describe the ticket agent because she was white, a description I generally leave out. Which exposed an unconscious bias to me: like many people, I don't call out the skin color of anyone except people of color. Why? Perhaps it's a lazy habit based on the time when the majority of Americans were white, but that time has passed. In American public schools in 2014, the "minority" student enrollment surpassed white students. The US Census Bureau estimated that in 2015, more babies of color were born than white babies—a statistic broadened by the fact that people of Middle Eastern and North African descent, regardless of their skin tone, are classified as "white" by the American government.

"I just think we need to be sensitive when we describe people by the tone of their skin when it's not an important detail," the young woman told me. "It's part of what makes being a person of color difficult in our society: the feeling of always being singled out."

She brought up a point I might not ever have considered on my own

had I not conversed with her. Her experiences, young as she is, are different from mine. She was raised in a different state, had a different family structure, practices a different religion, and went to a different school. Although she and I could both be described as "white"—although I doubt either of us ever has been—we are different people who wouldn't want to be lumped into a category of sameness.

The issue of skin color as a defining feature was laid bare in the afternmath of the protestor storming of the US Capitol in early 2021, and the consequences of the categorization were much graver. When the House was breached, Democratic congressman Dean Phillips from Minnesota had a jarring confrontation with white privilege. He recalls, "I screamed to my colleagues to follow me across the aisle to the Republican side of the chamber, so that we could blend in." He quickly realized, however, that "blending in" was not an option for lawmakers of color when in the 117th Congress—the most racially diverse in US history—more than 90 percent of Republicans were white.

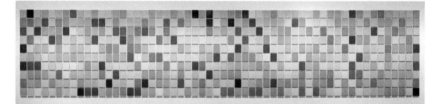

Synecdoche by Byron Kim, 2021.

In the face of white supremacist rioters, the color of his colleagues' skin could potentially and tragically seal their fate.

The Congress members who could not "blend in" were not just Black, or people of color; they were "non-white." What seems like a semantic distinction is anything but, and is underscored by Byron Kim's painting/sculpture at the National Gallery in Washington, *Synecdoche,* which I revisited after those riots. Comprised of over four hundred eight-by-ten portrait-sized panels of over four hundred different skin colors, the work made me realize, in stark visual terms, that no

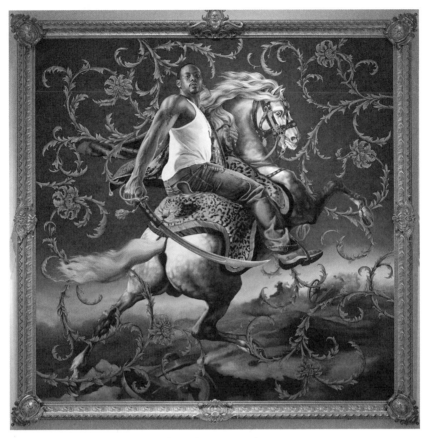

Officer of the Hussars by Kehinde Wiley, 2007, oil on canvas.

two people, regardless of skin color, should be randomly connected by race when it is not relevant. Even more to the point, in the label next to the artwork, a single name corresponds to each skin-toned panel.

Our world moves at lightning speed, and none of us, no matter how well-educated or well-intentioned, should rest on the assumption that we have learned enough or done enough internal revision. By continually examining ourselves and the things, people, and experiences that have and continue to mold us, we will be better prepared to overcome any internal biases that might hinder us in problem-solving

or otherwise hold us back and limit our influence both in and outside of our circles. To do this, we simply need to ask ourselves a simple question far more often: Why?

The Importance of Why

Seeking to understand problem-solving performance competence, researchers at the University of Pittsburgh studied college students studying. They closely monitored a group of physics students as they tackled four new chapters in a Newtonian particle dynamics textbook. Their conclusions were consistent with several earlier studies of people who had mastered mathematics, Chinese, and even acting: the most successful were those who engaged in a plan-recognition process with the most self-explanations. In other words: the people who asked themselves "why?"

"Why?" is so instrumental in reducing the complexity of decision-making tasks that *Fast Company* advises businesses to create a "culture of why." The same recommendation could easily apply to governments, families, or any group of people.

To practice asking yourself "why?" look at the painting on the previous page of a man mounted on a horse. Really look at it; absorb its details. Ask yourself why it was created and what you think it means.

Do you like it?

Why or why not?

Does it make you feel positive or negative?

Could your feelings be associated in any way with fear or desire?

Does the painting represent something you long for or something you don't wish to see?

The painting's title is *Officer of the Hussars,* and it was created by Kehinde Wiley, the same artist who painted former president Obama's official portrait. Much of Wiley's work is known for portraying Black people in historical poses wearing contemporary clothing in front of highly decorative backgrounds.

A replica of this painting was featured on the FOX show *Empire*, but the original hangs in the Detroit Institute of Arts. The oil-on-canvas work is life-sized; at ten feet by ten feet, it occupies an entire wall. It's colorful and striking and impossible to miss. I always find it interesting when I'm at the Detroit Institute of Arts to stand off to the side of the painting and observe visitors' reactions. Many recognize it from television; almost all are taken aback.

The comments I hear range from "That's how it should be!" to "Why do they have to hang things like that here?" Those who love it see it as a positive representation; those who don't cite its unusualness. Both sides agree it's an image not often seen in museums.

The polite adjective most nonfans use to describe it is "uncomfortable." When I ask for specific reasons, the answers vary. No one has ever expressly said it's because they are looking at a Black man in a position of power, but almost everyone refers to the subject of the painting.

I've heard that the man's stare is aggressive, that he's holding a large weapon in a threatening way, and that his attire leaves much to be desired.

"I hate those sagging pants," one woman told me.

"Why?" I asked her.

She thought a moment. "Because it's disrespectful."

"To you," I agreed, "but what about to him? Do you think the man in the painting finds his pants disrespectful?"

"Well, no," she said.

"Should he dress for you or for himself?"

"I suppose for himself," she conceded.

Another man told me that the mounted man's outfit was all wrong.

"Why?" I asked him.

"It just is," he said. "Too casual. It doesn't quite match."

I asked him to describe the entire outfit to me in detail.

"He's wearing a white tank and some kind of purple robe over one arm. He's got on jeans and a belt—don't know what good it's doing him, though, since his pants are falling down. Is that a logo on his shoes? Yes, Timberland. He's got on Timberland boots. I don't think logos belong in art. And it looks like a watch on his left hand. And a necklace. What's on it? Africa? As if we need to be reminded . . ."

"Why does his necklace bother you?" I asked.

"I think maybe it's because they're always so over-the-top, these rappers and celebrities with their giant jeweled necklaces and layers of gold around their neck. It's ridiculous."

"Do you think they find it ridiculous?"

"Probably not."

"Why do you find it ridiculous?" I asked.

"It's like they're flaunting their wealth. We get it, you're rich."

"Do you find stockbrokers ridiculous?" I asked. "With their Armani ties?"

"No," he said.

"How are they not flaunting their wealth, wearing a tie that costs hundreds of dollars?"

"I suppose they are," he said.

It wasn't the first time I had heard criticism of Black men wearing large gold necklaces; there's an offensive stereotype: "gold chains, no brains." So, I asked the man why he thought Black men wore gold necklaces, if there was maybe a deeper meaning. He didn't know of any. I then asked if he liked the actor Mr. T.

"Sure, that guy's cool," he answered.

I told the man about an interview Mr. T, whose real name is Laurence Tureaud, gave where he explained why he wore so much gold jewelry: "I wear gold for three reasons. One, when Jesus was born, three wise men came from the east, one brought frankincense, one brought myrrh, the other one brought gold. The second reason I wear gold is I can afford it. The third reason I wear it, it's symbolic of my African heritage. When my ancestors came from Africa, they were

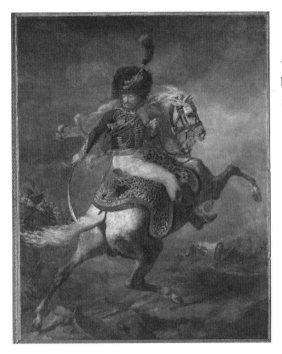

The Charging Chasseur
by Théodore Géricault,
1812, oil on canvas.

shackled by our neck, our wrists and our ankles in steel chains. I've turned those steel chains into gold."

When we dig deeper into the things we instinctively don't like, when we ask why—Why don't we like them? Why do they exist? Why are they the way they are?—we begin to understand and, hopefully, unravel our biases and open our minds to other meanings and the worth of other people's fears, desires, and beliefs.

Another visitor told me they didn't like the Wiley painting because it was just so "extra": "The leopard saddle, the wild horse rearing up while the rider stays calm, it's just too much. Very unrealistic."

Wiley is known for his anachronistic compositions wherein he places a contemporary Black model into an old master painting, an area of culture that has historically excluded Black people. The painting he reworked for *Officer of the Hussars* is *The Charging Chasseur*, an equally large 1812 painting by *Raft of the Medusa* artist Théodore Géricault, which also currently hangs in the Louvre. Take a look at it above and note the details.

Judith with the Head of Holofernes by Cristofano Allori, 1613, oil on canvas.

The rider, a white man, sits in the same position, on a leopard saddle on a horse that is rearing.

Do you like this painting? Why or why not? Are the reasons why the same or different from your response to Wiley's work? Do you see any ridiculousness or ostentation in the Géricault work? Does it make you view Wiley's painting any differently? Why or why not?

As an art historian, I'm all too aware that most of the subjects of canonical art, especially heroic images depicting war, feature white males and were created by white males. They are splendid artistically, but they do only show a portion of the picture of the ancient world, with a noble, romantic cast over white men at that. I think the reason people are initially uncomfortable seeing Wiley recast Black men as heroes, front and center, is because it's new and novel, something they're not used to seeing. All very natural, but it begs the question: Why? Digging in to answer can help us better understand the background and emotion behind some of today's contemporary protests about race.

It might be a simple question, but asking "why?" isn't always easy or comfortable. Many people have told me they're unhappy with Wiley, not for *Officer of the Hussars* but for other, more controversial paintings he's done.

In 2012, Wiley painted other works that depicted Black women beheading white women, a fact that was revisited by the press when Obama's portrait was unveiled. In two different paintings, both titled *Judith and Holofernes*, a Black woman in a long dress stands in front of a background of flowers holding a knife in her right hand and a severed white woman's head, by her hair, in the other hand. The outrage reached a fevered pitch when it was revealed that Wiley told the *New Yorker* that the paintings were "a play on the 'kill whitey' thing."

I can appreciate the beauty of the paintings, but I can admit that the subject matter was unsettling. I revisited the original work to reflect on why. The biblical story of Judith beheading the invading general set on destroying Jewish cities was the subject of dozens of paintings and sculptures and is often cited as a prime example of the "Power of Women," an iconographic topos in the Renaissance and Baroque periods. The specific work Wiley took as inspiration was the 1613 painting *Judith with the Head of Holofernes* by Cristofano Allori.

The painting features a white woman holding a knife in her right hand and the head of a white man, by his hair, in her other. Wiley omitted the female servant companion so the focus in his painting is squarely on Judith. As with the original, there is no blood or gore on either the knife—blade partially shielded in each case—or the severed head in Wiley's painting.

While I abhor violence, the original portrait has never really disturbed me. I don't feel threatened by it or uneasy. I don't wish to be in Judith's shoes, but I have admiration for her strength and bravery.

Why, then, does Wiley's depiction give me pause? Because the victim has changed from a white man to a white woman? Because it strays too far from the biblical narrative?

I turn my whys outward: Why did Wiley construct his painting this way? He'd answered the question of why he'd painted *Officer of the Hussars* with his own: "Why do we continue to undervalue the lives

of young Black men?" Is he giving the same message with his reimagined Judith, that we undervalue the lives of young Black women?

To further uncover my feelings, I then turn my whys back inward with the hardest self-examination question of all: Do I? Do I undervalue the lives of those who are not similar to me, in my comfort zone, or in my immediate vicinity? Do I treat them differently, even if I don't consciously mean to?

Delusions of class, grandeur, or goodness; overrating our own intelligence, importance, and overall self-awareness; and subconsciously seeking out those who are similar—as limiting as those may be, they are not our most pernicious modern prejudices. Instead, it is our bias against our own bias.

I'm-Not-Biased Bias

In numerous studies, researchers have found that most of us believe we have fewer biases than the average person. Which, statistically, just can't be true. They call this phenomenon the "bias blind spot," and it's especially worrisome because the more objective we think we are, the more likely it is that we discriminate. The reason for this is that by firmly believing we can't possibly possess such an undesirable quality, we give it no conscious attention, and are thus more vulnerable to its pull.

It makes sense: we overestimate our good qualities because we want to be good, and underestimate our bad qualities because we don't want to be bad. To prove, even just to ourselves, that we are good, objective judges of our own character, we'll even admit to some of our shortcomings—but only the ones that are culturally acceptable to be bad at, like time management or public speaking. We are innately loath to cop to more serious social crimes like gender discrimination, racial bias, or religious prejudice.

How can we remedy this? We need to ask someone else.

Unfortunately, we can't ask the people it's most likely easiest to ask—

our friends or family—since they are prejudiced toward us. Instead, social psychologists have found that the most accurate resource for uncovering truths we don't hold to be self-evident is our coworkers.

Just ask Ford.

In 2006, the Ford Motor Company was headed off a cliff. Its stock price sunk, its debts were given junk status, and it posted a record $12.7 billion loss. Managerial infighting was rampant; insiders likened internal meetings to the video game *Mortal Kombat*.

Henry Ford's great-grandson Bill, desperate to turn things around, hired a new CEO: former Boeing executive Alan Mulally. Unlike previous CEO Jacques Nasser, an outspoken Australian known for ruthlessly cutting costs and jobs—Nasser's nickname at Ford was "Jac the Knife"—Mulally was quiet and soft-spoken.

Within three years, while the rest of the automotive industry was crumbling under the weight of the recession and seeking government bailouts, Mulally transformed Ford into the most profitable automaker in the world.

An engineer by training, one of Mulally's favorite sayings was "the data will set you free." When asked to give leadership advice to his younger self, though, it wasn't data analysis he preached. It was knowing how others see us.

"It's so important that we each continue to develop our self-awareness," Mulally said. "How do we come across to other people? Do people like working with us—or do they want to run away?"

Just as the final step in painting a self-portrait is to show it to others and gauge their reactions, to truly master self-awareness, we must be brave enough to find out how others really see us. Do our coworkers think we're made of glass? Does our crew think we're unfit to be their captain? Our self-awareness survey is incomplete without this knowledge, but once we have it, we can use it to enhance and edit until we are the person we want to be, the person who can effect change and conquer anything.

Mulally knew he couldn't ask his managers and employees to practice self-awareness if he'd not already mastered it. Thankfully for Ford, he had. His insightfulness helped save the automaker and turn

it into a model of collaboration and efficiency. Instead of only focusing on price or profits, he made people a priority. Bryce G. Hoffman, author of *American Icon*, notes that Mulally created cultural shifts in part by "challenging Ford's most cherished delusions." He forced the automaker and all of its employees to take an honest look at what they were doing and why, and then reorganized their dissident strategies and priorities into "One Ford."

Similarly, we can gather everything that we've learned about ourselves and combine it into one self-portrait of self-awareness that is nakedly honest, nuanced, and powerful enough to solve even a headline-grabbing crisis.

As Jeremy Lin did.

Saving the Day with Self-Awareness

Jeremy Lin is a basketball rarity two times over. When he first became a starter for the Knicks, the slim Asian American guard scored more points in his first thirteen games than any player in NBA history over the same stretch. His hot streak continued for twenty-six games, a period that the New York papers dubbed "Linsanity," during which time New York Knicks tickets tripled in price. Eventually, he cooled down to become a solid player with a lucrative nine-year career that he topped off in 2019, when he became the first Asian American to win an NBA championship as part of the Toronto Raptors. He's well aware of the significance of his historic outlier status . . . because the press never let him forget it.

"I used to run from it," he told reporters, "because that's all anybody ever wanted to label me. 'Oh, he's Asian, he's Asian, he's Asian.'"

Since his professional debut in 2010, Lin has had to deal with his fair share of prejudice, from racial slurs to being stopped by security guards at NBA games. Problems don't discriminate, though, and in 2017, Lin found himself at the center of an unexpected controversy when he debuted a new hairstyle: dreadlocks.

Lin, then a player with the Brooklyn Nets, was quickly decried as the worst kind of "culture vulture" by a host of haters who complained that, as a member of a minority group himself, Lin should have understood better than most the oppression implied in his choice. While sportscasters and journalists around the country debated Lin's locks, the point guard was most surprised to find one of his heroes joining the condemnation.

Former Nets player Kenyon Martin, an African American who, after retiring from the NBA, played professional basketball in China, posted a video online accusing Lin of wanting "to be Black" and chastising the Nets for allowing the "foolishness."

"Do I need to remind this damn boy that his last name is Lin?" Martin said.

Lin's fans were quick to point out Martin's own hypocrisy: the large Chinese character tattoos running up Martin's forearm. To add insult to injury, Martin had previously admitted he didn't know enough Chinese to know what his markings actually represented. While Martin thought they read "never satisfied," NBA star Yao Ming, who was born in Shanghai, said the letters meant "not aggressive" or "indecisive." "Anyone who has seen Kenyon play knows he isn't like that," Ming concluded.

While the world waited breathlessly for Lin's comeback, instead of a counterattack, Lin showcased his amazing problem-solving skills, diffusing the situation before it escalated further.

"Hey man, it's all good," Lin wrote in a comment on Martin's original video. "You definitely don't have to like my hair and definitely are entitled to your opinion. Actually I [am] legit grateful [for] you sharin' it tbh [to be honest]. At the end of the day, I appreciate that I have dreads and you have Chinese tattoos. I think it's a sign of respect. And I think as minorities, the more that we appreciate each other's cultures, the more we influence mainstream society. Thanks for everything you did for the Nets and hoops . . . had your poster up on my wall growin' up."

Lin was able to navigate the situation gracefully because it appeared as if he had spent a lot of time in self-reflection. In an essay

for *The Players' Tribune* titled "So . . . About My Hair," Lin detailed his personal motivation for changing his hair so often and so dramatically. He realized that the unprecedented amount of press and pressure that surrounded his breakout year—his "Linsanity" debut—left him feeling boxed in. He started experimenting with outrageous hairstyles to prove to himself that he could rise above what other people thought of him. Before the dreadlocks, he'd sported a buzz cut, bowl cut, spikes, man bun, braids, and double ponytails. To him, his hair was an expression of freedom. Writer Cameron Wolf agreed, declaring, "Jeremy Lin, simply put, is an artist and his canvas is the peak of his head."

Lin also detailed how he had consulted with several African Americans before adopting dreadlocks to make sure he wasn't being disrespectful.

In the end, Lin acknowledged that self-discovery is an ongoing process, as we are all constantly evolving. He conceded that he may have been wrong about his latest hair choice—"Maybe one day I'll look back and laugh at myself, or even cringe."—and that Martin might change his mind in the future as well. "He might have a different viewpoint in a week," Lin told the *New York Post*. "But not if my whole fan base comes [for] him," he added.

To keep the peace, Lin modeled near-perfect self-awareness:

He knew what he liked and disliked—and why.

He wasn't afraid to be vulnerable.

He acknowledged his fears and desires.

He allowed for the possibility of changing his mind.

And he asked others how he would be perceived before he acted.

When we are engaged in a constant study of self, like Lin, we are better able to diffuse difficult situations and manage difficult people.

The better we know our own biases and behaviors, the more effective we'll be at problem-solving, crisis-averting, and leading others to their greatest potential.

That's not to say we have to sculpt ourselves in chocolate or soap (unless we want to!), but we do need to actively deconstruct our thoughts and beliefs to uncover any unconscious biases or logical fallacies that might color the way we see the world.

Now that we've learned how to clean the lenses that stop us from seeing the world as objectively as we could, we have one more wardrobe change to make. We need to try on someone else's shoes.

Change Your Shoes

Panorama view on Budapest city from Fisherman Bastion, Hungary.

In 1873, the cities of Buda, Pest, and Óbuda ("Old Buda") were united into the capital Budapest, now frequently called the Queen of the Danube. The second-longest river in Europe flows through the center of the Hungarian city past Gothic cathedrals, Renaissance castles, uni-

versities, museums, caves, concert halls, and thermal baths. There's Gresham Palace, an Art Nouveau masterpiece with peacock-covered ironwork gates. There's Buda Castle, a sprawling Baroque palace that now houses the Hungarian National Gallery and the Budapest History Museum. There's Fisherman's Bastion, a fairy-tale-worthy, cascading creation of white stone towers, terraces, and staircases. Everywhere you look there is stunning architecture, breathtaking art, and engineering feats of wonder, all against a spectacular natural backdrop.

But perhaps the most stirring sight in this dazzling UNESCO Heritage City is a small, simple sculpture on the banks of the river. Of shoes.

Just south of the Hungarian Parliament Building, a colossal structure with a 315-foot, bright red–tiled cupola and intricately carved, pristine limestone façade, sixty pairs of shoes lie facing the river. The shoes are a democratic mix. Men's and women's shoes are mingled with children's. Expensive heels stand beside rough-hewn work boots.

The shoes are not new. They show signs of wear: scuff marks, worn soles, missing laces. They aren't in a neat line either. They stand as if

The Shoes on the Danube Bank, 2005.

their wearers just took them off, perhaps in a hurry. Some are tipped over. All are covered in rust.

The shoes were sculpted out of iron as a memorial to the thousands of Jewish people who were lined up for execution on the banks of the Danube by the Arrow Cross militia, a Nazi-aligned party put into power by Hitler in 1944.

Tommy Dick was one of those people. When he was just nineteen, Arrow Cross officers burst into his Budapest apartment. They beat him with their pistols and demanded that he show them whether he was circumcised. Unsatisfied with that humiliation, they tied his hands behind his back and marched him to the banks of the Danube in the cold dark of night. He was joined by hundreds of other suspected Jews: mothers, daughters, senior citizens, children.

The Arrow Cross officers usually laid out a green blanket and demanded that everyone fill it with their valuables. Five-year-old Eva Meisels watched her mother take off her wedding ring and throw it onto the pile. Then, those gathered were made to take off their shoes.

Shoelaces were used to tie victims together to save bullets: once one was shot and fell into the river, those attached would be pulled along and under. An officer would follow behind with a bag, collecting the shoes for redistribution or sale.

It was these shoes, left behind by countless innocent individuals, that film director Can Togay and sculptor Gyula Pauer, who at four years old escaped the same fate by hiding with his family, decided to focus on for the 2005 memorial in their hometown. In doing so, they captured the horror of the time in a way that's both simple and striking. *The Shoes on the Danube Bank* memorial is intimate and tangible. Standing before it, safe in your own shoes, it's impossible not to imagine the people who were forced to take theirs off before being murdered. Author Sheryl Silver Ochayon writes, "The memorial is so effective because the touchable, corporeal shoes along the river, left behind empty and without their owners, force us to confront the question: Whose shoes were they? Who were the people that are missing from the sculpture?"

By putting themselves in others' shoes and allowing viewers to do

the same, artists like Togay and Pauer are able to tap into our collective consciousness. Choosing and executing perspective—literally, symbolically, structurally, and thematically—are integral parts of prep for any artist. Perspective can refer to the means by which artists execute a work to make it appear realistic or not, such as drawing a road on a two-dimensional surface so that it appears to converge into a narrower point as our eyes would see it in three dimensions. Perspective also refers to the decisions an artist makes about how they will organize their idea, how it's meant to be seen or experienced, what story it's telling, and how to execute that story. Perspective is something artists plan for, practice religiously, and constantly check to make sure they're getting it right.

To problem-solve as artists do, we must also actively address perspective. We must consider it as a means of stepping outside of ourselves and as a strategy for changing our physical and emotional vantage points.

Problem-Solving with the HIG

It has been a joy to discover how many people in such vastly different professions want to take advantage of The Art of Perception. I've started getting used to unusual requests from unexpected quarters. But when I got a call to bring my program to a team that drew from the CIA, the FBI, and the Department of Defense, I had to ask myself how I could really be of any help to a group of such highly trained specialists. This particular team was known as the HIG, an acronym for High-Value Detainee Interrogation Group. In the interest of national security, they deploy mobile teams, both in the United States and abroad, to collect intelligence through interrogation. Could I help them make a tangible connection between looking at art and gathering intelligence from hostile sources? This was going to stretch my capacities for creative thinking.

By this point, I had years of experience working with the intelli-

gence community on counterterrorism and surveillance initiatives. But the HIG's work was different. They had to question detainees, often in their own countries, who had direct or indirect knowledge of terrorist activity aimed at the United States and our allies. How exactly could I equip them with the tools for that? I started by trying to connect the analysis of artworks to the process of interrogation. In my experience, questioning is usually straightforward, even linear; you need information to get from point A via point B if you hope to land on point C ("Where did I put my glasses?" "Shall we meet again this weekend?" "What goes into a croque monsieur?"). But then I started thinking about abstract art. There is no point A, B, or C, let alone any linear connections in most abstract works, but there is a whole picture with its own dynamic, and that was where I decided to start. The more I thought about it, the more I realized that most questioning (I like to think of it as dialogue) is not linear at all. What if you ask a question and the answer, purposefully or not, takes the conversation in a new and different direction? What if you're willing to go in that direction (maybe to get more information, or just to disguise your actual intention) but you still want a response to the original, still-unanswered question? That's a lot of "what-ifs"!

One of the members of this team introduced me to the Latin term *festina lente*, which means "make haste slowly" or maybe "hurry up at your own pace." While that sounds oxymoronic, it's the right attitude for problem-solving. We may be in a rush to do what has to be done. But we probably won't find a solution unless we take on these tasks prudently and thoughtfully. The team contacting me was part of a research organization whose overall mission is to study and document strategies to advance the science and practice of intelligence gathering and interrogation. True, they wanted to improve their interviewing techniques, but essentially, they wanted to recognize and shape the rapport for their own ends, based on stronger awareness of visual cues.

All through my first session with them, I was looking forward to the debrief, when team members would tell me what resonated with them and what they thought would be most useful in interrogation.

What I heard surprised me: the presentation gave them tools they could use to sharpen situational awareness and shift the narrative. I'd always thought of situational awareness as physical: where you are, how you got there, how you could get out, how you'd describe where you are to someone who isn't there or just can't see you. Instead, these team members defined situational awareness in terms of the interviewee. What was the rapport? Was the connection moving in the right direction? Did the interviewer have a reliable impression of the interviewee and their ease or discomfort? These responses helped me broaden my own definition of situational awareness beyond just the physical.

The second skill they wanted to sharpen was their ability to shift the narrative. Artists do that all the time. The contemporary artist Titus Kaphar transforms works of art to shift the emphasis from one subject to another to engage the viewer in an unexpected dialogue. Géricault shifted the emphasis in his depiction of the raft of the *Medusa*, transforming it from a seafaring catastrophe into a political failure, pointedly recasting expectations of race and class in the process. The HIG interrogators found value in creative representations that upended your perspective, as in Velázquez's *Las meninas*, a portrait of life in the court of Philip IV of Spain, one that puts the viewer inside the painting, in the center of the complex social relations, in the middle of a quiet but highly charged moment at court. They appreciated the way one of the photos I showed—of a mother, seen from above, lying on the floor of a store beside her two children—challenged their immediate assumptions. While the picture seemed to show victims of a shooting, in fact, it captured one mother's quick thinking: she was trapped in the Westgate Mall in Nairobi on the day of the al-Shabaab mass shooting, but she'd spotted a wooden screen, where she quickly brought her children to hide, wrapping her arms around them both, and quietly singing in their ears to keep them calm (and to help them escape detection). All of these images inspired them to imagine new and nonlinear strategies that could help them extract more precise and substantive intelligence from their interviewees.

Finding Perspective

When painting *The Raft of the Medusa*, Géricault made a conscious choice about how he would depict his subjects. He could have easily, and perhaps righteously, portrayed the last few survivors as degenerate cannibals. One of the rescuers, a French soldier, d'Anglas de Praviel, published his firsthand account in 1818 and described the men on the raft as "lying on the boards, hands and mouths still dripping with the blood of their unhappy victims, shreds of flesh hanging from the raft's mast, their pockets filled with these pieces of flesh upon which they had gorged themselves." Instead, Géricault decided to portray the survivors with hope and humanity. A father figure grieves for a younger male; muscular men wave flags to summon a rescue. Their faces are awash

Elihu Yale; William Cavendish, the Second Duke of Devonshire; Lord James Cavendish; Mr. Tunstal; and an Enslaved Servant, artist unknown, 1708, oil on canvas.

with sorrow and pain, but not malice. Géricault had sketched studies for the piece that included a man eating another's arm, a close-up of a drowned man's head, and a crowd scene from earlier in the disastrous voyage that showed the actual onboard mutiny. Art historians believe he chose the tableau he did so the work would show universal suffering rather than individual folly and wouldn't distract from its underlying political critique of French slavery and imperial folly.

In the same way, we can dissect problems by studying the different perspectives inherent in them. To start, let's get used to noticing perspective and the impact it has. Take a look at the painting on the previous page.

Who is the subject (or subjects)?

How many people total appear in the painting?

How many different groups of people are there?

What can you tell about their relationships?

How would you rank the importance of all of the subjects in the painting? Who do you think is the most important? Who is the least? Why do you think that?

What details signify status or lack of status in the subjects?

According to the composition of the painting, the three white men seated at the table seem to be the most important figures. They are the largest and most detailed. They are dressed formally, wear jewelry, and drink from crystal glasses. The man standing to the left of the table wears less fancy clothes, but his position near the other men conveys his importance. In the background, a group of what appear to be children are playing, or perhaps practicing dancing, with an adult nearby. Their figures are not as large or detailed, suggesting they aren't as important to the scene. At the far right of the table, standing

in the foreground, also finely dressed and detailed, is a Black servant boy, denoted by the fact that he looks at the men and carries a wine cask. Not being relegated to the back signifies his importance, but a closer look at his person, and the silver collar with the padlock around his neck, shows that it is not due to his personal worth but his master's, as his presence underscores the man's wealth and power.

The painting was created in the early 1700s allegedly to commemorate the marriage brokerage of the daughter of Elihu Yale, benefactor and namesake of Yale University, to James Cavendish, the brother of the Duke of Devonshire. James sits at the table on the left, in the red coat; the duke is seated at the far right. Elihu Yale sits at the center of the table, somehow much taller than his companions. The artist manipulated the physical perspective to give Yale the place of honor, as we can see from the illogically slanting table. Standing nearby is a lawyer, Mr. Tunstal. As with the servant boy, the lawyer's presence is meant to convey the importance of the seated men, showing the amount of wealth involved in the transfer of Yale's daughter to Cavendish's household. Many scholars believe the girl in the yellow dress is Yale's daughter Anne. Her relegation to the background of a central event in her own life hints at her status. More recent research centered on clarifying the history of the painting has revealed that the identity of two of the sitters might be in question; Lord James Cavendish's and Elihu Yale's identities have been confirmed. The identity of the sitter previously noted as William Cavendish, Second Duke of Devonshire, has been updated to be, most likely, Dudley North, who had married Yale's elder daughter, Catherine. The identity of the lawyer, Mr. Tunstal, has been updated to be David Yale, the son of Elihu's cousin John Yale.

Being aware of and addressing perspective can help us better understand almost any situation. And change it.

When the artist Titus Kaphar arrived at Yale to study for his Master of Fine Arts, he found the Elihu Yale painting, prominently on display, "challenging." Instead of demanding its removal, he added to it. His answer wasn't to erase the problematic history, but to answer it. Kaphar re-created the same image, but with a new focus.

The scenario is exactly the same, but the perspective has shifted seismically. The Black boy is now the center of attention, his worth framed in gold. There is no collar around his neck, and instead of looking at the white men, he stares directly out at the viewer, implicitly bringing us into the conversation about the painting. Crumpling up the central characters of the original painting without discarding them, and framing and enlarging an otherwise overlooked character, created a powerful and thought-provoking shift in perspective.

Kaphar explains, "I wanted to find a way to imagine a life for this young man that the historical painting had never made space for in the composition: his desires, dreams, family, thoughts, hopes. Those things were never subjects that the original artist wanted the viewer to contemplate. In order to reframe the discussion, I decided to physically take action to quiet the side of the painting that we've been talking about for a very long time and turn up the volume on this kid's story."

When you saw the first painting of Elihu and his companions, how much thought did you give to the little boy on the right? How much more thought do you give him now? Perspective helps shift the narrative, and by shifting it, we can shift the entire conversation.

Multiple Perspective Shifts

When you start looking for a different perspective, you will find it. Then keep looking. If you can find one point of view you didn't automatically consider, you can find more.

The effect Titus Kaphar had reconceiving the Elihu Yale painting into his own, *Enough about You*, was so powerful that he repeated it. He took a portrait of wealthy white women sitting at a table laden with fruit and refashioned it to focus on the gold-framed face of a Black servant girl. But he didn't stop at that reconstruction. He continued, and still continues, to look for ways to highlight new angles in old works. He doesn't just crumple. He cuts and splatters, adds and sub-

tracts, inverts and subverts the view. Thomas Jefferson is sliced out of his stately portrait and placed in bed with his enslaved Black mistress Sally Hemings. George Washington, the father of American liberty, has his mouth covered by long strips of paper tacked on by rusty nails, the paper a reprinting of a newspaper advertisement placed by Washington seeking the whereabouts of his runaway slave Ona Judge. Kaphar obscures faces on paintings with tar, wraps figures in muslin, drops boxer Muhammad Ali on the desk of the Founding Fathers.

On the TED stage in Vancouver in 2017, Kaphar demonstrated his technique to reframe history live in front of an audience. He talked about how, as a Black kid in Michigan, he didn't grow up going to museums, but later, first in junior college, then college, learned to paint from copying masterworks from them. He showed the audience a slide of an example: *Family Group in a Landscape* by Dutch painter Frans Hals, shown on the next page.

If you had to list the things—people or objects or colors or shapes—in the painting in order of prominence, which would you say are the top three?

Kaphar then unveiled his own canvas re-creation of the image, a masterwork in and of itself. He explained how painting was a visual language, and that every single thing on the canvas was there for a reason. The silk breeches of the man and the gold necklace of the woman were meant to convey their wealth. The setting, the pose, their gazes, the items in their hands, the lace on their collars—all of it meaningful. "But," Kaphar said, "sometimes because of compositional structure, because of compositional hierarchy, it's hard to see other things."

He then dipped a wide brush in white paint. The man in the painting, Kaphar explained, was the tallest on purpose. The white male patriarch might not have been the tallest in real life, but he was made so by the painter to attract the viewer's gaze, so Kaphar shifted it. With broad strokes, Kaphar painted over the man's image. Without his presence, the woman came more into focus. Kaphar painted over her gold necklace, rendering her less dazzling, then her lace, her dress, and her person altogether. He continued this way, covering his own work with white paint until only the dog and young Black boy were left.

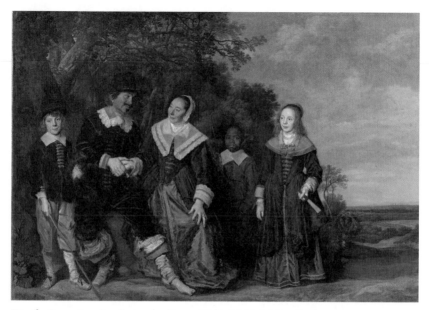

Family Group in a Landscape by Frans Hals, 1645–1648, oil on canvas.

Did you include either in your list of the most important things? Did you even see the dog? Go back and look if you missed it.

Kaphar continued to paint until he was satisfied with the image.

What would you say are the three most prominent things in the painting now? Did your list change?

What or who is obscured in your life, in your organization, in your workplace or school because of compositional structure or hierarchy? Make it a point to seek out those perspectives as well.

Kaphar concluded his presentation by stressing that his work isn't about covering up the past or getting rid of our history, as the answer to problems isn't erasure. To illustrate this, Kaphar added linseed oil to the white paint and brushed back over each character's face. He explained that the oil will make the paint become transparent, re-revealing the other faces over time. "This is not about eradication," Kaphar said. "What I'm trying to show you is how to shift your gaze just slightly, just momentarily."

Shifting our perspective, even slightly, can be a daunting prospect

because we can't be sure of what we'll uncover and how it might affect the stability of the system that serves some of us well. Kaphar noted that there is more written about dogs depicted in seventeenth-century art than about the identity of slave children, and how much easier it is to find out the specific manufacturer of the lace on the family's collars than it is to know about the boy in shadows. But the boy exists. He existed the whole time. Who is he? What's his history? What are his hopes and dreams? What have we as a society missed because we never bothered to find out? What is your company or institution or neighborhood missing because you don't seek out other perspectives?

Kaphar reminds his viewers that the overlooked perspectives are often those of the most vulnerable people in our society. Like a ship, our society or company or school is only as strong as its weakest point. If we look for other perspectives, especially those often obscured by ingrained structure or hierarchy, we might just find the next great artist or idea or product or solution . . . or we might stop a problem before it even has a chance to take root and grow.

Perspective Isn't Always Obvious

Perspective, however, isn't always easy to see. In the painting on the next page, the artist Hans Holbein the Younger uses a technique popular in the 1500s called "anamorphosis," in which a central theme was "hidden" in a distortion that could only be seen if the viewer changed their vantage point.

To see the distortion in the bottom center of the work, slowly twist this book clockwise until it is almost perpendicular to you, or keep it still and position yourself to the right of the book so that you are almost perpendicular to the page. Do you see it? Keep trying until you're able to find the correct perspective that reveals a skull.

The gruesome addition to an otherwise historical portrait is known as a *memento mori* in the art world, a reminder rooted in religious tra-

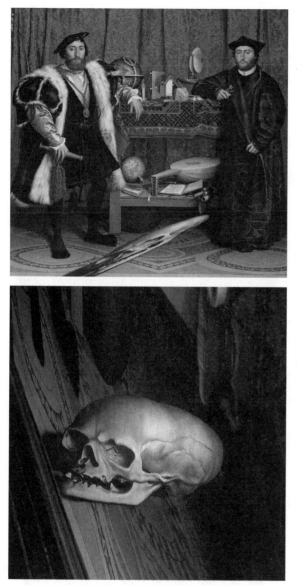

Jean de Dinteville and Georges de Selve ("The Ambassadors"), by Hans Holbein the Younger, 1533, oil on oak. Dinteville, a French nobleman posted to London as ambassador *(left)* together with his bishop friend de Selve *(right).*

Detail of the skull in the painting above.

ditions of the inevitability of death and the fragility of life. The Latin translation is literally "remember death."

Artist Kerry James Marshall employed the same technique in his answer to the lack of art in museums depicting regular Black life. "I am overwhelmed by white figure representations every time I go to

School of Beauty, School of Culture by Kerry James Marshall, 2012, acrylic on canvas.

a museum," Marshall said. "It is almost universally understood that these images are the foundation of art in the Western world."

To help balance the scales, Marshall creates large works that feature Black people the same way artists have showcased white people in everyday life for centuries: frolicking beside lakes, working in their businesses, and even just posing. In his 2012 painting *School of Beauty, School of Culture*, Marshall used an anamorphosis to call attention to a different kind of memento: the omnipresence of beauty ideals.

If you turn the painting to the left, a Disney-like princess, blonde and pale-skinned, emerges front and center. Even in the midst of a salon that caters to Black clientele and celebrates Black beauty, a place buzzing with activity and filled with Black iconography, the specter of what society deems physical perfection looms large. The adult patrons work around it anyway, but it is there, silent and looming. The children notice and question it; a little boy in overalls even bends down to try and figure out what's "behind" it.

The idea behind anamorphosis is that by forcing a viewer to change their physical perspective to the work of art, they would also become conscious of their gaze. In this way, artists encourage actual movement to shift perspective and augment interpretation rather than just looking at a work of art passively. The execution takes planning and extra work, of course, but the reward for the artist is that more people would focus on the intentional message and the work as a whole. It also changes viewers' experience with the work of art; they evolve from passive seeing to active assessment.

We can use this technique to assist us in problem-solving by consciously changing our perspective, physically, emotionally, and intellectually. Instead of just looking at a situation straight on, noticing only what is familiar to you, try looking from another's point of view. This is something novelists do all the time. Without this skill, characters would all be modeled after the author and would make for pretty tedious fiction. If looking at an object or piece of art, look askance at it, from the right, from the left, or even upside down. Making the shift initially requires thought and deliberation, but over time the process can become automatic and take you beyond simple linear thinking. High school senior Ian Smith did, and it helped him get into college.

Like most high school seniors, when Ian read his dream college's application essay prompt, his heart sunk. The question was broad yet daunting: "What event of the twentieth century would you change?"

Ian was a good student but not a great writer. And he didn't consider himself very creative or artistic, so the idea of answering in verse or sketching his response was out. He wanted to write a straightforward, respectful response, but he knew that the competitiveness of college admissions warranted a unique response. He was born in New York City just after 9/11, but so were thousands of other kids. What event would he change? Good things didn't really need changing, so he thought through the tragedies of the time: the Great Depression, the world wars, the Holocaust, the war in Vietnam. Since his mother's family is Jewish, preventing the Holocaust was personally very important to him, but how would he wish that into existence? Killing Hitler seemed the obvious answer, but it wasn't unique or true to

Ian's morals. Instead, Ian put himself in a surprising place: in Adolph Hitler's shoes. He studied the Nazi leader from childhood to see if he could figure out what helped transform Hitler into such a despicable human being. Ian found his answer: he would go back to 1908 in Vienna and have the Academy of Fine Arts admit the eighteen-year-old Hitler.

According to his own autobiographical writings, Hitler longed to be an artist. As a teenager, he applied for admission to art school in 1907 and was rejected. But Hitler didn't give up. He hung around the Vienna cafés frequented by famous artists hoping someone would mentor him. No one did. He tried to make money illustrating postcards. His business failed. He applied to the Academy again in 1908 and was again rejected with not a small amount of criticism. Frustrated, directionless, and so poor he often slept under bridges, young Hitler began to absorb the anti-Semitic mindset of the city's overlooked and dejected who resented the rich Jewish community that had flourished under the Habsburg emperor Franz Joseph I. Perhaps, Ian thought, if Hitler had been accepted into art school and taught to use his passion creatively, he wouldn't have instead used it for revenge and annihilation.

Ian knew it was risky to give the century's greatest despot even the slightest hint of humanity, but putting aside his own distaste for the dictator and trying to see the world through his eyes for just a moment gave Ian a greater empathy toward the downtrodden and got him accepted into the college of his choice.

Considering a different perspective isn't just useful for problem-solving; it can also help us proactively avoid problems. Far too often, problems that didn't need to be problems arise because we neglected to look at a situation from a different angle. For instance, not taking the time to consider a novel fundraising idea from the viewpoints of their own invitees cost the Virginia Museum of Fine Arts some bad PR and public ill will, the very opposite of what museums seek.

Unlike the government- and royal-sponsored museums in Europe, American museums were founded and rely on a capitalist economic model of raising their own revenue to maintain operations. As such,

Western Motel by Edward Hopper, 1957, oil on canvas.

even the most prominent US cultural institutions continually struggle to stay solvent. Sotheby's reports that even though the Metropolitan Museum of Art in New York City has $4 billion in listed assets, they aren't very liquid, with only $7 million in cash holdings. With such tight operating budgets, museums have to be creative without courting controversy that will affect their bottom line.

To increase visitorship and revenue, in 2019 the Virginia Museum of Fine Arts conceived of a novel experience to coincide with an exhibition of Edward Hopper's work. The popular twentieth-century American artist is known for his quiet interior paintings, including many hotel rooms, so the museum paired sixty-five of his works with pieces by thirty-five other artists to explore how hospitality settings, and the people frequently in them, are depicted. Along with the art, the exhibition offered educational programming such as lectures, symposia, classes, and a unique proposition: the opportunity to spend the night inside a Hopper painting. The museum faithfully re-created Hopper's *Western Motel* into an actual room in which guests could immerse themselves and spend the night.

As someone who spends 190 days a year on the road for her job, I am often in hotel rooms. Having stayed everywhere from roadside

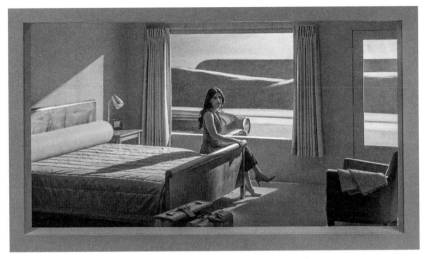

Virginia Museum of Fine Arts Hopper Hotel Experience, October 26, 2019–February 26, 2020.

lodges to five-star resorts, from bed and breakfasts to convents, I often find myself ruminating on the experience of spending time in a strange room. I marvel at the details—such as the hotel room where the bathroom light turned on automatically when my feet hit the floor next to the bed—and the many layered nuances of the choices made by architects, designers, and hospitality employees. I was sold on the idea of spending the night inside a Hopper painting re-creation, even if many of my museum colleagues thought it was a thinly veiled, cheesy fundraising gimmick. Alas, I wasn't alone, as the experience quickly and unexpectedly sold out.

Unable to spend the night in the painting-come-to-life, I pored over the photographs and press. Contrary to my colleagues' negative initial reactions, the exhibit and the pop-up "hotel room" were incredibly well-received by almost everyone. Almost. One person who was lucky enough to take part in, and duly excited for, the museum sleepover was acclaimed art critic Seph Rodney. Rodney, unfortunately, did not have a great experience. He likened it to "being a character in a horror film" and noted that he "woke up screaming."

Rodney didn't just randomly get tickets. He was invited by the museum's communications department. With a PhD and a Rabkin Art

Journalism Prize, Rodney is a museum specialist, a book author, and a faculty member at Parsons School of Design. He is also a Black man. A Black man who found being put in a back-of-house "room" with no privacy, no facilities, and no self-security unnerving. While the fake door to the room had a lock, it also had an open panel in the middle that let in light or anyone who wished to enter. There was an armed guard assigned to stand outside the room, which only made Rodney more unsettled. When he jolted awake in the middle of the night, convinced that someone was in his room, he was afraid, and yet too afraid to act. He recalled, "I want to run out and see if the guard is actually awake and present, but then I think that a Black man running out of a room in an agitated state with no one with me to bear witness when I encounter personnel who carry firearms and instead I wait . . . I spend a good part of the next day thinking about who thought this was a good idea."

Rodney wrote about his less-than-stellar experience in *Hyperallergic*, a highly regarded online art journal with more than a million readers. The bad press could have been avoided if anyone at the Virginia Museum of Fine Arts had analyzed the idea from the perspective of potential visitors, especially visitors they had invited. It doesn't take much introspection to imagine how a solo Black man might feel about being put in a room guarded by unknown and *armed* personnel. What about a young, single woman? How might she feel about sleeping behind an unsecured door? Or a visitor who needed closer access to a bathroom?

To problem-solve effectively, we must make it a habit to consciously change our perspective. And to do that, we need to take it personally.

Making Perspective Personal

There are three iron signs alongside *The Shoes on the Danube Bank* memorial that read in English, Hungarian, and Hebrew: "To the mem-

ory of the victims shot into the Danube by Arrow Cross militiamen in 1944–45." If that is all I had told you about the sculpture, even if I showed you an image of the shoes, you would not have had the same reaction you did upon hearing the story of how nineteen-year-old Tommy Dick was beaten, molested, and marched to the river. The personal and vicious details about one of the victims transformed a pile of rusty iron shoes into a living memorial.

Fear of dying became all too personal for members of Congress on January 6, 2021, when a rally to protest the election of Joe Biden as the forty-sixth president of the United States turned violent and deadly. When supporters of Donald Trump stormed the Capitol building, senators and representatives took cover under desks, under chairs, and in closets while calls for their assassination caused cacophony and chaos in the hallowed halls. The members of both parties had participated in past discussions and actions—or lack thereof—regarding lawlessness, looting, and guns, but once the violence breached the "People's House," where they actually worked, they were ready for

Object: Abolition of the Slave Trade, or the Man the Master, 1789.

legislative change. After experiencing the threat of death firsthand, a number of elected officials on both sides of the aisle instantly sought accountability at the highest levels of government. Had the rioting occurred elsewhere in Washington, not threatening their bodily safety and security, would they have sought accountability with such determination and vehemence? Having a personal stake—or skin in the game—has a way of shifting perspective and heightening awareness.

Take a look at the illustration on the previous page.

How does the image make you feel? No matter what race you identify with or where you live, the image is upsetting, as it shows one group of people subjugating, abusing, and taking advantage of another. But I want you to dig deeper. Strip away the surface indignation and arm's-length excuses. Look again and ask yourself harder questions. *Why* do you feel the way you do? You, personally, not you as a citizen of humanity. Does the image evoke fear or desire in you? Why?

For Americans and Western Europeans, this image represents the opposite of historical reality. It's actually a satirical etching from 1789 from the British Museum arguing against the abolition of the slave trade in Great Britain because the author believed it would lead to retaliation.

If you identify as white, this role reversal is probably not something you're used to seeing depicted in art. For people of color, especially Black Americans, reminders of slavery are ubiquitous, from statues in city parks to famous slaveholders printed on our currency. Viewing a role reversal forces us to confront how things feel for others. Now take a look at the image on the next page, and consider these questions:

What was the first thing you thought when you saw this image?

Do you have positive or negative feelings about the image?

Why do you think that is?

Did the image make you uncomfortable? If so, what specifically made you uncomfortable?

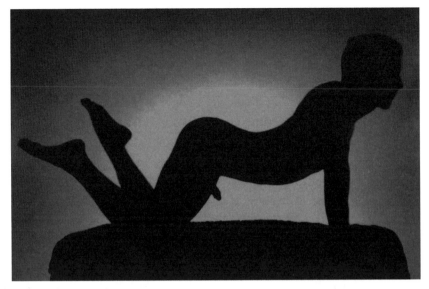

Icon by Karen Zack, 2010.

Why do you think the image makes you uncomfortable or not?

Does the image evoke fear or desire in you? Why?

How do you think it would make your father feel?

Why?

How do you think it would make a seven-year-old boy feel?

Why?

What do you think the image is promoting?

For women, this image represents the opposite of cultural reality. This piece by Karen Zack was part of a 2011 exhibit at the SOMArts Gallery in San Francisco titled *Man as Object: Reversing the Gaze* that sought to examine the "politics of exposure."

If you identify as a heterosexual male, this image is probably not something you're used to seeing. For people who identify as women, even seven-year-old girls, images of their gender identity being objectified are quite common, from billboards and magazine covers to the mud flaps on trucks, and ubiquitous across the internet.

I was immediately reminded of the full-body woman's silhouette that has graced truck wheels' mud flaps since the 1970s. As a young girl on road trips with my family, I remember looking at the shiny silver woman-in-recline bouncing along and worrying about her. What was she doing there? Even at a very young age, though, I knew she was there for her voluptuous body, a thought that frightened me and made me not want to grow up. The pervasiveness of this fear throughout a woman's life was captured in a tweet during the #MeToo movement by an account named "#YesAllWomen": "Because what men fear most about going to prison is what women fear most about walking down the sidewalk."

Examples of artists bravely willing to shift perspective can be found, even if their resulting work subjected them to ridicule, acer-

Olympia by Édouard Manet, 1863, oil on canvas.

bic reviews, and worst of all, a fleeing market. Édouard Manet's *Olympia* of 1863 is an anchor in any nineteenth-century European art course. Viewers meet the deadpan gaze of the reclining nude woman as the Black servant brings flowers from an implicit and recently departed male "client." Highly sexualized and racially divergent, the painting features the servant hovering, barely discernible from the dark background as the white woman's body is on full display, between the full blooms and the black cat, arching its back. The painting, although shocking in its confrontational nudity, underscored accepted racial and sexualized stereotypes of nineteenth-century Paris.

Fifty years later, in 1913, the Swiss artist Félix Vallotton shifted the perspective of the iconic painting's subjects, not only to equalize their positions physically but to highlight the sexualization of both figures, not just the white woman's. In *La Blanche et la Noire* (*The White and the Black*), a nude white woman still reclines, but the male gaze is gone be-

La Blanche et la Noire by Félix Vallotton, 1913, oil on canvas.

cause the woman's eyes are closed; instead, a bejeweled Black woman, smoking a cigarette, sits on the bed next to her and beholds the sleeping woman with a tender gaze. The heightened cheek color of the former and the lighted cigarette of the latter imply a postcoital pose that completely negates both the servility and male presence of Manet's painting. Vallotton was neither female nor Black, but his willingness to suggestively depict a lesbian, biracial liaison enabled him to stretch the imagination of the viewer and behold a wholly new perspective of sexuality in painting.

To get your mind thinking outside of your own experience, try answering the following questions. There are no right or wrong answers. Just jot down one you think fits for each.

What might men fear most?

What might women fear most?

What might people of color fear most?

What might white people fear most?

What might children fear most?

What might parents fear most?

What might immigrants fear most?

What might transgender people fear most?

What might new employees fear most?

What might leaders fear most?

No two people have the same fears, and the ability to shift their perspective to understand those fears can explain behaviors they

might otherwise question. Recently, I boarded a public bus in New York City with a male friend who is considerably taller and visibly stronger than I am. A few stops later, a deranged man, who was screaming incoherently, boarded the bus, and I signaled to my friend that we should get off. He rolled his eyes and said that I was "so childish" to be afraid. The ranting man then turned his attention to me, shouting obscenities and sexually abusive threats. Incensed, I jumped off the bus at the next stop and left my friend to fend for himself. My friend called me the next day to apologize not only for not acknowledging my fear, but also for not respecting what I felt I had to do to ensure my own safety. Because our behaviors manifest our own fears, we need to think twice before judging another's actions without that context.

No matter what race or gender you embrace, spend the next week actively looking around your daily life for representations of people who don't look like you. Consider whether those images are submissive, degrading, or mildly offensive. If you're not represented, take a moment to ask yourself how it would feel if you were. How would it feel to be constantly afraid of being accused of wrongdoing or constantly afraid of being sexually harassed? How would that affect your self-esteem, your attitude, your job, your health, your children?

If we take our cue from artists who present the world from different angles, and actively consider other perspectives, we can gain better insight into the viewpoints of our neighbors, friends, or colleagues so that we might work together to solve problems.

But what about when we are the problem?

Shift Others' Perspective about You

Sometimes it's not our own perspective that needs changing, but that of others. Whether we are trying to convince someone to consider another point of view, or—to make it personal—to help them to stop seeing us as the source of their discontent, we can turn to the artist's

viewpoint as well for lessons on shifting the gaze of how other people see us. Artemisia Gentileschi did.

Born in Italy in the late sixteenth century, when women had few life choices outside manual labor or marrying well, Gentileschi showed a prodigious talent for painting at a young age. Women taking up a brush was only tolerated as a hobby for aristocrats, which Gentileschi was not, so in response, her father sent her out of the studio and into the convent. Multiple times. It didn't work, as Gentileschi refused to give up her passion. Finally, her father, widowed since she was twelve, gave in and let Gentileschi paint. By the time she was seventeen, she had created her first masterpiece. Her father boasted that she had "become so skilled that I can venture to say that today she has no peer." He hired a master painter to tutor her, a man who promptly raped her.

Gentileschi's father sued the man for stealing his daughter's virginity, which, if given freely, would have rendered her unmarriageable. During the very public trial, the salacious details of the attack were recounted over and over again as Gentileschi's honor was put to the test. She was physically inspected and tortured on the stand to see if she was telling the truth. After seven grueling months, the rapist was found guilty, probably more due to the other unsavory aspects of his character that had been uncovered—he was having an affair, plotted to kill his wife, and stole from his employers—than justice for the teenage girl. The rapist never served time, however, but Gentileschi's reputation took a terrible beating. Many spectators suggested she encouraged her attack through her own behavior, by daring to be a painter, which was then the domain of men. The audacity to be a skilled painter certainly made it even worse.

Gentileschi did not let the attack or the trial or the gossip define her. Instead, she crafted her own image—literally. She went back into the studio, despite the discomfort and discrimination, and painted gigantic, dramatic portraits of women. Women you couldn't find in other paintings. Women in positions of power. Women in heroic situations. And she painted herself into a lot of them. She reveled in self-portraiture. There she is as biblical heroine Esther. There she is as Judith, determinedly beheading Holofernes, who bears a striking re-

Self-Portrait as the Allegory of Painting (La pittura) by Artemisia Gentileschi, c. 1638–1639, oil on canvas.

Judith and Her Maidservant with the Head of Holofernes by Artemisia Gentileschi, c. 1623–1625, oil on canvas.

semblance to her rapist. There she is as Saint Catherine of Alexandria. And perhaps most daring of all, there she is as a painter.

Gentileschi reframed her own narrative. In the process, she became one of the most sought-after painters of her time. She was the first woman ever accepted into the Florentine Academy of Fine Arts. One art journalist notes, "With this badge of honor, Gentileschi could buy paints and supplies without a man's permission, travel by herself, and even sign contracts. In other words, through painting, she had gained freedom."

Since 2015, the Manhattan District Attorney's Office has offered the same opportunity for freedom through art to people arrested for low-level crimes. As an alternative to prosecution or jail time, offenders are offered a free course at the Brooklyn Museum called Project Reset. If they complete it, their cases are dismissed. The class involves looking at art that features themes of agency, discussing it, and creating their own.

One of the pieces they study is *Shifting the Gaze,* which Titus Kaphar created live on the TED stage. Instructors, like artist Sophia Dawson, have participants re-create Kaphar's process on art they make in class to learn how to "shift the gaze on how someone looks at you personally . . . on how people see your community, your neighborhood."

The program helps address a myriad of civic and community problems. A study by the Center for Court Innovation found significant "reductions in recidivism, improved case outcomes, and positive participant perceptions." Case resolution times for participants are shortened from the average eight months to just two. The program eliminates the need for court appearances, saving time and costs, and allowing participants to not miss work or school. The program's 98 percent completion rate shows that untraditional, nonpunitive interventions can be effectively used for compliance and accountability. Since no charges are filed in court, participants are able to move past their mistake without fear of future academic or employment prejudice, a clean slate they appreciated immensely. The program also fosters a positive relationship between the community and criminal justice agencies, as almost all participants noted how much they appreciated the respect and kindness they received during the entire process from the arresting officers to the defense attorneys. "Shout out to the officer that put me in this," one participant wrote. Another called Project Reset a "miracle": "This program changed me. I feel like whoever made this program was a genius at giving people second chances and giving people the push they need." Many called for the course to be rolled out around the country because everyone deserved to "gain a new perspective."

Inadvertent mistakes, wrong decisions, criminal behavior, and life-changing trauma all have the potential to be the impetus for personal growth and redemption. But shifting lenses on those events to turn them into something from which we can heal and grow is really hard work. It takes time, energy, and diligence.

One rainy November morning, Joseph Luzzi kissed his heavily pregnant wife before he left for work, fully expecting to see her

again at dinner. Instead, hours later, he was rushing to the hospital. She had been in a terrible car accident. Doctors couldn't save her, but they were able to deliver their baby daughter, Isabel. In an instant, Luzzi became a widower and a first-time father. For four years, he existed in a hell of grief, finding his eventual salvation through the love of family and friends and great literature. As a Dante scholar, Luzzi naturally turned to one of the greatest pieces of written art, Dante's *Divine Comedy*, to help himself out of his own dark wood. Now, Luzzi is a celebrated author—he documented his journey in a book, *In a Dark Wood: What Dante Taught Me about Grief, Healing, and the Mysteries of Love*—a world-renowned speaker, and the founder of an education and consulting company. He's also now remarried and the father of four children, Isabel and three more with the violinist Helena Baillie.

This capacity for people to turn tragedy into triumph is called "posttraumatic growth" by sociologists. It is defined as "the positive psychological change that is experienced as a result of the struggle with highly challenging life circumstances." If you need help rewriting your story, do as Luzzi did: look to others and look to the art.

Shift Others' Perspective about an Issue

As we learned in the last section, human reason doesn't rely solely on facts because people gravitate toward self-confirming data and reject information that doesn't align with their beliefs. We can help someone stuck in the echo chamber of their own opinion the same way many artists do: by appealing to first hearts, then minds.

In *Visual Intelligence*, I wrote about French photographer JR who is known for creating epic murals by pasting giant photographs of regular people onto the sides of buildings and across expansive landscapes. The *New Yorker* notes, "JR is often drawn to places whose residents' humanity and individuality are habitually ignored or subsumed in political rhetoric: Tunisia, Iran, Palestine, the favelas of Rio de Janeiro."

A border patrol officer on the US side of the Mexico border wall, across from an art installation by artist JR, on the Mexican side, near Tecate, California.

"JR sees things from a different perspective," his good friend the American magician David Blaine says. A reporter who followed JR, who has remained anonymous due to the questionable legality of his street art, noted, "He has a knack for making the invisible—people, usually, the poor, the marginalized, the forgotten—visible. JR's work has been to find a strange angle or a previously hidden corner and bring them to us."

In 2017, JR waded into the weighty controversy of illegal immigration at the US and Mexican border with a gigantic statement—in the form of a baby.

JR visited Tecate, a border town in Mexico, and interviewed local subjects. In one house, a baby kept peering over his crib rails, and JR was struck by the similarities of the slats in a crib, prison bars, and sections of the border wall. He explained his vision to the child's mother and asked for her permission to photograph her baby. She agreed, tell-

ing him, "I hope in that image they won't only see my kid. They will see us all."

JR enlarged the photograph and pasted it onto special scaffolding he built in Mexico so that the baby would peer over the fence into the United States. JR says he hoped people who saw the installation would think about the child: "What is this kid thinking? What would any kid think? We know that a one-year-old doesn't have a political vision or any political point of view. He doesn't see walls as we see them."

JR posted a photo of the project on his Instagram with the simple caption: "Work in progress on the Mexican side of the US/Mexico border." No more, no less. No press release, no lengthy post with political commentary. Just the photo of the baby, Kikito.

The reaction was immediate as thousands of comments flooded JR's account. None of them mentioned US immigration policy or Trump. There was no "hate debate." JR notes that his installation "didn't bring a political conversation, but a human conversation. It was really just a love message."

Love was also the catalyst in changing many people's attitudes about a different controversial issue that carried a heavy stigma: the AIDS epidemic. Researchers at the University of California, Davis, found that in the early 1990s, many Americans "feared" people with AIDS, felt "disgust" toward them, and believed they "deserved their illness." Such prejudices are an impediment to public health, as they lead to a lack of individuals getting tests, quality care, and even funds for research. To help combat that stigma, television producer Jonathan Murray decided to take a gamble casting for the third season of the MTV hit *The Real World* and include a young man living with AIDS. For Murray, finding seven strangers to live in a house, have their lives taped, and "find out what happens" wasn't just for drama, but for diversity. Having grown up in a fairly homogeneous town in upstate New York, Murray said showcasing people with diverse backgrounds was a "core element" of the show to "help, at least our young people, change their perspective on diversity."

The young man he found was Pedro Zamora, a twenty-two-year-old immigrant from Cuba. He was smart, soft-spoken, sensitive, hand-

some, and the first openly HIV-positive gay person on television. Pedro quickly won over his roommates, many of them from conservative backgrounds who had never met a gay person, let alone one living with AIDS. By allowing his life to be recorded twenty-four hours a day and aired on television, Pedro won America's heart. Before meeting Pedro, most viewers' only exposure to someone living with AIDS was through the media reports of another kid their age, Ryan White, who at age thirteen in 1984 was denied entrance to his school and brutally bullied because of his diagnosis. Ryan, however, got the virus from a blood transfusion; Pedro was very open about contracting it through unsafe sex.

As viewers watched Pedro live his life on camera for four months, they saw a young man with hopes and dreams laugh, cry, get sick, fall in love, and even get married. Tragically, Pedro died just hours after the airing of the season finale. His impact was felt worldwide. Then president Bill Clinton, attending a fundraiser for a charitable foundation named after Pedro, underscored his impact: "Now no one in America can say they've never known someone living with AIDS." His former roommate Judd Winick noted that Pedro "changed how people think AND feel."

Opening someone's heart to an issue can make all the difference. Michael Sidibé, executive director of the United Nations Program on HIV/AIDS, writes, "Whenever AIDS has won, stigma, shame, distrust, discrimination and apathy was on its side. Every time AIDS has been defeated, it has been because of trust, openness, dialogue between individuals and communities, family support, human solidarity, and the human perseverance to find new paths and solutions."

Artists often use their own concept of beauty to break down walls and bring viewers together. Titus Kaphar knows that some people are first attracted to his work because they are "compelled by the technique, the color, the form, or composition." He's delighted, though, because that "aesthetic beauty" can serve as a Trojan horse and allow people "to open their hearts to difficult conversations."

Similarly, we can fill our conversations and interactions with beauty in the form of clear, calm, active engagement and respect-

ful responses. A young woman I know is brilliant at this. She was a high school debate champion, is a fiery go-getter, and definitely has opinions . . . on everything. But she's very careful with how she expresses them. She's an attentive listener who will lay out her points both logically and with love, and she doesn't shut down conversations when she doesn't agree. Instead, she looks straight into your eyes and says one word: "interesting." There's such simplicity in that answer. She's not agreeing or agreeing to disagree—which really means being stuck on a difference. She's letting you know she's heard you and she's thinking about your response. In response, people open up to her and her views. I met a supervising electrician in Detroit who handled things similarly. He knows from experience that union workers in a swing state often have loud and differing opinions on many things. As a manager, he didn't want to talk about heated issues at work, but he also didn't want to stifle anyone's voice. His go-to response to something he doesn't agree with: "You've brought up some really interesting points. You've given me a lot to think about."

New York University Stern School of Business professor Beth Bechky spent a year studying the interactions between manufacturing employees at a semiconductor plant in Silicon Valley to determine how disparate groups of people solved problems. Due to its size—five thousand employees and $1 billion in annual revenue—the company had many of the hallmarks of a small society. The specialization of skills required by a diverse range of jobs created "occupational communities" within the organization, communities that came to a project or problem with different perspectives, both micro and macro. Engineers didn't see equipment the same way technicians did; assemblers on the production floor didn't share the same global view of the company that managers did.

To better understand their positions, Bechky embedded with three distinct groups, each with different levels of experience, expertise, and education. For five months, she worked in the technicians' lab assisting them in constructing subassemblies. For four months, she was part of a team of assemblers who built machines in a clean room. She finished her participant observation by shadowing design engineers

and drafters for several months. She not only worked alongside each team, but also attended after-hours social events with them.

Having witnessed and recorded many misunderstandings and miscommunications, Bechky determined that those who overcame problems most successfully were the ones who first found common ground with others. In many cases, this act of sharing meaning led to a transformation of understanding. The transformation occurred not just when individuals received new information, but when they incorporated that knowledge into their own practices. "It enhanced the individual's understanding of their work world, enabling them to see the world in a new light," Bechky noted.

In the early 1970s, an entire village was founded in Israel to help people from around the world see each other in a new light. Neve Shalom/Wāhat as-Salām, whose name in both Hebrew and Arabic means "oasis of peace," was started by a Jewish-born Catholic priest in the hope that Jewish Israelis and Arab Palestinians could live together peacefully. According to a professor who traveled to the village from Toronto, the goal was not assimilation, but "the creation of a sociocultural framework that would enable residents to live on terms of equality and mutual respect while conserving the distinct cultural heritage, language and sense of identity each individual brought to the community from the complex mosaic of Palestine's historic communities." The original 120-acre site was a desolate, treeless orphan community in "no-man's-land" without status or official support. Half a century later, it is a thriving town of multiple generations governed by a democratically elected secretariat.

At the center of Neve Shalom/Wāhat as-Salām's community outreach is its School for Peace, which welcomes more than one thousand visitors every year to participate in programs designed to help people understand the viewpoints of others. One of those workshops, called "Art as a Language of Communication," brings Israelis and Palestinians to look at and make art together. The participants interact through music, dance, storytelling, and creating art in various mediums including clay, arabesques, mosaics, and calligraphy. Organizers Dafna Karte-Schwartz and Diana Shalufi-Rizek recall that the

first few days are always "difficult," since each attendee needs time to "let go of their fears and unrealistic expectations and be comfortable enough to share their feelings in the group," but everyone quickly "puts their efforts into finding each person's creativity and inner beauty." Dialogue—both external and inner—begins to flow naturally as part of the creative process. Karte-Schwartz and Shalufi-Rizek note, "Art, beyond its aesthetic function, enabled the participants to communicate on a level that transcended the political dimensions of the conflict. Each day we were able to witness how the participants peeled off another layer of hesitation, suspicion, and fear, and used the released energy to build bridges of trust and support." Success is measured by participant feedback—"An extraordinary experience!" "I wish there were more encounters like this one"—and the fact that lasting contacts are created.

Common ground can help bridge the gap between even the most divergent perspectives. Before you dive into an issue, find shared sentiments and build upon them. Use art as an icebreaker. Show it to someone, study it together, talk about what you see. More often than not, the participants in my Art of Perception seminars are diametrically opposed to my own politics and view of the world, but from the get-go, I introduce works of art that I know have the potential to resonate with all of us. The simple act of discussing the art will spur dialogue that opens our minds to the shared experience and the beauty of others' perspectives.

Embracing the Unfamiliar (Part Two)

In many ways, the urgent request that came in to me from the unnamable government agency who contacted me at the start of the pandemic was the culmination of the work I'd been engaged in for the past two decades. I have routinely fielded inquiries from the intelligence community, law enforcement, medical professionals, the financial industry, schools, colleges, and other groups who want me

to tailor my highly participatory seminars in ways that might improve their visual acuity and enhance their particular set of observational skills. But I usually face the opposite situation than the one I confronted with this group: normally my contacts bury me in more background information than I could ever need to develop a program, so over the years I've become adept at ignoring nonrelevant information and getting to the heart of what they really want.

I'd start by asking for a summary of challenges their group is encountering, and then we'd talk about how I've dealt with similar issues in the past. They'd refine their description a little, and usually, after a brief series of questions, I could tailor a presentation to their specific needs. This current inquiry, however, differed by orders of magnitude. From the minimal information I received, I could figure out that the team was highly sophisticated, had been expertly trained, and put the greatest emphasis on the performance of their personnel in stressful situations: in other words, they were forced to confront the limits of human fallibility in a fast-moving crisis. Connecting works of art to highlight the most relevant issues for discussion and analysis is always my challenge, but this case begged the question: What kind of art could sharpen high performance under stress?

In my second call with Caroline, I did get one more clue, a problem that the team kept running into: the individuals were so expert and so highly trained in whatever it was they did that when they misperceived something, they found it extremely difficult to believe that they had actually based their communication with the rest of the team on a misinterpretation of the data. To put it another way, they found it hard to believe that they could make mistakes. So now I knew that they were confident (probably too confident), and so capable and experienced that they felt statistically certain that they were never wrong! Even after several playbacks, these high achievers sometimes failed to see that they'd acted on a wrong assumption.

This was a crucial clue, and I soon settled on a selection of images that could not only help them fix these critical lapses but also help them sharpen both their visual acuity and their interpretation of ambiguous information. I hoped that this might help them in their future

missions, about which I still knew nothing. I'd recently been watching an intense cable series set in the French equivalent of the CIA that was full of whirlwind decisions based on the tiniest scraps of intel. And so I named my new project "Cyclone," after one of the life-and-death operations on that show. Given the short time between the first phone call and the scheduled presentation, I had to move quickly and furiously. For me, too, failure was not an option. So I had to define the problem with more care than usual.

Artists, too, must first make sure the scope and parameters of their project are solidified. British sculptor Barbara Hepworth wrote, "Before I can start carving the idea must be almost complete." In problem-solving, we must first define the problem before we attempt to outline the steps to its solution. As the *Harvard Business Review* notes, "the rigor with which a problem is defined is the most important factor in finding a good solution."

One of my favorite problem-solving mantras comes from Albert Einstein, who was understandably preoccupied about how the world would react after the creation of atomic weapons. He said, "We cannot solve our problems with the same thinking we used when we created them." Maybe we haven't been able to solve so many problems because we've been relying on the same jargon and strategies for way too long. Maybe some of the problems were created *because* of this system. All the more reason to look in a different direction: to the artist.

Define the Project

In 1817, when Géricault first became obsessed with the *Medusa* and its wreck, he had reached a crossroads. He'd just come back from two years in Italy, where he'd spent time painting, and pining for his young mistress, Alexandrine-Modeste, married to a man twenty-seven years her senior, who also happened to be Géricault's uncle and former employer and patron. Upon his return from Italy, the heedless couple threw themselves back into their affair; several frank and intimate sketches of a couple in passionate sexual embrace survive from this period. Not surprisingly, two months later, Alexandrine became pregnant.

The ensuing complications appear to have ended the affair for good. In August, Alexandrine gave birth to a boy who was registered in Paris as a child "of unknown parents," then sent off to grow up in Normandy, far from anyone involved in the triangle. By that point, Géricault had cut off all his hair and shut himself off in his studio, exchanging one passion for another. The news of the pregnancy came just as the trial of the *Medusa's* captain, the Viscount de Chaumareys, began, returning the scandal to the public eye. As the artist's personal life fell apart, Géricault threw himself into his research with a romantic intensity.

He rented a remote studio and cut himself off from his friends. He tracked down survivors and interviewed them, sketching their portraits and even letting several of the men live with him as they tried to reenter society and deal with the aftershocks of their experience. He went to hospitals to study the dying and the morgue to study the dead. The Beaujon Hospital even allowed him to bring severed body parts home with him—many morgues had a borrowing system like libraries for artists—and he painted them from different angles and at different degrees of rot. When he learned the *Medusa's* carpenter had survived the wreck, he commissioned the man to build a replica of the raft in his studio on which he posed his friends (like the promising young painter Eugène Delacroix) as live models. He took another model of the raft out to sea himself to study how it maneuvered on the water. He may have been driven into this frenzy of research by heartbreak and personal circumstance, but his end result is a masterpiece in no small part because of his meticulous planning and inventive research. This scandalous and horrific event with profound repercussions had overtaken Paris, and he had to organize all its facets to fit on a canvas.

We often skip the many laborious important steps when we're problem-solving because we're impatient to arrive at the solution. Rather than a conscious, personal decision, however, our desire to hurry is often automatic and unconscious, learned from nurture and hardwired by nature. We've been conditioned by school to provide answers as quickly as possible, and the workplace to prove productivity, which often values quantity over quality. Even our brains are programmed to accept an easier, "good enough" answer to conserve energy, a compromise that the Nobel laureate economist Herbert Simon called "satisficing," a not always happy blend of "satisfying" and "sufficing."

In our haste, we can inadvertently twist the problem itself to suit the outcome we might find the fastest or the most easily, even though it may not necessarily be the best outcome. Sherlock Holmes alludes to this tendency early in "A Scandal in Bohemia," when he says, "I have no data yet. It is a capital mistake to theorize before one has data.

Insensibly one begins to twist facts to suit theories, instead of theories to suit facts." If we're not careful, we can end up solving the wrong problem entirely, wasting time, resources, and goodwill. Or we can end up with a sloppy solution that doesn't satisfy anyone.

To combat this, another Nobel laureate economist, Daniel Kahneman, author of the now modern classic and perennial best-seller *Thinking, Fast and Slow*, suggests slowing down and engaging in more deliberate thinking. That was Phil Terry's goal in 2009 when he founded Slow Art Day. Tired of being "dragged" to museums by his wife, Terry realized he didn't enjoy the outings because he hardly looked at the art; he just raced around, checking items off an invisible list. "People usually go to a museum, see as much as they can, get exhausted, and don't return," he says.

This pattern isn't good for the visitor or the museum. To combat it, Terry went to the Jewish Museum in New York and spent a full hour in front of just one piece: Hans Hofmann's *Fantasia*. He found the experience enlightening and oddly invigorating. To share his newfound appreciation for slowing down and really seeing, he created Slow Art Day, an annual, global event in which museums curate calming experiences—such as yoga and orchestra music—before guiding visitors to spend time in front of just a handful of selected works. Ironically, Terry finds that this slowdown ends up "energizing" participants.

Our approach to problem-solving should be the same: carefully collecting and considering everything we'll need before we plunge in. To do that, we'll first create a problem definition, which, at its core, is a simple formula:

Who + When + Where + Why

Problems are often convoluted and complicated, and condensing large amounts of information—whether it's a company's entire fiscal year, a defendant's case, or a student's behavior during a semester—isn't

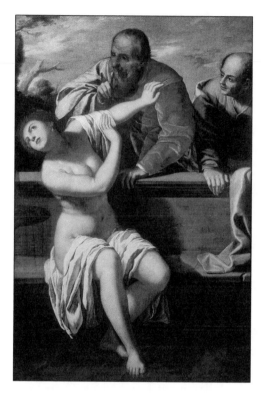

Susanna and the Elders
by Artemisia Gentileschi,
c. 1650, oil on canvas.

always easy. We'll practice culling down to the basic information needed for a problem definition by studying something else with vast data points: a painting.

Look at the image above and break it down into 1) **who** is involved 2) **when** and **where** is the action depicted taking place, and 3) **why** is there a conflict?

There are three people in the painting, two men and one woman; the former are clothed, the woman is naked. The woman is seated with a wall behind her and a towel covering the tops of her legs. The two men are leaning over the wall; the man on the right is looking directly at her and the man directly above her seems to enclose her. Noticing the distinct body language of each can help define why the viewer would perceive a conflict. The woman has assumed a defensive posture: her hands are raised in a gesture to push the men away, her body is turned from them, and there is heightened color on her

face and a perturbed, almost angry expression. The man facing the woman appears to gesture to her to be quiet as if alerting someone to this situation might create a bigger problem. Inherent in the inequality of the figures is that the woman is naked and seated while the men are standing above her and clothed. If they surprised her during her private moment, her vulnerability and safety seem to be in conflict.

You may recognize the subject of the painting as the biblical story "Susanna and the Elders." This version was painted in 1610 by Artemisia Gentileschi, whom we discussed on page 90. In the Book of Daniel, the Jewish maiden Susanna leaves her house to bathe privately in her garden. Two elderly men observe her and plot to sexually assault her and then approach from behind to startle her. They attempt to extort Susanna by telling her that if she reports their actions, they will testify in public that they observed her in adulterous acts when she claimed to be bathing. Susanna did not relent and instead called for help. She was arrested. At trial, the men's testimony was not consistent, confirming Susanna's innocence, and she was vindicated. While as viewers, we might not pick up on all the details of the biblical tale, taking the time to focus on the who, the when, and the where helps us look more deeply into fundamental questions about conflicts like this.

In 1922, the artist Félix Vallotton offered a type of solution to the problem illustrated in the Gentileschi painting with a painting of his own. Susanna and the Elders was a popular subject in art history for its depictions of lust, power, and the triumph of truth and virtue. As Titus Kaphar attempted to radically shift perspective by re-creating works of art from existing paintings, Vallotton was more subtle in his treatment of these unfortunately timeless subjects. He kept the who, changed the when and where, and repositioned the conflict to reverse the power and realign the problem in his mind and for his viewers. See Vallotton's version of this subject, with the canny title of *La chaste Suzanne*.

The who is the same three subjects: one woman and two men, but in Vallotton's version, the woman appears fully clothed, has narrowed her eyes, and sports an exquisitely jeweled, sparkling hat. Instead of exposing Susanna's nudity to the viewer and the lecherous men, we

La chaste Suzanne by Félix Vallotton, 1922, oil on canvas.

see the figures only from the neck up. The two men are now leaning in toward Susanna as if she is the one doing the talking and they are the ones forced to listen to her. The redness of their ears perhaps signals that they are listening (or embarrassed by her language) and their shiny pates accentuate their age. Complete role reversal. Suzanne's facial expression asserts control over the situation, and she has the men enclosed in a pink banquette, the color reinforcing the clear impression that the gathering is on her terms, not theirs.

Tracking the who, when, where, and why in any conflict involves observation of the big picture, small details, and the nuance of body language and facial expression. Awareness of color, perspective, and vantage point, literally and figuratively, provides additional "data" to help us figure out what is going on beyond what is on the surface and ultimately solve the problem.

"Why is there a conflict?" is an integral part of this formula, but if not framed correctly, it can lead us astray. To avoid looking for solu-

tions before we've finished defining the problem, we must refrain from trying to figure out the biggest why: Why did the problem occur? Instead, ask yourself this:

Why Do You Want to Resolve This Problem?

Understanding our motivation can give us a new perspective on the problem that will, in turn, open up new possibilities for seeking a solution. Aiming the why at ourselves makes coming up with an answer considerably more difficult than any questions about "who" or "where" or "when." But it may be the most important question we have to consider. Doing so helped a private high school in Michigan avoid a permanent closure.

Due to a declining birth rate since 2001 that hit a record low in 2017, schools across the state of Michigan have been facing declining student populations. With fewer students, schools struggle to maintain a workable budget.

Like many others, St. Mary's, a Catholic boys' high school in Orchard Lake, Michigan, faced a shrinking enrollment. Since the school depends on tuition to stay in business, fewer students means less operating revenue. They ran a projection based on the declining admission numbers and determined that if nothing changed, the 135-year-old institution might have to shut down as the nearby Ladywood High School had in 2018. Their problem definition, the Who + Where + When, was fairly easy to generate:

If they didn't get more middle schoolers to apply to St. Mary's, the school was in danger of closing.

The board of directors was then asked why they wanted to solve the problem. "To save St. Mary's" was the most common response.

While seemingly obvious, stating your motivation for wanting to solve a problem can help widen its scope, opening up an issue to more creative solutions. If the board had determined they only wanted to "increase enrollment," they might have only looked at recruitment

efforts, such as poaching potential students from rival boys' schools. If their answer had been "increase revenue," they might have considered a tuition hike. Discovering that their main catalyst was to save the school itself allowed the board to think differently about how to expand their student base. If they hadn't known the underlying "why," they might never have come up with their ultimate solution—to invite girls to join the school for the first time in its history. The school's legacy of being all-male became less important than the desire to maintain the legacy of a venerable educational institution.

Diving Deeper

Earlier in the book, we looked at how to discover our prejudices and shift our perspective of others. Viewing information through different and broader lenses will provide a more solid foundation for finding solutions and, better yet, help make those solutions we come up with more sustainable.

John Keane, Professor of Politics at the University of Sydney, calls our current post-truth age, where facts are often labeled alternative or optional, the result of unprecedented "media decadence." Never before have we had to wade through a "hyper-concentration" of journalists, bloggers, public commentators, public relations agencies, politicians, think tanks, imposter and parody news sites, Photoshopped materials, mashups, memes, and trolling platforms, all collected and spread by digital robots. It's overwhelming at the least, often disheartening, but in the end, it means we can't be sure about the veracity of what we are reading and seeing.

When English professional soccer player Raheem Sterling, a young Black man born in Jamaica and a midfielder for Premier League club Manchester City, debuted his new leg tattoo on Instagram in 2018, there was an immediate uproar that made the front pages of the British press. The inking was deemed "sickening" and "totally unacceptable" by everyone from broadcasters to members of the Order of the British Empire.

Lucy Cope, a local mother, demanded Sterling cover it up. "If he refuses, he should be dropped from the England team," she told the press.

Sterling's new tattoo was of an M16 assault rifle.

Cope, founder of the nonprofit group Mothers Against Guns, said, "Raheem should hang his head in shame. It's totally unacceptable. He's supposed to be a role model but chooses to glamorize guns."

Before people rushed to judgment, deciding that Sterling's tattoo was meant to glamorize guns, they should have simply asked him why. Why did he get it? Sterling gave the world the answer a day later, explaining that the gun tattoo had "deeper meaning" for him: "When I was two, my father died from being gunned down to death. I made a promise to myself I would never touch a gun in my life."

When gathering information about a problem, dig deeper to separate fact from fiction, to eliminate biases, to get the backstory. We can miss the full story because we didn't look hard or long enough, but also because it was hidden from us for various reasons: the other side wanted to win, those in power didn't want to lose it, or even just that the full story wasn't as sensational.

I've certainly fallen victim to basing my own very strong opinion on half the story. In the late summer of 2017, I was having breakfast with a member of Congress when I complained about the White House lifting a water bottle ban in national parks that had been instituted by the previous administration. The headlines I'd read had made it clear: the decision was catastrophic for the environment. "Trump's Decision to Allow Plastic Bottle Sales in National Parks Condemned" declared the *Guardian*. The subtitle was even worse: "Reversal of ban shows 'corporate agenda is king, and people and environment are left behind,' say campaigners." The *Washington Post* explained it this way: "National Parks Put a Ban on Bottled Water to Ease Pollution. Trump Just Sided with the Lobby that Fought It." I read the articles, and several others, including the "Disposable Plastic Water Bottle Recycling and Reduction Program Evaluation Report" from the National Park Service itself, and could find no redeeming qualities in the decision.

"Here's what you didn't hear," the senator told me. "We spent millions of dollars on water filling stations in national parks that are ex-

pensive to maintain, and that the public doesn't use. And for reasons I can't comprehend, only water bottles were banned, not soda bottles. Guess what took off in sales?"

It turns out people have become dependent on disposable water bottles, and when they showed up at national parks unprepared for their elimination, they turned to the next best thing: disposable soda bottles. The increase in consumption of soda was not only unhealthier for Americans, but worse for American parks, since soda bottles are heavier to withstand carbonation. There are certainly more nuances to the story, but I was so blindsided by my lack of knowledge of fairly serious counterpoints that my argument fell to pieces.

I'm not blaming the media; it has always been in the business of being in business. The media's job is to inform, but if they don't generate headlines that generate interest that generate revenue, then they won't have jobs. Our job is to ask the questions that uncover the answers behind the clickbait.

As our world turns to visual imagery to tell a story more often, our job discerning the truth becomes a bit harder. Journalists have long touted that a picture is worth a thousand words, but sometimes even pictures don't reveal the entire truth.

On February 1, 1968, Associated Press photographer Eddie Adams was in Saigon. The streets were chaotic, as two nights earlier, during the Tết holiday, Vietnam's lunar new year, normally a time of truce, Northern forces had surprised everyone with a coordinated attack on more than one hundred South Vietnamese cities. Adams didn't lack for things to photograph, but when he raised his camera and clicked the shutter on a graphic shooting, he captured an image that would win him a Pulitzer Prize.

It would also haunt him for the rest of his life. The image of a young man in a plaid shirt wincing as a bullet was fired into his temple by an older, uniformed man reverberated around the world and became a symbol of the senseless brutality of war. Many scholars believe it helped turn the tide of public opinion in the United States against the country's involvement in the war.

Gen. Nguyen Ngoc Loan, South Vietnamese chief of the national police, fires his pistol into the head of suspected Viet Cong official Nguyen Van Lem on a Saigon street early in the Tet Offensive, February 1, 1968.

The shooter was quickly identified as a South Vietnamese officer and police chief, an ally of the United States, which meant America was backing impromptu public executions—possibly of innocent civilians. The young person was widely assumed to be a poor bystander, a regular person caught in the wrong place at the wrong time.

Those assumptions were wrong.

"Pictures don't tell the whole story," Adams said later in his life. "It doesn't tell you why."

In reality, the young man wasn't so young. He was thirty-six. And he wasn't an innocent bystander. He was a squad leader for the Viet Cong, purposefully dressed in street clothes to better carry out attacks on civilians. He had been captured at the site of a mass grave of thirty civilians, allegedly just having slit the throats of a South Vietnamese lieutenant colonel, his wife, the man's eighty-year-old mother, and his six kids. He was pulled out of a van in front of Adams, who

thought the police chief was just going to interrogate him. Adams took dozens of photos of the prisoner being marched up to the officer. The one chosen by his editors isn't even an accurate representation of the original: it's cropped for effect, eliminating the other military police in the background.

Adams himself assumed the shooter was a "cold, callous killer," but after traveling the country with him, he changed his opinion. The man was a major general and chief of the South Vietnamese National Police. He'd been instrumental in rallying his troops during the Tết offensive and preventing the fall of Saigon. The murdered lieutenant colonel had been a close friend of his. Adams came to believe the general was "a product of modern Vietnam and his time" who was unfairly vilified by his photo. The two became friends; Adams even testified in his defense in front of Congress. That's not to say Adams condoned the killing. Instead, he believed he was a party to it.

"Two people died in that photograph," Adams later wrote. "The general killed the Viet Cong; I killed the general with my camera."

How do we overcome the incendiary image? Ask questions about it. Look for the backstory on the who, what, where, and when. And don't forget to ask yourself why. Why do you believe something? Why don't you? Why does it make you feel the way you feel?

Why did you feel the way you felt about Raheem Sterling's tattoo? About the national parks water bottle ban? About the Vietnam War photo?

To effectively problem-solve, we need to be able to ask ourselves, and others, uncomfortable questions. We cannot look away or shy away from things we do not like.

Address the Uncomfortable

Take a look at the following images, and write down three similarities and three differences between them.

There are dozens of possibilities: they both show life and death,

Flowers in a Wooden Vessel
by Jan Brueghel the Elder,
1606–1607, oil on wood.

Running Thunder
by Steve McQueen,
2007, 16mm color film
continuous loop.

they both include reflections of light, one is a painting while one is a film still, one is older while the other is current. It really doesn't matter what your answers were. The important thing is that you were able to demonstrate elasticity, seeing both things shared and not in images that aren't easy to look at, let alone analyze.

The image at the top is a painting by Jan Brueghel the Elder, *Flowers in a Wooden Vessel*, from 1606–1607. It depicts flowers at all stages of

life: dead flowers and live flowers and flowers that haven't bloomed yet. The image of the dead horse on the bottom is a still from a 2007 film installation titled *Running Thunder* by Steve McQueen, who also directed the Academy Award–winning Best Picture of 2014, *12 Years a Slave*.

They aren't necessarily pretty pictures or pretty stories, but problems usually aren't either. We need to be able to address uncomfortable subjects like those depicted here—death, decay, aging, pests, mortality—if we ever hope to solve them. Chances are the problems you've faced, or are currently facing, don't involve pleasant things. How can we get better at addressing the uncomfortable? The same way artists and athletes and everyone else get better: by practicing. Let's do it again. Look at the following two images and list three similarities and three differences.

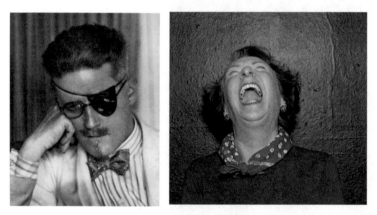

Left: James Joyce, photograph by Berenice Abbott, 1926.
Right: Mary, Milwaukee, WI, photograph by Alec Soth, 2014.

The image on the left is a photograph taken by American photographer Berenice Abbott of the writer James Joyce wearing an eye patch. Abbott was known for her portraits of expatriates in Paris in the 1920s. The picture on the right is from Alec Soth, an American photographer whose subjects are often alone.

Now, I want you to dig deeper. Really study the images. With limited information on their backstories, write three other similarities and differences. It might be uncomfortable and even difficult, but you're stretching your brain, and this type of analysis will become second nature in no time. Come back here when you're done.

Did you see more this time? Maybe differences in intimacy or composition, one subject making eye contact, the other looking up with eyes closed? Did you include the look on each subject's face? How about physical similarities between the two subjects? Or maybe how they are together a study of contrasts—of calm acceptance and exuberant laughter?

There is no right or wrong answer unless you wrote nothing. No one is going to see everything, and everyone is going to see different things, which is why it's important to use your unique perspective to document what you see, both the obvious and the not-so.

State the Obvious

I love paintings, but I try to mix up the media I use in my classes and include photographs, especially current ones, whenever I can. I was in London recently and had added a new slide to my presentation that had caught my eye.

I asked participants to describe what they saw, and one man raised his hand. In his fabulous English accent, the man said, "I see a young man with a shaved head dressed in camouflage with a black-and-white patch on his shoulder, so I'm thinking he's in the military. He's looking straight at the camera, sitting on some kind of small chair. It appears he's making himself something to eat, but I have no idea what that mess is on his lap!"

To me, it was obvious: the young man—who happened to be a participant in a contemporary war battle reenactment in Tennessee in 2004—was preparing a peanut butter and jelly sandwich. It wasn't ob-

Josh Vance (aka Crash) with Peanut Butter & Jelly. Joelton, Tennessee. Photograph by Alec Soth, 2004.

vious to someone from the United Kingdom, though, and wouldn't be to people from many other countries, as they don't eat peanut butter and jelly sandwiches. In fact, while to me a "PB&J" is the epitome of childhood comfort, many Brits don't even know what it is, or if they do, find it repulsive.

While the choice of sandwich filling might not seem like a life-or-death detail, to someone allergic to peanut butter, it would be. Don't ignore information you think is obvious because you never know when the consequences for someone else will be deadly.

After I presented at the international charity Save the Children, a program manager recounted the time he had worked in Mozambique in the late 1990s. A humanitarian worker had flown in from the United States, come to the local Save the Children office, greeted everyone, and then left to deliver aid to the villages. Everyone in the office knew that a particular road nearby was dangerous because of buried antipersonnel land mines left over from the civil war. They assumed the visiting aid worker also knew. He didn't. He took the road and was killed en route. Don't assume anyone else knows what you know. Chances are, they don't. And even when we do see the same

thing, since we perceive the world according to our own unique perspective, we won't all process the information the same way.

Heidi Walsh, an executive vice president at an aviation technology company, told me how she was working on an image processing program for military drones. To ensure the highest level of verisimilitude and resolution, her team printed out twenty-three different images taken by drones. To ensure the best perspective possible, they called in twenty-three different military personnel to choose the best image. Scarcely any of them picked the same image. Thus, it appears that not only do no two people see anything exactly the same way, but the decision of what is best, most valuable, or most effective varies just as widely. We can't assume any of our observations or judgment calls are shared by anyone just because they have access to the same information that we do.

An intelligence colleague of mine took the point one step further. While we may be looking at the same data, information, or image, what we choose to focus on will also vary. His photographs taken from his office window are of the same image, but one focuses on the icicles immediately outside the window and the other sees right

Perspectives by Colton Seale, Peterborough, NH.

through the icicles to focus on the trees in the background. We must remain cognizant of not just what others might see but how they are looking.

Even though we might all be presented with the same information, we don't all process it the same way. That means that we shouldn't

place an inordinately high value on our first instinct or dismiss an interpretation simply because no one else shares that perspective. Welcoming outlier perspectives and aberrant data as we're gathering information will help ensure that we're taking the most inclusive view of our problem.

See What No One Else Does

After you've noted the obvious, look for the opposite: the overlooked. Too often, we miss critical information because it's "hiding." Look to the outskirts. Look underneath. Seek out the unseen.

This image is from an exhibit shown at the Tate Britain in 2017. There are one hundred items. What do you think they are?

Untitled (One Hundred Spaces) by Rachel Whiteread, 1995, installation photograph, as displayed in Duveen Gallery, Tate Britain, during the Whiteread exhibition.

The most common answer I hear is "Jell-O" because of their color and translucence, a guess that takes me right back to my childhood like PB&J. They are, in fact, made of solid resin.

The exhibit is called *Untitled (One Hundred Spaces)*, and it was created in 1995 by Rachel Whiteread, a sculptor and the first female artist to win the Turner Prize, the highest honor in the British art world. Her work calls attention to unseen spaces. For this work, she cast the empty space underneath one hundred different chairs.

Artists are particularly good at noticing things outside the norm, perhaps because it's a place they often inhabit. American artist Jean Shin has made a name for herself creating sculptures out of items cast off by society. In 2003, she built the installation pictured below in a park in New York. What do you suppose it is?

The installation hung between trees, providing shade and casting moving shadows on the ground. Called *Penumbra*, it was made from umbrellas she'd found in trash cans around the city. She saw beauty and protection from the sun in what others saw as failed protection from the rain.

Penumbra
by Jean Shin, 2003.

New York architects Amanda Schachter and Alexander Levi also collected discarded umbrellas, four hundred of them. They used the metal skeletons and 128 used, two-liter soda bottles fitted with LED lights to construct a 24-foot-diameter orb they set afloat on the Harlem River. Their project was illuminated at night and built to call attention to the amount of debris in New York City's waterways.

Harvest Dome 2.0 by Amanda Schachter and Alexander Levi, 2013.

Have you ever considered the empty space under a chair—its shape, its volume, its usefulness? You've no doubt seen the space under a chair, or even used it for your feet or your bag, countless times in your life, but have you ever stopped to really look at it or think about other ways it might be used?

How many times have you seen or thrown away broken umbrellas or empty soda bottles? How many times have you taken a second and thought about how else they could be used? Look at things that failed other people. Look for the things that everyone else is missing.

I included an entire chapter in *Visual Intelligence* on the importance of finding information that's hiding in plain sight. It's an incredibly

useful skill for surveillance and safety, but it's also critical for problem-solving. After the book was published, I received a letter from a homicide detective detailing how the simple reminder helped him solve a case. He was called to the scene of a murder in a part of town that had seen too many similar crimes. A prostitute had been found dead, rolled up in a carpet.

Unfortunately, the killing of a sex worker is not a rare occurence in New York. By the death rate, prostitution is one of the most dangerous professions in the United States, worse than logging, or working on an oil rig or Alaskan fishing boat. Prostitutes are physically attacked on average once a month. For various reasons—a disconnect between precinct databases, the fact that these women purposefully live in the shadows—the murders are often unsolved. A&E television network's 2016 documentary series *The Killing Season* explored the epidemic, finding that often coroners don't even report such unidentified bodies to the FBI, losing one last chance at giving them back their name.

This is the perfect example of a daunting, entrenched, system-wide problem that can be solved. To do so, individuals both inside law enforcement and beyond need to acknowledge their bias, work to overcome it, and make these women just as much of a priority as any other person. I aspire to use my platform—this book and my classes—to seek out professionals to train who are dedicated to reducing domestic violence, suicide, homelessness, and addiction. These issues belong to us all as a society and need to be fixed not just for the victims but for the greater good.

In November 2020, as a result of city leaders responding to the "defund the police" movement and cutting that budget by $150 million, the Los Angeles Police Department announced plans to dissolve its Sexual Assault Unit, the same one that investigated film producer Harvey Weinstein. You don't have to work in this field to call your local government and law enforcement leadership and demand that no citizen be left behind, not sex workers, not sexual assault survivors, not anyone. When we hear about decisions like this, we can speak up. Each and every one of us. Just like the detective who wrote me did.

This particular detective had seen it all. But having just read *Visual Intelligence* and having taken my course, he was trying to see better and more. When he arrived at one crime scene, the other officers had already made a series of assumptions based on an all-too-familiar grisly sequence of events: a sexual assault that ended in murder, with the body wrapped and dumped in a remote location, in a marsh in Brooklyn. No one was happy with what this implied statistically: that they were looking at the body of a prostitute. If they were right on that—and the circumstances certainly pointed to that conclusion—it meant that there was very little likelihood that the crime had been reported or that anyone had filed a missing persons report, one of the tragic realities that made solving this kind of crime so hard. The body would have to be fingerprinted and checked for matches. Since about 99 percent of prostitutes have been picked up before and fingerprinted, the chances of finding a match were high, but the process could take days.

It wouldn't hurt to check the body again, the detective thought, to see if the first people on the scene had missed a detail that could help them ID the victim faster. So he unrolled the rug the deceased was wrapped in and noticed how the nail polish on her fingers matched the nail polish on her toes. This detective knew the hard work that prostitutes put in, and he was aware of the parts of their appearance they bothered with; as a rule, elaborately matching mani-pedis were not something they'd waste their time or money on, especially in winter. This didn't prove that she wasn't a prostitute. But it did give them a new lead to follow while they were waiting on the fingerprints.

And, in fact, when the detective checked to see if a female fitting the description of the victim had recently been reported missing, he got a match. The woman turned out to be a graduate student who'd been abducted after a night out with friends. Her last known interaction— with the bouncer at the bar where they'd been celebrating—led to the bouncer's conviction on charges of first-degree murder. In addition to clearing the case, the police were able to communicate to the prostitutes in that area, who'd already heard about the murder, that there wasn't a killer stalking them. Their work was precarious enough without the added stress of a murderer in their midst.

The detective could easily have spotted this small detail, the one that ultimately led to catching and convicting a killer, without the benefit of an Art of Perception session. He had years of experience to draw on, and his eye was already well trained. But for some reason, he attributed the impulse to scan the victim, to look again for the decisive detail, to his experience looking at art. Not only that, he was so certain of the connection that he sat down and wrote me. It was a gratifying moment, one that made me think that maybe I was right to give up my practice of the law to concentrate on art.

Mexican artist Jorge Méndez Blake visually represented how one small thing can have a monumental effect when he built a thirty-five-foot-long brick wall at the James Cohan Gallery in New York City in 2019. He didn't use mortar or cement, instead balancing the bricks on top of each other. The perfect symmetry was interrupted, however, because he'd placed a single paperback book, *Amerika*, an unfinished novel by Franz Kafka, on the floor in the very center. While the bricks are barely out of sync directly around the book, stepping back, we can see how the entire structure is disrupted by the single addition. Nothing is too small to have an impact. Don't think a piece of information isn't big enough to talk about. Bring forth everything you can.

A few months ago, I was at dinner with my cousin Nancy when she grabbed my hand with a worried expression on her face. "Amy, your fingers are blue!" she said. I've been through some pretty hefty cancer treatments, so I don't take any bodily abnormality lightly. Thankfully, after a thorough investigation, we discovered my hands were discol-

Amerika by Jorge Méndez Blake, 2019, bricks, edition of *Amerika* by Franz Kafka.

ored due to the dye on my new blue jeans. I'm so grateful to my cousin for pointing out the small detail she noticed. Even though, in this instance, the information didn't lead to anything serious, it might have.

If the Tampa viewer watching Victoria Price on WFLA-TV during the summer of 2020 hadn't taken the time to email Price about a small detail she'd noticed, things might have gone differently for the twenty-eight-year-old reporter.

"Just saw your news report," the viewer wrote. "What concerned me is the lump on your neck. Please have your thyroid checked. Reminds me of my neck. Mine turned out to be cancer."

Price hadn't even noticed the lump herself, but she did see a doctor, and the lump was a cancerous tumor. The cancer had already spread to her lymph nodes, which she also had removed. If the viewer hadn't noticed and told Price about what she saw, the cancer could have metastasized even further. "I will be forever grateful to the woman who went out of her way to email me," Price wrote on social media.

In an update after her successful surgery, Price admitted to the *Today* show that she almost didn't heed the woman's advice. "I was totally going to dismiss it," Price said. "I was like, 'I don't see anything.'" Price's boyfriend convinced her otherwise.

Price's all-too-human reaction embodies another lesson of noticing what others might not: don't just speak up, listen when someone else does. It's also a reminder that, when gathering information about a problem, we should also look to others who have faced a similar issue.

Find Precedents and Do Your Research

While our problems are shaped by our particular circumstances, they most likely share at least some aspects with problems that have come before us. Using that information and building upon it can help us save time and resources. Rather than reinventing the wheel, we can customize it to suit our needs.

Every field, from science to supply management, relies upon the work that has preceded it. Art is no exception. Books and movies, from *West Side Story* to *Harry Potter*, repeatedly build upon Shakespearian stories, while the Bard himself borrowed plots from others. *Hamlet* is drawn from an old Scandinavian fable. In *Macbeth*, a ghost declares that defeat will never come until the forest itself marches on the castle, so the English invaders carry tree branches to fulfill the prophecy. J. R. R. Tolkien told a friend that the "shabby" resolution left him with such "bitter disappointment and disgust" that for *The Lord of the Rings*, he created a species of living trees, the Ents, that actually uprooted and went to battle. Working with what came previously can help anyone craft a better outcome.

When Japanese printmaker Suzuki Harunobu added full color to woodblock printing in 1765, a revolution was born. Until then, everything around the world was printed in black and white, or with a few spot colors, and had to be tinted by hand afterward. Harunobu's innovation allowed Japanese art to be mass-produced, which allowed it to spread widely throughout the country and drove the price down, which allowed more people to purchase and enjoy it. When Japan opened to the West a century later, European artists marveled at the ease of replicating complex and vibrant colors. Impressionists began adopting Japanese techniques from using large swaths of simple colors and bold outlines to removing the illusion of depth and eliminating the horizon in their works. Vincent Van Gogh was particularly inspired by it, telling his brother, "All my work is based to some extent on Japanese art." Van Gogh collected hundreds of prints, hung them in his studio, and painted a copy of one, *Geishas in a Landscape*, into one of his self-portraits.

While no one else can feel the exact pain of our job or marriage or family member or company or community loss, exploring how others handled similar challenges can be extremely useful. We might discover inspiration for solutions, or, perhaps even better, valuable data on what not to do.

For instance, almost every media outlet, and many of us person-ally, could learn from the mishandling of a top story from 2019 when a group of boys from Covington Catholic High School in Kentucky visited Washington, D.C.

One major magazine summarized the reporting of the events of Friday, January 18, 2019, this way: "A group of white teenage boys wearing MAGA hats mobbed an elderly Native American man on the steps of the Lincoln Memorial, chanting 'make America great again,' menacing him, and taunting him in racially motivated ways. It is the kind of thing that happens every day—possibly every hour—in Don-ald Trump's America." The *New York Times* titled its first piece about the story: "Boys in 'Make America Great Again' Hats Mob Native El-der at Indigenous Peoples March." Political commentator and former governor of Vermont Howard Dean wrote: "#CovingtonCatholic high school seems like a hate factory to me." Actress Alyssa Milano wrote: "This is Trump's America. And it brought me to tears. What are we teaching our young people? Why is this ok? How is this ok?" followed by, "The red MAGA hat is the new white hood. Without white boys being able to empathize with other people, humanity will continue to destroy itself."

At the center of the firestorm was a sixteen-year-old student, a white male wearing a red hat embroidered with "Make America Great Again," who was videotaped standing toe-to-toe with an older Native American. Amid the hooting and hollering of the people gath-ered around them, the young man stands still and says nothing, ex-cept to shush his fellow classmates. He smiles at the older man; some say smirks. The boy's name was quickly released on social media and repeated by major news outlets. He was labeled "smug," "a deplor-able" with "the look of white patriarchy." A prominent reporter asked, "Have you ever seen a more punchable face?" He and his family, along with other students from the school who were present, received phys-ical, professional, and death threats.

After a third-party investigation was conducted by the diocese overseeing Covington Catholic High School, more video from the incident came out, completely altering the narrative. The elder Na-

tive American man was found to have fabricated much of his story and parts of his own background. The scene had escalated because another group nearby, Black Hebrew Israelites, had been threatening both the Catholic schoolboys and the Native Americans. The students were documented defending the Native Americans and respectfully standing up to the hate and bigotry of the Black Hebrew Israelites. Caitlin Flanagan, a writer for the *Atlantic*, and a Catholic herself, eventually sat through every minute of every video available of the interaction between the Covington Catholic High School students and a member of the Black Hebrew Israelites. Thanks to her meticulous review, she determined that "throughout the conversation, they disrespect him only once—to boo him when he says something vile about gays and lesbians." The students then asked their teachers/chaperones for permission to sing their school's spirit songs to drown out the hateful rhetoric from the protesting adults. The young man at the center of the dispute had been approached, not the other way around. He stated he'd remained "motionless and calm" to try to "de-escalate a tense situation." During his smiling silence, he says he was praying. And the red hat? He'd just purchased it by the Lincoln monument on a whim as a souvenir.

The boys also weren't the rich white kids that many in the media had made them out to be. They were from a small town in Kentucky, the nation's fifth-poorest state, where the poverty rate is 25 percent and the median household income $38,346, well above and below the national averages of 12 percent and $63,179. So why did some, including those who'd publicly attacked the Covington students, refuse to accept that these boys had been able to empathize with other people, and possibly had been the only respectful, responsible ones around? It is easier for us to believe the worst in people we think badly of already, but to do so makes us biased and can blind us to important information, which might end up exacerbating our original problem.

Milano, for one, doubled down. She wrote she was "sorry, not sorry," adding, "Everyone who proudly wears the red hat identifies with an ideology of white supremacy and misogyny. Everyone who proudly wears those hats gives a tacit endorsement for the hatred and the violence we've seen these past few years."

Falling into the "everyone" and "always" trap will also bias us against finding the facts. Notice whenever you use either of those words and make it a habit to instead convey accurate accounts of who and how often. It might be "too many" and "too often" for our liking, but dig deeper. Look for the outlier or the exception.

Perhaps reliving the details of the Covington Catholic students' D.C. encounter was uncomfortable for you—wherever you stand on the issue. These are the types of problems we walk away from. We must work through them and study them afterward, so we don't find ourselves in the same situation. The true lesson here, though, comes from learning from precedent. Milano, along with a host of public figures, politicians, and media companies, was sued by the young man from Covington along with eight of his fellow students for $800 million for defamation and libel, among other things. CNN and the *Washington Post* already settled their suits for an undisclosed amount, but according to Flanagan, "the damage to their credibility will be lasting." Flanagan notes that the suits could have been avoided had those in the media adhered to the journalist ethics that held "if you didn't have the reporting to support a story, and if that story had the potential to hurt its subjects, and if those subjects were private citizens, and if they were moreover minors, you didn't run the story."

But it's getting harder for even the most established news organizations to ignore the viral stories and trending videos that seize the nation's attention. Everyone wants to get a piece of a hot topic, and that kind of pressure is at odds with the kind of thoughtful analysis that comes with careful (some would say boring) investigative reporting. You don't have to be employed by a media company to learn from this story. Every one of us must be concerned with avoiding litigation and how we handle interactions with minors. Every one of us must avoid jumping to a conclusion that could cause lasting damage to the reputation of a blameless person or institution. When gathering information about a problem, slow down. Take time to ask how others have acted in a similar situation and how they solved the problem in front of you. Are there policies or precedents that have helped them? You might find some startling answers, or the inspiration (and support)

you need to speak up. When you can find the right precedents, you're not really going it alone.

Give Everything One More Pass

Just as artists add multiple layers and writers go back and edit their work, make sure before you move on to the next step that you've considered everything. Lindsay, a cosmetics sales associate at an upscale department store, lost a guaranteed commission by jumping to the conclusion that she had all the information she needed from a customer. When a woman approached her, Lindsay, eager to make a sale, enthusiastically announced, "I have the perfect product for those lines around your eyes!" A kind suggestion, perhaps, but ill-informed. "I was here for hand cream," the woman huffed. She left the counter without purchasing anything. Lindsay tried to anticipate and solve her customer's problem all in one go, but she had incorrectly assessed the situation. Don't try to imagine what someone else's problem is. Ask them specifically. And be sure to ask everyone.

When the Renaissance Philadelphia Downtown Hotel wanted to renovate its 152-room, historic, Old City property, it turned to award-winning firm Campion Platt for "unexpected design elements around every corner." The hotel unveiled its refurbishment in 2018, noting it was going for "artful design with clever irreverence." There are pop-art representations of the Founding Fathers, wallpaper that invites guests to decipher the Declaration of Independence, railings that resemble Ben Franklin's glasses, and a one-hundred-foot-long graffiti wall by local artist Dan Murphy.

To produce the spectacular results, the hotel and interior design companies consulted a host of different people, from local craftspeople and construction managers to property management experts, designers, and even valued guests. The one group they neglected to consult, however, was an integral part of a hotel's sparkle and shine: its cleaning staff.

The hotel redesign uses a mix of different materials and "a combination of grit and glittering finishes." This is apparent in the sleek, modern bathrooms that are covered in an unusual, black, shimmery fabric wallpaper. The effect is hauntingly beautiful; however, the fabric—which is mounted around the showers, toilets, and sinks—catches and holds every speck of dust . . . and white toothpaste. The wallpaper was undoubtedly expensive, and probably quite exquisite when untouched by human travelers, but, like a dark piece of insulation, cannot be touched. Nor scrubbed. After just a few weeks of use, the walls were covered with stains and the cleaning crew's attempts to remove them, which resulted in a "frizzing" effect that did not go unnoticed by guests, or their reviews. The mistake could have been avoided had the design firm gotten input from all users of the rooms, not just those staying in and those selling them, but those responsible for their upkeep.

I have learned firsthand (many times!) the importance of not jumping to conclusions until I have all of the information. After training Special Operations forces at the Chrysler Museum of Art, I settled into a cozy bed and breakfast in Norfolk, Virginia. The next morning, I saw there was a small buffet on the sideboard that we could help ourselves to while the owner cooked a hot breakfast to order. There was an older woman at a nearby table who said to the owner, "I'd like coffee with cream, no sugar, and a plate of fruit." I was taken aback that she would ask for things that were meant as buffet items, but the owner obliged the request. The woman continued asking the owner for things, and by the time she got to "another napkin," I almost lost it. I wanted to say, "Get it yourself. Can't you see she is busy cooking?"

However, as I've trained myself to do, I did a final observatory sweep of the situation before I said anything. Something drew my eye to the end of the table where, tucked in beside the wall, I saw two metal crutches with sockets for the elbows. The woman couldn't walk. I found out later that she was a longtime visitor to the B&B, and the owner was used to assisting her with the breakfast buffet. She was, in fact, a physician from the National Institutes of Health who has devoted her life to researching and treating diabetes in Africa. I was a

single comment away from embarrassing myself and her and possibly everyone else in the room.

The proverb "measure twice, cut once" is wise advice for more than just construction, crafting, and clothing designers. Top chefs suggest reading through a recipe twice before starting to ensure you're not wasting ingredients, short on something integral to the dish's success, or starting an overnight recipe thirty minutes before a party. The same holds true for problem-solving: when we rush to find a solution, the result can end up not fitting because we didn't first measure the problem accurately. Really study the situation before moving on to the next step. Look at it from different perspectives. Look behind it, around it, under it. Define the problem, dig deeper, and then think about gathering your materials and mobilizing your resources to put all of that preparation to work. Address the uncomfortable things about it, state the obvious, and look for what others might have missed.

Once that's been done—twice!—we can move on to the next phase of the artist's process: the Draft.

Draft

Problem-solving, like creating art, involves making a coherent narrative out of materials—or information—that one has gathered. The artist may begin with nothing more than raw materials, but the process quickly turns to putting those materials together in a way that conveys meaning. It's the process of creating order from disorder. This is the stage where the artist begins drafting.

While each discipline demands its own specific drafting process—filmmakers storyboard, writers might outline, painters sketch, designers might sew a muslin mockup—the artist begins with a rough draft. Ultimately, a rough draft will be honed into the final work, but the iterative process is key to a successful rendering of any work. In this section, we'll look at how to draft a solution to a problem by breaking down the process, as artists do, into constituent parts of a whole.

The Beauty of Focus

While the method to organize and prioritize whatever you've collected is going to be unique to your preference and your problem, there is much to learn from how artists view information—specifically in terms of their focus. This ability—the willingness to shift your focus—may even be more useful to an artist than skill. That's how Dan Scott saw it.

Scott is an Australian native who painted in his childhood. He wasn't interested in imparting any kind of coded messaging in his works;

La clairvoyance
by René Magritte,
1936.

he simply wanted to capture the beauty of his country in landscape paintings. Sadly, he wasn't able to receive the kind of artistic teaching he craved, so he stopped painting and became an accountant. Years later, he rediscovered his passion for art but found he had lost his childlike facility. Determined to start over, he scoured the internet for information and watched hundreds of videos—not on how to create art, but how to analyze it. It might have been his training as an accountant that was influencing his drive to create art. Still, his rationale was simple: "If you don't understand what is going on in a master artwork, how can you expect to learn how to paint it for yourself?"

Scott found that while there were loads of information out there, not much of it was helpful to him. So he started a blog, *Draw Paint Academy*, focused on the information that had helped him. Scott explained the impulse simply: "I may not be the best artist in the world, but I strive to be one of the most helpful."

One of the first things Scott does is illustrate how an artist might see a painting differently. He starts with American Impressionist Childe Hassam's *The Sea* from 1892 and then creates lines and shapes in the painting to illustrate how he sees it. Have a look at the image on the next page. What do you see?

Most people would say they see a woman sitting in a rocking chair by

Dan Scott, Childe Hassam, *The Sea*, 1892, focal points, 2018.

the water. An even more accurate description might be: while wearing a high-necked, long dress and holding a flower, a woman appears to be under a shaded awning, surrounded by more plants and flowers. This description seems accurate. However, it's not the only way of looking at it. Ask Scott what he sees, and he'll give you the following list:

Clusters of circular shapes for the plants and flowers

Rigid shapes for the chair

Suggestive lines on the ground to move you around the painting

Lines on the dress to give a sense of form

Varied colors and lines to create the illusion of plants and vines

Repetitive dashes of color in the clouds and ocean

While Scott breaks down a work of art into its visual elements, the same process can be used for analyzing the information we've gathered about a problem. As an attorney who found a way back to art myself, I've taken many art history classes, and I find Scott's instruction valuable for its simplicity. He is able to focus in on the core of analyzing art by asking himself simple questions. The first is particularly useful for breaking down a problem:

What Are the Main Focal Points?

Scott's folksy approach mirrors his straightforward thinking: "Have a think about what areas the artist wants you to look at. What areas are being emphasized and what areas are left vague? Where are your eyes drawn toward in the painting? Then, go a step further and analyze how the artist is emphasizing these areas."

He does this using Claude Monet's *The Thames below Westminster* from 1871, noting, in words and with white outlines, that his eyes travel the most between three main focal points: the jetty, the boats in the water, and the tower in the background.

Ask yourself the same question about all the information you've gathered. What draws your attention? What do you keep returning to?

This is a form of prioritization, but from a visceral rather than a purely factual standpoint. Maybe some of the information you've gathered is large or obvious, but smaller details still gnaw at you. Note that. Now ask why.

Does the information you focused on in Monet's painting jump out because it's familiar to you? Or, perhaps, you noticed certain aspects because you've never been to London? How do your own perceptual filters

Dan Scott, Claude Monet, *The Thames below Westminster*, 1871, focal points, 2018.

affect how you see and value the information in front of you? Does desire or fear play any part in your reaction? Are you drawn to the brightest thing or bothered by the blanks, the barely discernible, the unknown?

Knowing Notan

Another way that artists analyze the fundamental pieces of a work is by using a method called a notan study. Notan originates from Asian art concepts of light and dark harmony; the word is an anglicized combination of the Chinese words *nóng*, which means strong or concentrated, and *dàn*, meaning weak or light. Think yin and yang. Notan is based on the Asian art concept that strength and balance in composition is found through a harmonious relationship between light and dark.

Notan is used to strip away color and detail so an artist can concentrate on the fundamental building blocks of an image. To create a notan study is to literally reduce an image into its lightest and darkest aspects. One could allow a computer program to convert a subject to black and white, but it would make this conversion without sensitivity. Values darker than 50 percent would become black, and values lighter than 50 percent would become white. This will indeed create a notan, but it wouldn't necessarily create a harmonious arrangement of shapes. The most elegant conversion takes place in the mind of the artist. A notan study is highly interpretive.

Yin and Yang

Scott demonstrates this with the 1878 painting *Girl with Flowers, Daughter of the Artist* by Ilya Repin below.

How can looking at a painting using notan help to solve problems? By using the concept of notan to break down data into a basic, binary form. Too often, the amount of information available is daunting. To avoid being overwhelmed, we have to allocate both limited time and ever-shrinking resources. Notan offers a simple method of sorting by opposites. Landscape painter Mitchell Albala, who has written extensively about notan, and incorporates it into his classes on composition, says, "When artists are first exposed to notan, they often see it as a high contrast value study, a map of the patterns of light and shadow. Of course, it *is* that to some degree, but the notan's true strength lies in its ability to define shapes and patterns, which are the building blocks of a composition."

"When we observe the human form, we don't actually see the bones, yet the balance and integrity of the skeletal structure is clearly reflected in the outer form," says Mitchell. "Similarly, if the underlying notan design

Left: Girl with Flowers, Daughter of the Artist by Ilya Repin, 1878.
Right: Dan Scott, notan study of *Ilya Repin, The Girl with Flowers, Daughter of the Artist, 2018.*

is strong and balanced, then the artwork that is based upon it is also strong and balanced."

The notan approach of distilling information can be adapted to deal with problems beyond the picture frame. Take the biggest headache in the hospitality industry. As of 2019, there were more than 859 million customer reviews on the travel aggregate site TripAdvisor. If you work in the hotels, you know those comments, and the millions of others on other travel sites, can make or break your business. All companies prioritize reputation management, but in travel and tourism, it's of the utmost importance, as the vast majority of guests research and book online. Ninety-eight percent of TripAdvisor users believe the site's reviews are "accurate of the actual experience." Ninety percent of travelers will avoid booking a hotel if they see the word "dirty" in an online review. A single negative review can cost a company as many as thirty customers.

Furthermore, guest satisfaction is directly linked to revenue growth. According to executives at Expedia, a review score increase of 1 point equates to a 9 percent increase in a hotel's average daily rate, and four- and five-star reviewed locations generate more than double the conversions of those with lower ratings.

Rather than getting overwhelmed by the volume and veracity of online reviews, a hospitality company could use a notan study to simplify the data pool. Every review would have to be sorted into two opposite categories; in this case, positive and negative experiences. The company could then concentrate on the very best and the very worst, making sure to thank their biggest supporters and address their harshest critics. Since, on average, 60 percent of reviews are positive and just 12 percent are negative, workload is dramatically reduced.

A notan study could also help in the classroom. As budgets shrink and student-to-teacher ratios grow, educators are stretched thinner and thinner. Many teachers worry that they can't give the same amount of time and attention to every student and that resources are finite. Instead of trying to divide their time equally and constantly battling the feeling of falling short for everyone, a teacher could create a plan to focus extra energy on the very top and the very bottom performers in the class

Cascade Dusk
by Mitchell Albala.

Cascade Dusk,
notan study, by
Mitchell Albala.

who don't have access to resources outside of the classroom to help them achieve their goals. On the surface, it might not seem fair, but a system based on equity, not equality, will produce the best results in this situation. The students in the middle of the class are already managing well. The students who are struggling or not stimulated aren't fulfilling their potential because they don't have extra help.

In its simplest terms, notan is a study of opposites. Use it to find the contrasts in your information: the light and the dark, the positives and negatives, the biggest and smallest, the highest and lowest, the most and the least. Whether for your business or personal conundrums, using notan could be as simple as planning for the best-case scenario and the worst-case scenario, and using those as focal points.

Many elementary schools introduce the concept in art class by having students make a notan square. The classic activity has kids take a simple square, usually made of black construction paper, and draw shapes on the edges. The shapes are then outlined, cut out, and glued onto a larger piece of white paper to show the mirror image patterns.

The activity is also called "expanding the square," and even the youngest students are quick to see the possibilities.

Maggie Holyoke, *Expanding the Square*, 2021.

How much more can we discover when we apply this brand of thinking in other arenas? Can we use the information we have to seek out its opposite? And don't forget the biggest duality of all: the opposite of what we have is what we don't have. As a drug enforcement agent once remarked to me after learning to look at art to rethink his professional issues, "You took me so far outside my box that I now know what to look for when I go back in."

Break It into Bite-Sized Pieces

By 1818, Géricault had spent ten months prepping *The Raft of the Medusa,* which he intended to exhibit at the Paris Salon in August 1819. He'd made stacks of preparatory sketches. He'd attacked the subject from many different angles, in studies that showed the crowded raft when it was first abandoned, or the days later, when the people on the raft divided into warring factions, attacking each other, and throwing their fellow passengers overboard. He'd sketched several survivors from life. But he had yet to paint a single stroke on the gigantic blank canvas—twenty-three feet wide and sixteen feet high— that was ready to go, waiting for him to begin.

"I am disorientated and confused," he wrote. "I try in vain to find something steady; nothing seems solid, everything eludes me, deceives me."

He had good reason to be distracted. His uncle had discovered the affair between the painter and his young wife, and the betrayal caused a rift between the families that was never repaired. Alexandrine-Modeste gave birth to Géricault's son, but he was not allowed to see either of them. His uncle forced her to give the child over to the state

as an orphan. She would live the rest of her life in pious seclusion in the countryside. Géricault's mood was black. His inspiration gone. But his self-imposed deadline was not going away.

In his remote studio with his head shaved like a renunciant, he set up a small bed so he could sleep just feet from his canvas, hired a concierge to bring him food, and locked himself away for the next eight months. He allowed very few people in or out, accepting visits only from his assistant and live models. A young artist who visited noted that the "noise of a mouse" was enough to upset him. Eliminating distractions, however, did not lead to instant creation. The enormity of the project he'd committed to weighed on him heavily.

This moment—the state of arrest that a blank canvas, page, or screen can inspire in even the bravest—is a challenge that artists and writers know all too well. It has often been referred to as a "block"— writer's block, artist's block, creative block—but the term has evolved as it was recognized as an impediment that hits more than just creative types. Ambitious efforts—budget cuts, caseload increases, bigger yearly goals, staffing cutbacks, efficiency expectations—can immobilize anyone in any field. The phenomenon is now known as Overwhelm, a verb-turned-noun with a capitalization to mark its importance and universality.

Sarri Gilman, a licensed marriage and family therapist, defines Overwhelm as "a state of too muchness"—"Too much to do, too many expectations, too many unsolvable problems." Health-care workers, frontline responders, and working caregivers—parents or kids who look after their parents—are particularly vulnerable to it. Health educator Melanie Gillespie notes, "Overwhelm feels like a Paleolithic-era tar pit. We get stuck in it, and suddenly, the more we struggle and flail, using the same action that got us there in the first place, the more we sink and get stuck."

How do we deal with enormous unresolved issues? The same way artists have. Break the project down into manageable pieces. Then find the freedom in each piece of the grand strategy.

For centuries, artists have used various methods to demarcate their canvases not just to keep the proportion in balance, but also to divide

the workload. Ancient Egyptians used a string dipped in red ink to mark lines on their work surfaces; artists in the Middle Ages used nails and string. Géricault took the grid system one step further. Most artists work on their canvas in stages according to the paint colors, starting first with an overall layer of red or gray to set the midtone, and then adding forefront figures first, sticking to silhouettes of the same color. Géricault, on the other hand, left his gridded canvas stark white, planted himself in front of a small section of it, and painted everything in it. Instead of having live models posed together on his re-created raft, he called them in one by one, working only on their figure until it was completed. A fellow artist, Antoine Montfort, likened his process to laying a mosaic or putting together a giant jigsaw puzzle.

But Montfort went on to become a leading academic painter, specializing in painstaking ethnographic scenes (of Greek soldiers, nomads, falconers, etc.). This suggests that he may have absorbed some of the lessons Géricault had to teach about skill, but missed the real breakthrough of the great Romantic: feeling. Montfort probably should have chosen another example: Géricault approached his giant canvas not like a painstaking copyist, striving to fit everything exactly into place, but more like a fresco painter, in the style of da Vinci and Michelangelo. Remember, the painter had just come back from two years in Italy, where he studied the great frescoes. Underpainting, that is, sketching in the rough outlines of the scene in the painting, is impossible when you're working on wet plaster, as the great fresco painters must. Any preparatory sketches disappear into the plaster after a day. Instead, they must work quickly, in sections, filling the vast areas piece by piece, and working with speed in every one. They have to jump in, fresh each day, with the same confidence every time, finishing the entire surface by working section by section, balancing careful planning with confident improvisation. The tension between these two styles of working—the demands of skill and the necessity for speed—is one big factor in what makes Géricault's painting, like the Sistine Chapel, so impressive and so alive.

Many modern artists approach their work in a similar fashion, concentrating on the pieces while they're shaping the whole. In the cre-

Left: , Cold Dark Matter Shed before explosion, photograph by
Hugo Glendinning, 1991.
Right: Cold Dark Matter Explosion, photograph by Hugo Glendinning, 1991.

ations of Kumi Yamashita (whose art adorns the cover of this book),
the whole is explicitly reliant on the pieces. She sculpts with light and
shadows, arranging objects in front of a single light source to create an
image. The result is often unexpected, as it is unconnected to the com-
ponents used. I sometimes show her pieces like the one on the cover in
my presentations as a representation of self. The object is to unite all
the seemingly disparate pieces into a coherent image.

When I present her work, I hold up a handful of blocks. "This is me
before I leave the house every morning," I say. "First I need to gather
the pieces and make them resemble a person."

Perhaps the best example of breaking a project down into manage-
able pieces can be found in Cornelia Parker's *Cold Dark Matter*. To ex-
plore the constant specter of violence that shadows us from the cradle
to the grave, the British artist reverse-engineered an explosion. She
constructed a small garden shed in her studio and moved it outdoors
in the English countryside. With the help of the British army, she det-
onated it.

Afterward, Parker gathered all the salvageable pieces and recon-
structed the original structure, hanging the twisted, charred, and
broken fragments from the ceiling of a studio. Before hanging the
pieces, Parker carefully laid them out, cataloged each, organized the
collection into groups, and started the reconstruction bit by bit. While
the mangled pieces smelled of the explosion and reminded Parker of
a morgue, she remembers that "as the objects were suspended one

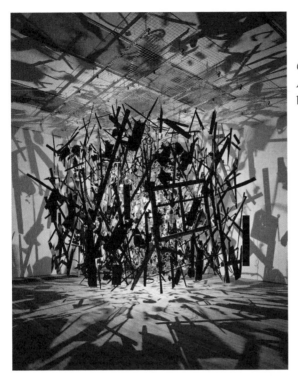

*Cold Dark Matter:
An Exploded View,*
by Cornelia Parker.

by one, they began to lose their aura of death and appeared reanimated." In the end, the reassembled shed looked like it was exploding *and* coming back together again.

Parker then lit the new shed from within with a single bulb, which allows the individual pieces to take on new forms and meaning as they cast shadows onto the ceiling, floor, and walls. Of the final work, Parker says, "Its meaning unfolds gradually."

Seeing *Cold Dark Matter* in person is a humbling and haunting experience. Once we understand Parker's process, the final work is a wonderful visual reminder that we can come out of problems— whether individual or collective, minor or major—transformed, lit from within. We can take the pieces and reassemble them into another form that is stranger, more open and vulnerable, and even more beautiful.

What's Missing

Not every part of Parker's exploded shed was recoverable. Some pieces were reduced to dust; others blew too far away to find. The missing pieces, however, were just as important as the found ones. They added to the final product, providing the gaps that allowed the light to shine through and made the overall piece more visible.

In addition to her shadow work, Kumi Yamashita uses what's missing to create something new. For a series called *Warp & Weft*, she pulled threads from a piece of black denim. She yanked and cut and removed. The empty spaces left behind revealed the profile of a woman. Yamashita removed what was obscuring the image she saw so the rest of us could see it as well.

Warp & Weft, Mother No. 2 by Kumi Yamashita.

Some artists aim for what is missing in a different way. They know that the mind is constantly trying to make connections, even when the separate elements they present to the viewer seem impossible to connect. They challenge you to make connections—and toy with your need to understand—by carefully constructing a puzzling image that the mind struggles to resolve. To observe how this works firsthand, take a look at the next image and see how much you can

Retrospective Bust of a Woman by Salvador Dalí, 1933
(some elements reconstructed 1970), painted porcelain, bread, corn, feathers,
paint on paper, beads, ink stand, sand, and two pens.

still see and analyze, even knowing that critical information is being
withheld.

Using only what you can see and surmise, list three things you
know about this image. Facts only, please. If you can't come up with

three things, just list what you can. Then, list three things you *don't* know about it.

For purposes of seeing a different perspective, cover up your answers and show the image to someone else. Did they list the same things you did? What differed between you?

The piece, titled *Retrospective Bust of a Woman,* is a sculpture from 1933 by the surrealist artist Salvador Dalí. Surrealist sculptures often combine objects that don't have a logical or apparent connection and create something new from disparate parts. In this case, the artist took the porcelain painted bust of a woman and added a pair of corn cobs around her neck along with a strip of animated images. There is a loaf of bread on her head on which rests an antique inkwell featuring a couple nodding their heads in what might be prayer. The woman's skin is white, her hair yellow, her eyes brown. There are colored beads outlining her hairline, and what appear to be ants crawling across her face.

Does it make sense? Not to me. Does it have to? No. I can still look at it carefully and talk about it even if I don't know or understand everything (or even the first thing) about it.

Did this sculpture remind you of anything? Did it remind you of anything in this book? Do you like this work? Why or why not? Does it make you uncomfortable? (My teenage son gave a resounding "yes!")

Looking at strange or evocative or disturbing art can make people uncomfortable precisely because they don't understand it. Asking questions and voicing discomfort can remove our barriers to understanding. The same is true when it comes to solving a problem. Not having the answer does not justify walking away. Having more questions than answers—known in many fields as an "intel gap"—is often the key to finding a solution.

How Is It All Connected?

On his art analyzing blog, Dan Scott concludes with a final question we should ask ourselves: How is everything connected?

To help find the answer, consider the painting below.

Two centuries after Goya's painting, fellow Spanish artist José Manuel Ballester began a project, much like Titus Kaphar's, where he removes the people from famous paintings. Their absence reveals what was previously overshadowed or hidden, changing the focus of the pieces. Take a look at Ballester's Goya re-creation on the next page.

The Third of May 1808 in Madrid by Francisco Goya, 1814–1815, oil on canvas.

I had never noticed the square-shaped lantern at the riflemen's feet in the original painting. It's an extremely important detail, as it's what's illuminating the central figure in the white shirt in the dark of night. Instead of lighting the soon-to-be victims to the benefit of the shooters, the lantern now shines over empty hills and a pool of blood.

In the next image, you can see that *The Raft of the Medusa* gets the Ballester treatment as well.

Seeing these versions of these paintings begs the question: What essential information are we missing in our own lives and in our immediate surroundings?

The Third of May by José Manuel Ballester, 2008, photographic print on canvas.

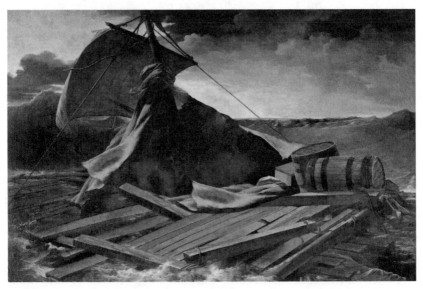

La balsa de la Medusa by José Manuel Ballester, 2010, photographic print on canvas.

When we're problem-solving, it can seem like we're up against the impossible: staring down a gigantic blank canvas or a field full of thousands of ruined fragments. It's then we realize that picking up the pieces after an explosion maybe wasn't the hardest part; it's how to not sink beneath the waves of Overwhelm.

Despite being young, relatively inexperienced, and having never worked on a large-scale project before, Géricault was able to attack an enormous empty canvas and transform it into *The Raft of the Medusa* because his careful preparation and process allowed him to work freely. He had dozens of smaller sketches and drafts to guide him so he was able to paint section by section with a sense of freedom and confidence that still comes through more than two hundred years later.

There is no perfect way to organize or analyze information, but if we take on the process with confidence, moving forward one step at a time, always keeping an eye out for the hidden, we can make progress. Progress that turns into promise that just might turn into a masterpiece.

Recognize Relationships and Red Herrings

Pygmalion and Galatea by Jean-Léon Gérôme, c. 1890, oil on canvas.

In Greek mythology, the sculptor Pygmalion created his version of a perfect woman in marble. He would gently caress it. He would kiss it, hoping it would kiss him back. Pygmalion fell in love with his great work. Deeply, passionately in love. He called it Darling and brought it

gifts. He dressed it up in jewelry and fine clothes, but, the writer Ovid tells us, the statue was "even more lovely" naked. The sculptor took the statue to bed with him, making sure it had the softest pillow, just in case it could feel.

He prayed to the goddess Aphrodite to send him a woman as perfect as his statue. She did him one better and brought the statue to life. The next time Pygmalion kissed and stroked the statue, it glowed and softened under his touch until the "ivory girl" blushed, kissed him back, and then opened her eyes. The pair wed, had a daughter nine months later, and, according to the story, lived happily ever after.

The Greek myth, immortalized and eroticized in just fifty-four lines of Ovid's *Metamorphoses*, has captured the imagination of artists and storytellers for centuries. It's the inspiration for hundreds of paintings, poems, short stories, plays, operas, ballets, and even comic books (Wonder Woman is sculpted out of clay by her mother and given life by the same goddess). It influenced George Bernard Shaw's 1912 play *Pygmalion*, which in turn served as the basis for the Broadway musical and then Academy Award–winning movie *My Fair Lady*; the 1990 Golden Globe–winning film *Pretty Woman*; the 2007 Academy Award–nominated *Lars and the Real Girl*; and a subplot in the 2019 Netflix comic-based series *The Umbrella Academy*. The story has universal appeal—famous Egyptian author Tawfīq al-Ḥakīm wrote his own successful version, *Pijmalīyūn,* in 1942—because, at its core, it's about relationships: with ourselves, with others, with art, with the Divine, with the romantic ideal.

Relationships can determine our happiness, health, wealth, and even our rates of mortality. In this section, we're going to take a hard look at them, since they're the root cause of—but also the solution to—many of our problems. We'll allow artists to lead us in our exploration, as part of their expertise—as well as that of curators, and historians—is to identify relationships in and around works of art. This correspondence is not exact, of course. You probably won't fix a broken relationship by looking at a Matisse or a Mehretu. (If you do, let me know!) But it should be clear by now that looking at art

can train us for the high-stakes mental work that is hard to practice. So you don't just go in cold. In art, the relationships between such visual elements as shape, color, and form and design principles like symmetry and scale are everywhere. They, too, can be delicate, stormy, troubled, dreamy, and so on. We can analyze those relationships in the same way that we analyze the relationships among the pieces and players of our problems.

Let's look first at the painting at the beginning of this section on page 157, *Pygmalion and Galatea*, painted in 1890 by French artist Jean-Léon Gérôme. It takes on the story of the sculptor and his great love. It features Pygmalion, a sculptor, perhaps not surprisingly painted to look like a younger version of Gérôme; Galatea, a statue turning into a human woman; and Cupid, the god of love, hovering in the background, aiming his arrow at the couple. It's set in Pygmalion's studio, presumably in Cyprus, where he lived, at the precise moment in the myth when Galatea comes to life. You can see the color of human flesh creeping down her still stone-white legs.

What relationships are depicted in the painting?

Do you think the relationship between Pygmalion and Galatea is romantic? Why or why not?

Do you think the relationship between Pygmalion and Galatea is problematic? Why or why not?

Between Pygmalion and Galatea, who has the most power?

Why do you think that?

Does anything in the painting support or refute that?

Gérôme captured active moments with such realism—he specialized in exotic locales and erotic situations—that a viewer feels as though they are in the room with his subjects. Because of this, and

perhaps also due to the prominent naked backside of a woman, it's one of the most popular works at the Metropolitan Museum of Art in New York City. The famous image is reproduced on posters, T-shirts, and even face masks. Reactions to it, however, are generally split. Some bristle at the idea of a man creating his version of a perfect woman. Others see preordained love or even the personification of rebirth with the support of someone else.

Art historian Kate Lemery, who worked for the National Gallery of Art and the Smithsonian Institution, has a copy of the painting hanging in her master bedroom, purposefully placed so it can be seen from the hallway. "Even when I pass *en route* while performing dreary domestic duties—laundry-folding and vacuuming," she writes, "my heart quickens to see it." She first encountered the image as a teen on a high school field trip from Iowa and was drawn in by its "beauty" and "romantic theme." To her, it is "a touching image of love—a kiss transforming cold white marble to the rosier tones of human flesh." The idea of being "kissed back to life" has been embraced by both men and women from Shakespeare's Romeo to singer Gwen Stefani who, in a speech at the 2016 *Glamour* magazine Woman of the Year event, thanked her boyfriend Blake Shelton "for kissing me back to life." For Lemery, the painting shows the artist as a creator of life and represents her own awakening to art.

Others view the painting and what it depicts less favorably. Amanda Lampel, an art educator who worked at the Met, calls the painting "a tad alarming for feminists everywhere," as she sees a woman being touched before she can give consent: "Upon closer inspection, it becomes evident that Gérôme is showing us the moment just before Cupid strikes Galatea with his arrow. Technically, Galatea does not necessarily love Pygmalion back yet. The way she grabs his arm screams, 'Get off!' In this moment, she's just a girl getting creeped on, and she can't even get away from this dude because her legs are still frozen in ivory." (Look back at the painting and take a look at Cupid's arrow still cocked in his bow.) When the National Junior Classical League, a youth group for high school students, chose Pygmalion and Galatea as the theme for a couple's costume contest at its 2020 convention, many, in-

cluding Latin scholar and editor of *Ad Aequiora* Dani Bostick, decried the decision. Bostick wrote, "Trivializing rape is dangerous and unethical. Sexual assault cosplay has no place in education."

Which assessment of the painting is correct? Does it honor or harm women? Unlike facts, relationships have levels of nuance that can make them difficult to unravel when problem-solving. It helps to consider the source.

Let's start with the people who communicated information to us. In this case, we read the opinions of Kate Lemery, Amanda Lampel, and Dani Bostick. We must, then, find out who they are. Do they have any expertise in the subject? How close are they to it? Are they involved in any ancillary areas that might inform their stances?

All three are women, which means they have first-person knowledge of how women are treated. Lemery and Lampel have similar artistic credentials; the former is an art historian who worked for the National Gallery of Art and the Smithsonian, the latter an art educator who previously worked at the Met. Bostick is also an educator, a high school Latin teacher who has also trained officers at the US Air Force Academy. This information gathering is not to pass judgment or rank the women in any way; it's merely an exercise in evaluating our sources. The same strategy should be taken when evaluating information of any sort. Is the messenger reliable? How much experience do they have? Where did they get their information? What personal biases might they bring to the information?

To evaluate such perceptual filters, we'll look to any other information we can find. Lemery is a work-from-home mom, novelist, and freelance writer whose articles have appeared in the *Washington Post*. Lampel has written more than one hundred entries for *Sartle*, a blog that positions itself as "rogue art history," where she regularly mixes art with pop culture. Bostick has also written for the *Washington Post*, as well as *Marie Claire*, *Cosmopolitan*, and *Parenting*. Additionally, she's a counselor and advocate for victims of sexual abuse and assault. Do these women's backgrounds color the way they see *Pygmalion and Galatea*? When evaluating anything, we must be cognizant of filters, both our own and the ones that others have as well.

As far as a direct link to the work, none of the three painted it, brokered its sale, or own it. We know Lemery saw it at least once in person on a high school field trip, and that it had such an impact on her that she keeps a reproduction of it in her bedroom. Having worked at the Met, Lampel regularly interacted with the painting. She notes in her bio that she "loves when children point out all the great butts that the museum has to offer." It's unclear if Bostick has seen the original. As modern Americans writing in 2020, none of the women has any relation to the artist who created it 150 years ago. Let's look, now, at him.

Who was Jean-Léon Gérôme, and more specifically, how did he feel about women? We must be conscious that any facts we collect cannot be the sum total of his character. Still, we'll piece together the most complete picture we can. As we will learn later in the book, the impossibility of perfection should not hinder us. It can even help us.

What we can know of Gérôme is that he lived for almost eighty years, most of them during the nineteenth century; he was born in France in 1824 and died there in 1904. He married the daughter of his art dealer and had four daughters and a son with her. His marriage is said to have been "a long and happy one"; he is not known to have had any mistresses. His wife was his sometime subject, but his favorite model, the one on whom Galatea is based, was Emma Dupont, who posed for him for over a decade. Dupont arrived in Paris at the age of seventeen and turned to modeling after her boyfriend abandoned her and left her penniless. Her work with Gérôme and other artists paid well—twice what seamstresses earned and more than male models were paid—and allowed her to rent a modest apartment. She features not just in his work, but also in many photographs of the artist at work; they both appear comfortable in these settings. A journalist who interviewed Dupont during this era noted she was "clever" and came up with many of her poses herself. There's no correspondence between Dupont and Gérôme that has survived, but he did her multiple paintings (as did other artists

Gérôme and Dupont, 1885.

she posed for) at a time when he was arguably the most renowned painter in France.

Firsthand accounts from those who knew him called Gérôme a "magnetic" personality. He was an academic painter at a time when that term was high praise, a professor at the École des Beaux-Arts, where he ran one of the most popular and selective ateliers. Gérôme engaged in a very public crusade against the new school of Impressionist painting, just when his own work was getting lambasted by contemporary critics as a commercialized pandering to the masses. Thanks to advances in photography (and to his father-in-law, who was a leading international dealer), Gérôme was one of the most reproduced artists in the world. By 1880, he had produced a large body of original work—some seven hundred of his paintings and seventy sculptures survive today. While the vast majority does not, his most popular work does feature the nude female form, most often as a historical figure, such as

Truth Coming from the Well, Armed with Her Whip to Chastise Mankind by Jean-Léon Gérôme, 1896.

A Roman Slave Market by Jean-Léon Gérôme, c. 1884.

Cleopatra, or the personification of ancient goddesses and virtues. This indicates that the obsession with naked women perhaps comes more from the collector and consumer than the artist himself.

When he did portray nudity, Gérôme made women the central figure, where the viewer looked first and most likely longest. Their forms and faces were realistic and, many times, emotive. One well-known work with a not-so-subtle title has a woman representing Truth. *Truth Coming from the Well, Armed with Her Whip to Chastise Mankind* references a quote from the philosopher Democritus, "Of truth we know nothing, for truth is in a well." After it was revealed as part of a permanent exhibition at the Musée Anne de Beaujeu in Moulins, France, in 2012, the image quickly became a feminist reaction meme, and during the quarantine of 2020, the image was adopted by some women as a Zoom background. In another painting, *A Roman Slave Market* from 1884, a single woman, presumably for sale, has been stripped of her clothes on a stage in front of an entirely male audience. With her body language—uneven stance, head burrowed in her elbow—Gérôme seems to give the silent figure a voice. Let us look, then, back to the specific painting in question on page 157.

Knowing as we now do that artists, especially from past centuries, gave the most important person in a painting the highest perch, what do you make of Galatea being taller than Pygmalion? Gérôme's choices underscore this fact so they can't be missed: even though Galatea is bending down and Pygmalion is straining up to reach her from atop a box, on tiptoe, calf muscles tensed from effort, still she towers over him. Some historians have interpreted this as an image of female dominance, noting that as the object of his total affection, it is she who possesses ultimate control over him.

This idea of gender power reversal reminds me of something a friend of mine once said when his wife was pregnant with their first child. I asked if he was hoping for a boy or a girl, and he said it wasn't up to him.

"Of course it was," I teased. "Her egg has the X chromosome. Your sperm had either an X or a Y. That determines it."

He raised an eyebrow at me. "Quite the opposite. My sperm had

no control. I guarantee you, like the bouncer at a VIP club, her egg decided which one was coming in and which one wasn't. My wife is the boss of everything that goes on in her body."

I loved his shockingly different way of looking at fertilization. On its website, the Stanford School of Medicine declares very specifically, "The sex of the baby depends on which sperm gets to the egg first." What if the outcome of conception isn't a race but, rather, an audition? What if, instead of painting a portrait of male wish fulfillment, Gérôme painted *Pygmalion and Galatea* as an image of artistic madness? We must consider all of the possibilities and all of the players.

This leads us to the author of the source material: Ovid the poet, who first wrote the tale of Pygmalion. Classics scholar Geoffrey Miles calls the original poem "one of the most potent male fantasies . . . a perfectly beautiful woman designed to the lover's specifications and utterly devoted to her creator." Was that really Ovid's intention?

Going back to the beginning may seem like a lot of analysis for one issue, but problems rooted in relationships can be especially difficult and serious, and even involving the potential for legal and criminal repercussions. It's not something we want or can afford to get wrong. Which brings us back two thousand years to the first-century Latin poem. The canon of literature from this period is today often labeled patriarchal, which could be true based on the number of authors who were men versus women, but is it fair to say that the story of Pygmalion is, as Ovid wrote it, misogynistic? Critics are quite split. Those who believe the story espouses nonconsensual sexual contact often point to the line where the statue is awakening and "blushes under her creator's touch." The Latin word used is *erubuit*, which can mean to blush "with shame." Those who believe the story is a "charming little tale" note the word can also mean to blush "with modesty." Love story proponents who believe that Pygmalion doesn't hate all women since he fell in love with one he made mention that Venus, a female goddess, granted his wish and is the one who chose to make the statue human, and recall that the sculptor was so careful with his creation he was afraid of bruising her. Lust story proponents believe Pygmalion was afraid of bruises out of guilt because he handled his statue so violently. Some critics call the

statue a "love object"; others deem it a "sex toy." One even surmises that Pygmalion is an agalmatophiliac, a person who gets sexually aroused by nude mannequins. Others mention the sculptor doesn't "dare" ask Venus to bring his actual statue to life, instead asking for a woman "like her." One classics teacher takes it a step further, writing, "Looking at this text more critically, the statue is not an object of lust, but rather of repeated sexual assault and violent rape." The story has been hailed as both a "glorification of male superiority" and "a surprising reversal of male and female gender roles" showcased by "a sad and pitiful weakness" of a man so desperate to be loved. Which reading did Ovid intend? Perhaps we can find clues in his other writing.

One of the central themes in Ovid's *Metamorphoses* is how power is used to silence others. The story immediately preceding Pygmalion's features women who are turned to stone as punishment for their promiscuity. Spurred by his dislike for them, Pygmalion vows celibacy, yet falls in love with his own statue, who then comes to life. Ovid wrote it during the rule of the emperor Augustus, who had just enacted "marriage laws" that punished both celibacy and adultery in a bid to encourage legitimate heirs. These laws were especially harsh toward women, allowing men to kill their own wives and daughters. Some argue that with the story of Pygmalion, Ovid is mocking the laws and conservative attitudes of the time; others read the tale as supporting them. Ovid did write a three-volume treatise on romantic and sexual love, *Ars Amatoria*, in which he counseled men on how to woo women with advice such as "don't forget her birthday." In the introduction to a 1965 edition, translator B. P. Moore called Ovid a "classically trained trickster" whose work "represents a radical attempt to redefine relationships between men and women in Roman society, advocating a move away from paradigms of force and possession, towards concepts of mutual fulfilment."

Presented with this collection of evidence, would you change any of your answers from page 159? Before, did you consider the idea that Galatea could have had power over her sculptor? Did you think about how the painting might be triggering for some viewers who had experience with sexual assault? With more information, it's now easier

to see that the relationship between Pygmalion and Galatea as depicted in the Met painting by Gérôme can be interpreted as romantic or something more problematic. Which interpretation is correct? In a word: both.

Reconciling Relationships

Pygmalion and Galatea represents hope to some viewers and hurt to others. We can reconcile this dichotomy by acknowledging both views. That isn't a cop-out. We aren't choosing sides or determining innocence. We're not ranking degrees of rightness either; in relationships, everyone's feelings can be true. One viewpoint might be more forceful than another; one might simply be louder but not more correct. When untangling relationship problems, the goal is not to play judge and jury but detective and moderator. We can do this by diligently gathering as much information as possible, opening the door to input from others, including ancillary players, and acknowledging all positions. This means lots of listening intently and facing tough choices.

Suppose you are a teacher presenting the story of Pygmalion to students. What should you do, knowing that the poem and the painting can be interpreted in completely opposite ways? Simply refusing to discuss the work because it is problematic isn't the best option. And shying away from difficult issues does not inspire anyone. In fact, on most troublesome subjects (infidelity, racism, insolvency, global pandemics), shying away from the problems only causes more or more severe problems. To solve this particular problem as a case in point, let's recall what we've learned from artists about confronting ambiguity, tackling thorny conflicts, and making plans:

Step #1: Clean Your Lenses

First, we should examine our own biases and possible prejudices toward the work. Does it invoke fear or desire in us? Is there anything in

our past or present circumstances that might color how we approach the work? By recognizing and acknowledging our filters, we help ensure they won't unconsciously influence us.

Step #2: Change Your Shoes

Next, let's consider how the work might affect others. What might other people in our lives—both those who generally agree with us and those who don't—have to say about the work? How might it feel to be a male student in the classroom? A female student? A student who has experienced sexual assault? A student who doesn't think they'll ever find love? A nonbinary student? A student of color? By seeking out and considering other viewpoints, we can craft a more inclusive solution.

Step #3: Define Your Project

There is a lot of information to consider, so let's organize and assess it at a high level. To do that, we can craft a quick notan study: boiling our options down to opposite extremes. What is the best-case scenario if we decided to present the work? What is the worst-case scenario? Can we live with the latter? What is the best-case scenario if we decided *not* to study Pygmalion? What is the worst-case scenario?

This nineteenth-century painting, and the Greek myth it was based on, may seem remote, but the issues it forces us to confront are as fresh as today's headlines. And looking closely at art can help us work through successful strategies for dealing with these controversies. When I was in D.C. recently, a career government attorney was bemoaning the fact that her town was considering renaming her daughter's elementary school to distance itself from a historical namesake. "He was a man of his time," she said, referring to the namesake. "We cannot judge him based on our views today."

This attorney was not bothered by the original name, but that doesn't mean other people weren't. If I were on the town board and had to make a decision on the issue, I would listen to all sides and then evaluate the repercussions of each option. How much would it hurt the people who didn't want the name changed if it were? It's an inconvenience, it's uncomfortable, and it would require some funds for re-

branding. How much does the current name harm current students, their families, and their viewpoints? I would put myself in their shoes and imagine having to walk through the doors of a state-sponsored institution that bears the name of someone who harmed others. How motivated would I be to go to school? How motivated could I be to succeed if I thought those in charge were against me? Tradition is a guiding force, but it doesn't have the final say. We should not simply accept something because that's the way it has always been. Recall St. Mary's school for boys.

The Latin teacher Ian Lockey was focused on the story of Pygmalion and the Classical tradition when he said, "Let's not accept stories as they were taught to us; rather, let's bring our modern lens and energize a future generation to join us in fighting for a discipline we can be proud of." He could just as easily have been talking about nearly all of the art we've looked at here. Critical review—that is, the tools we've been practicing to look and, more broadly, to think and experience—allows us to do more than appreciate the nuances of an artwork. It gives us the chance to see our own filters and perspectives in action, and to adjust our vision to suit a changing world.

Problem-Solving with the NBA

Sometimes, it seems like all I talk about in my sessions is art—along with death, disaster, disease, and dystopia. In truth, The Art of Perception isn't really that bleak; looking at art together prompts lots of laughter and much good humor and never, ever is there a dull day—especially if the client is the National Basketball Association. Somebody in the organization had heard about my work helping law enforcement professionals sharpen their perception skills, and they hired me for a session custom-designed for NBA security chiefs at their upcoming conference. In Las Vegas.

That's how I ended up in a cavernous, windowless hotel ballroom packed with about two hundred people, 95 percent of them men well

over six feet tall. At 4 p.m., when I was slated to take the stage, my two-hour session was the sole obstacle between them and a cocktail party, including live music and lavish spreads of food, hosted by the NBA. The functionary whose job it was to introduce me took the stage and read blandly from her notes: "Amy Herman has traveled all the way from New York City to tell us how looking at art can help with security at all NBA games."

That was the cue for me to get up and walk to the front of the ball-room. It also turned out to be the cue for every person in that audience to look down and start scrolling on their phone. The countdown to the cocktail party had started. They were aiming to get through the next two hours as painlessly as possible, even if it meant drowning me out. I had my work cut out for me.

I grabbed the mike and looked out into the blinding lights. "Let's do a replay on that intro, OK?," I said. "This is going to move fast, it will open your eyes, and I am in charge. Got it?" Once I said that, heads bobbed back up, and from the few expressions I could make out, they were now wondering, "Who is this lady and what the hell is she going to talk about?"

Keeping my promise, I started with a command. I told them to introduce themselves to the person sitting to their right and decide which one would keep their eyes open and which one would close them. During the next few minutes, this roomful of security and basketball experts described to each other paintings by Monet and Picasso—with eyes opened, eyes closed, hands flailing, faces squinting, and lots of yelling. Then I showed them what they had missed in each of the paintings. The next two hours flew by faster than they ever imagined.

It was a given that these guys already possessed excellent perception. Their jobs demanded that they spend their working hours scanning noisy, boisterous crowds; listening on earpieces; and keeping their eyes peeled for the safety of the players, all while keeping the exits and the GM (general manager) in their line of sight and their guard up in the middle of the cacophony of announcers and cheering. They're wizards at multitasking. Nonetheless, every game is a com-

plex assembly of moving parts, and it's all too easy to become complacent, especially when you're good at what you do.

I knew the room overflowed with expertise, and so I used works of art that would test their resistance to distraction and help them balance as they took in the big picture and kept their eyes peeled for the small details. I wanted to show them how to articulate both what they observed *and* what was *not* happening. Something that cop had said to me years ago echoed in my mind, precisely because it was so spot-on for this group as well: "Take them just far enough out of their box so they know what to look for when they go back in." Whatever I was going to say or show them in that hotel ballroom had to resonate with them when they got back in their arenas, up in the stands, between the players and the crowds. I absolutely had to make the connections real, and I had to make them stick.

Often in a session, I'll show two works together and talk about how to make sense of the pair, and what each work brings out, how seeing them side by side can amplify some ideas, and which things one of them does better than the other. The two images on the next page are both about noise, in different ways. The Archibald Motley painting *Nightlife*, from 1943, is about external noise, the competing noises of music, movement, an excited crowd. The painting by Louise Fishman, *Too Much, Too Much*, from 2020, is more about internal noise. Fishman, with her bold, almost defiant, energetic brushstrokes, is often compared to the abstract expressionist "action painters" of the '50s and '60s but her more contemporary take on gestural painting helps viewers to visualize noise from a fresh perspective.

Looking at these paintings, I spoke with the security chiefs about the internal noises they have to deal with, things that need to be silenced—home life, a sick child, their own aches, physical or psychological—for them to work at games with all the awareness that calls for.

At the end of my presentation of almost one hundred works of art, I told them I would be at the back of the ballroom signing the copies of my book that the NBA had purchased for them. Expecting a mass exodus to the cocktail party while I sat alone at the table counting

Nightlife by Archibald Motley Jr., 1943, oil on canvas.

Too Much, Too Much by Louise Fishman, 2020.

the minutes until I could return to my room, I was joyously surprised to see the line for books wrap all the way around the room. What's more, as I signed book after book, I was delighted to see that many of these guys were former New York City cops. Of course, there were hugs for my hometown cops, after which they invited me to join them and personally escorted me to the cocktail party.

Over shrimp creole and cold beer, I heard why my session, despite the lackluster start, was a breath of fresh air for weary conference attendees: no videos, no stats, no charts, and no bullet points in an endless stream of PowerPoint slides. A manager from my hometown arena, Madison Square Garden, summed it up eloquently: "You brought us into your world, and now we can go back to ours with our eyes open wider."

Patterns in Art

Our brains enjoy natural patterns, from spiral seashells to flower petals, which is likely why so many artists incorporate them in everything from architecture to needlepoint. British philosopher and mathematician Alfred North Whitehead wrote, "Art is the imposing of a pattern on experience, and our aesthetic enjoyment is recognition of the pattern."

At its core, a pattern is a relationship between things that are alike and things that are not. The same number in a row—3, 3, 3, 3—is a pattern, as are different numbers—3, 700, 15, 15, 700, 3—depending upon how they are arranged. Artists are taught to use the relationship between visual elements, like shape and color, texture and form, and design principles—symmetry, movement, proportion—to communicate meaning.

Dutch graphic artist M. C. Escher was inspired by both nature and mathematics. Look at his woodcut image on the next page, and list all of the patterns and relationships you can find. Given the title, the first one might be: "day and night."

Beyond the relationships between color, pattern, shape, and direction, did you note things that were local and things that were universal: human and nature, land and horizon, church and state, good and bad? Go back and compare both the micro and the macro.

We've found patterns and relationships (in art, and between us and the art, between ourselves and those around us)—now what do we do with them? The same thing an art student would: examine why

they exist. What brought them into play? What makes them continue? What makes them harmonious or discordant, dangerous or inspiring?

The Writing Center at the University of North Carolina, Chapel Hill, instructs first-time art history students to think of a work "as a series of decisions that an artist made." "Your job is to figure out and describe, explain, and interpret those decisions and why the artist may have made them." The same can be applied to studying relationships. Once you've identified a pattern of behavior, try to determine why someone might act or react the way they do. For the most part, behavior is a choice. What led to that choice? What exacerbated or alleviated it? Figuring out why certain behaviors exist can allow you to set up a system that encourages good patterns and enables you to intercede before bad ones can become a problem.

During the global pandemic, tension in public situations increased dramatically, particularly for people in the service industry. Lockdowns, supply-chain disruptions, low inventory, lost jobs, fear, and anxiety combined to push people on both sides of the counter over the edge. Reports of tempers flaring and, incredibly, guns being drawn became depressingly more common. Whenever I ventured out in public during those months, I found myself moving

Day and Night by M. C. Escher, 1938.

quickly, holding my breath, and surveying a path to the exit more often than not.

That August of 2020, I was visiting family in a small suburban town and stopped into the Kroger supermarket to pick up dinner. I was waiting in line at the deli counter when a man in the produce section started shouting. I couldn't make out what he was saying, but his anger and animated body language were easy to spot from across the store. In a matter of seconds, a group of employees appeared, forming a socially distanced semicircle in front of him. They stood still; only one of them spoke. I saw her nodding quite a bit. She never raised her voice or her hands. Her calm authority and the respectful presence of her coworkers seemed to mollify the man. His shoulders relaxed a little. His tone softened. He wasn't happy, as he set his basket down on the floor and stomped out of the store, but that first outburst was the sum of his rebellion. An employee quickly scooped up his discarded items and disappeared with them. Everyone else went back to work.

I couldn't help but seek out the woman and offer my awe and appreciation for how she and her coworkers had handled the situation. She told me that despite the general increase of customers getting irritated, working at the store was her favorite job because of the supportive community that management had created.

"They treat us like family," she said, "and they've all become my family. We look out for each other and we know our bosses have our backs."

They'd all been trained recently on deescalation techniques, she told me, something that I understood was a tactic for law enforcement and military. I had just witnessed this training play out successfully. I asked her what was it that she'd found most useful.

"Besides knowing that I'll be supported by management, the best thing we learned was how to watch for patterns in someone's behavior, even before they start screaming," she said. Employees were taught to pick up the nonverbal cues that signaled a customer was getting upset: rapid pacing with an empty basket, clenched fists, animated physical movement. Whenever they did identify those patterns, employees

were then supposed to monitor their own body language and tone to make sure they projected calm confidence.

"If you're calm, it calms them down," she told me. "We display the behavior we want them to reflect—respectful, calm, we give them space."

While Kroger management's immediate goal might have been to stay off the local news, their pattern-recognition training was yielding so much more. Employees and customers felt safe and wanted to keep coming back.

Pattern recognition takes practice, but anyone can hone their skills by looking at art. At a conference for obstetric sonographers—cleverly titled "Womb with a View"—Dr. Jo-Ann Johnson, the symposium chair, was looking at an ultrasound of a brain in the first trimester with Ravi Kapoor, a world expert in the field. He described to her how the lines in the frontal lobe were so predictable and could tell so much about the future health of the baby. "You want to know the best source for training your brain to recognize patterns?" he asked Jo-Ann. "Art. I learned that in the book *Visual Intelligence*. I tell all of my students if they want to get better, look at art." Jo-Ann followed his advice and then hired me to speak to the subsequent conference as one of their keynote speakers.

Let's practice recognizing patterns in human relationships with the painting we've used before, shown again on page 178: *The Raft of the Medusa*. What patterns do you notice in the placement of the figures on the raft?

They are not all in the same position, yet their positions are not totally unique either. I noticed three distinct postures for the men: lying down, kneeling, and standing. Other patterns I noted: men with their arms outstretched and men with arms by their sides. There are men lying faceup or facedown. All of the living men seem to be looking in the same direction save for two. That pattern alone led me to follow the gaze of the majority. What were they looking for or at? There seems to be a speck on the horizon, so let's zoom in to page 180. Upon closer inspection, the marking appears to be a ship.

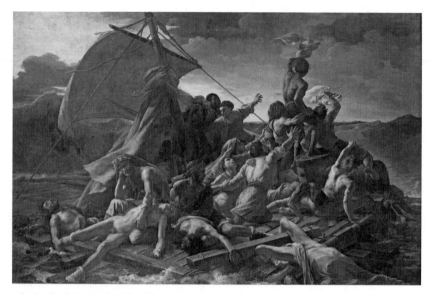

The Raft of the Medusa by Théodore Géricault, 1819, oil on canvas.

Before looking for patterns, did you ever consider that most of the passengers were looking in the same direction? Did you consider why?

Let us now examine the opposite: the men who aren't looking toward that ship on the horizon. Who are they and where does their gaze go? One near the mast looks to his neighbors. The other, a gray-haired man with a red cloth over his head, also looks away, but not at anyone else. He is the sole living individual who does not appear to be looking at anyone or anything. Look at the first detail of the painting on the opposite page.

What can we determine about the relationship between him and the man he holds? The difference in skin color suggests that the kneeling man is alive, while the one lying in his lap is not. Many art historians believe the pair to be a father and son, based on the age difference and the forlorn, defeated expression of the older man. Others have noted the man's bandaged, bloodied arm and wondered if he was injured trying to protect the body of his son from cannibalism.

The Raft of the Medusa by Théodore Géricault, 1819, oil on canvas. Detail of bottom center section.

Other patterns in the appearance of the figures on the raft include their skin color. Most have fair skin with three exceptions: the man on top of the barrel, a man standing huddled by the mast, and another lying facedown, presumably dead. What does this pattern, of the Black men being scattered throughout the raft, tell us? That death doesn't discriminate? That in the end, we are all human?

There was only one Black man recorded to have survived on the raft in real life, Jean Charles, an African crewman. After befriending another survivor, an engineer named Alexandre Corréard who was a staunch abolitionist and spoke with the painter extensively, Géricault not only made sure Charles had the topmost position, he created two more Black characters for emphasis. Let's look closer at the relationships surrounding Charles.

Aside from occupying the highest perch, which as we've seen in art

The Raft of the Medusa by Théodore Géricault, 1819. Detail of top center section.

denotes importance, Charles is supported by everyone surrounding him. He's fully embraced from behind and leverages his knee into the back of another passenger. While his left hand is raised, his right clasps the hand of the man behind him. Indeed, hands connect, holding, comforting, supporting all across the raft.

Artist Aengus Dewar takes this analysis a step further, noting that

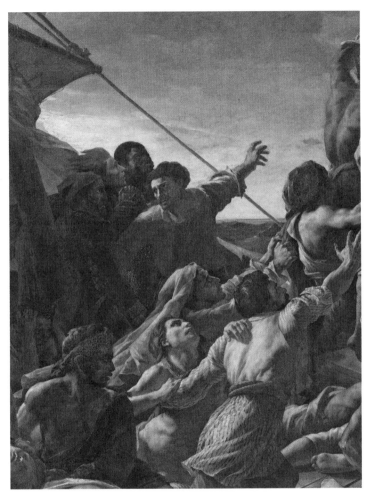

The Raft of the Medusa by Théodore Géricault, 1819.
Detail of center section.

the Black men on the raft are not portrayed as "chattel to be sold or discarded," but with "brotherly" connection. He writes that the Black man lying down "appears to have been cared for by the man twisting to help the signalers."

It's hard to see in reproduction and even in the original due to the bitumen Géricault used, a kind of tar that was meant to make blacks

darker but ended up rotting entire paintings, but the figure based on Haitian model Joseph, standing by the mast, has his hands clasped around his neighbor's. In what Dewar calls "the most eloquent and humane gesture in the picture," the two men seem to be praying together. What was Géricault trying to convey with this relationship? Equality in prayer and the hope of salvation?

I want to believe that, but I am an optimist who believes in the goodness of God. Another person might not be so accepting of that interpretation. What if the passengers' hands are clasped in simple despair? What if the Black man lying across the white man was murdered by him (note the bloody axe nearby)? We cannot blindly accept the results of our or anyone else's findings without first running them through our own perceptual filters.

Patterns in Us

After I gave a presentation to the National Retail Federation on how looking at art to hone our observation and perception skills could help with loss prevention, a big guy, chewing a toothpick, stopped me in the lobby of the hotel.

"I oversee the Department of Refunds," he told me. "We always have to assess every situation and decide whether or not the person is telling us the truth. After listening to you, I realized I see patterns in myself."

He explained that he found himself, more often than not, deciding who was honest and who wasn't before they even opened their mouths, not based on their body language or appearance, but on his previous experiences. He knew this prejudgment wasn't comprehensive or correct. I hear the same thing from those who work in law enforcement and the medical field. It's easy to fall into a pattern of seeing something because we've seen it before, and to end up searching hardest for what we believe should be there, even if it's not

the best solution. If we don't run these patterns we discover in ourselves through our perceptual filters, they can become red herrings that distract us away from the critical information we need.

Simply knowing we're capable of and likely to do this can help ensure our pattern recognition doesn't evolve into a pattern of expectation. Here are a few more concrete ways to stop your expectations from automatically filling in the blanks:

- Carefully examine information and answers that you found *first*
- Carefully examine information and answers that you *instinctively favor*
- Question information or answers that are *merely satisfactory*
- Consciously work on not avoiding answers that are *uncomfortable* for you
- Always look for *alternatives*
- Ask a *colleague* to review the information or answers with you

To navigate problems with relationships successfully, we must look at all of the information objectively, rather than trying to fish for facts that suit our desired solution. This takes time and clarity of thought; these are not resources that are always readily available. It is work, but the results, in the form of grounded solutions, are well worth the effort.

While our short attention spans and instant gratification culture long for quick conclusions, to avoid making mistakes that lead to bigger problems, we have to commit to a process. That doesn't mean that the process can't be efficient. In fact, as we're about to learn, deadlines—even though they are historically rooted in death—can be lifesavers.

Set a Deadline

Photo by Anthony Cabaero. Designed by Carlon Ramong and Mihailo Andic.

When he approached Camp Sumter in the dark of night, seventeen-year-old John McElroy had no reason to think it would be any worse than the prison he'd just left. He'd spent a month with his fellow captured Union soldiers in a converted tobacco factory in Virginia, and expected the same cold, dreary confinement at this

new place in Georgia. Instead of brick walls, however, he found enormous logs stuck five feet into the ground, the remaining twenty feet of trunk placed so close together as to provide not a single crack. As he and the rest of the Sixteenth Illinois Cavalry were marched through two separate gates, they realized there was no floor or ceiling. Instead, they were to be housed in a simple, open-air stockade.

Andersonville Prison, Ga., August 17, 1864, southwest view of stockade showing the deadline.

They were given no supplies or coverings, no culinary instruments, not a single canteen or cup. The first arrivals cobbled together primitive lean-tos from reeds in the oozing swamp that ran through the middle of the camp—another private wrote that "the whole camp looked like a collection of pig pens"—but as the weather soured and more prisoners poured in, most were left to burrow into the sludge to find shelter. Overcrowding, exposure to the elements, lack of provisions, and disease turned the camp into one of the largest and deadli-

est of all Civil War prisons. McElroy later wrote that he found it hard to even conceive of, let alone describe, "the spectacle of seventy thousand young, strong, able-bodied men, starving and rotting to death."

McElroy, a printer's apprentice who had joined the Union Army the year before in St. Louis to help overturn the "vicious social system" of slavery, could manage the heat and smells, the maggots and hunger. What he could not abide was the Dead Line.

Shortly after arriving, McElroy and a band of fifty other brave souls tried to escape in the middle of the night with a knotted rope they'd fashioned from rags. With it, fifteen men were able to scale the stockade walls before guards noticed and began firing on them. The escapees were soon returned, each chained to a sixty-four-pound iron ball. To discourage any other prisoners from attempting the same feat, a line of stakes connected on top by a thin strip of wood was erected twenty feet inside the walls. Orders were issued that anyone even touching this deadline would be shot without warning.

The first man was killed the very morning the line was drawn. A German named Sigel, delirious with fever, reached under the railing to fetch a piece of cloth. Others were gunned down for trying to retrieve clean water, for walking too close, or for no reason at all. McElroy understood the rules of war but believed the Dead Line murders were inexcusable. "There was never the least military or other reason for inflicting all that wretchedness upon men, and, as far as mortal eye can discern, no earthly good resulted from the martyrdom of those tens of thousands," McElroy wrote.

McElroy survived his fifteen-month imprisonment and went on to pursue a career in publishing, eventually becoming the editor and cowner of the *National Tribune* newspaper in Washington, D.C. It is perhaps not a coincidence, then, that the next popular use of the term "dead-line," now hyphenated, described the line on printing presses that demarked the limits of where text would no longer be readable.

While deadlines have evolved into nonlethal time constraints, many people still approach them in mortal terror, or close to it. A *New York Times* bestselling author who's written more than a dozen books confessed to me that she feels the weight of the word far heavier than

she should. "My husband has had to remind me, more than once, that no one is coming to break my kneecaps if I miss a deadline," she said. "But somehow, viscerally, that's how I feel."

Sean Famoso McNichol, one of the founders of LVRN Records (short for Love Renaissance), home of Grammy Award–nominated hip-hop artist 6lack (pronounced "black"), expressed a similar sentiment to me: "The word *dead*line in itself sounds harsh, but I guess that's literally what it needs to be! As an ultra-creative trapped inside of a business world, I personally hate deadlines but could not live without them."

Despite their distaste for them, both artists agree that deadlines are necessary, as they stimulate creation and, perhaps more important, completion. To produce commercially successful work, even (perhaps especially) creative people need to temper their passion with structure. Without deadlines, many novels would never get written, chapel ceilings painted, or new music ever released.

Leonardo da Vinci, never satisfied with the *Mona Lisa*, carried it around with him for years, constantly tweaking it—ultra-high-resolution scans show she once wore a number of hairpins and even a pearl headdress—before permanently injuring his hand and never finishing it. Indeed, the book you now hold in your hands might not have ever been published were it not for a deadline that forced me to stop rewriting and adding. I could write ten volumes on how art helps us better navigate the world if I were not rightly constrained, but how long would that take me, and who would ever read it?

"Not only myself, but my staff need deadlines in order to keep the train moving," McNichol says. "We constantly have to massage our creative counterparts and artists through the process so that their craving for perfection doesn't ultimately have a negative effect on their careers or our business model."

In the same way, deadlines are essential to problem-solving. They give a project, or problem, importance; and, better yet, a vision of completion. Without them, we might not ever put down the pen, step away from the computer, or hit send on a big ambitious project. With them, we have a structure that propels us forward and can even help cultivate solutions.

The Power of the Process

Compared to other types of art, album covers might seem like a minor genre, but they are, in reality, a huge undertaking. The design for the cover isn't just a visual identifier for the music, it's also a massive branding project that must reflect the artist or band's current direction. Album cover art is frequently incorporated into large-scale stage design for acts when they go on tour. The cover imagery, printed on merchandise, can also create a new revenue stream; the electric blue rampant lion from the cover of the Rolling Stones' *Bridges to Babylon* album was featured on more than eight hundred different items.

When *Bridges to Babylon* graphic designer Stefan Sagmeister, who has created album covers for some of the biggest names in music, including Lou Reed, David Byrne, and Aerosmith, first met with Mick Jagger, the lead singer asked him to visit the Babylonian collection at the British Museum for inspiration. Sagmeister obliged, and then went to his studio to create. To temper his creativity within a corporate business, Sagmeister employs a unique deadline practice: he starts playing an album and tells himself he has to be done with whatever he's working on by the time it's finished. "The kind of snap decisions that you have to make when a deadline begins at the first song puts you more in tune with your taste and gut instincts," he says.

Chuck Close, an artist who created hundreds of works of art, including the cover for Paul Simon's album *Stranger to Stranger*, noted the key to his output lay not in waiting for inspiration, but in just getting to work. In an interview about his creative process, Close revealed his belief that "all the best ideas come out of the process: Things will grow out of the activity itself and you will, through work, bump into other possibilities and kick open other doors that you would never have dreamt of."

By shifting our perspective on deadlines, as Sagmeister and Close have, we can harness their benefits. Not only can they lead to the discovery of the unexpected and possibly better, but deadlines can also help alleviate the stress of not having a plan or having too much time

to second-guess yourself. They can also breed confidence, since they give us goals that we can meet and even exceed.

Deadlines don't have to be a bear—unless you plan for them to be.

How to Set Reasonable Deadlines

A 2019 poll asked American employees to rank the things they found most stressful at their workplace from a list that included travel, physical demands, competitive colleagues, dealing with the public, and even bearing the responsibility for other people's lives. The response that more people chose than any other, by a large margin, was deadlines.

Often, the biggest problem trying to wrestle with deadlines is that the limits aren't set correctly in the first place. No amount of music or goodwill is going to make a bad deadline better, or an impossible deadline achievable. We can avoid setting ourselves and others up for failure if we set reasonable deadlines up front that aren't too tight or too lenient. And we can do that by expressly tailoring the deadline to the person we expect it from.

When choosing the cover concept for his debut studio album *Free 6lack*, Ricardo Valdez Valentine Jr., aka 6lack, wanted an image that was simultaneously powerful, aggressive, and calming. The natural choice: a bear.

"I feel like as big and vicious as a bear can be, a bear also has grounding qualities," Valentine says. "They're peaceful in a way, and they have qualities that are healing."

The result, pictured on page 185, of 6lack sitting on a bed next to a giant grizzly bear, was hailed as "One of the Best Album Covers of the Year" by *Complex* magazine.

"People always think it's CGI [computer generated imagery]," Valentine told the magazine. "That's a real bear, though!"

Finding the bear, it turns out, was easy. Getting the seven-hundred-pound, seventeen-year-old beast to do what they wanted it to was an-

other matter entirely. "You can't *make* a bear do anything," Valentine wisely notes.

The secret to the astounding photograph was everyone's ability to recognize the bear's timeline. Rather than rush things for their calendar, Valentine and the crew worked with the animal's schedule. The entire first day, they let the bear do nothing but wander around the set and sniff things.

"He would walk in, look around, and walk back out to the trailer," Valentine recalls, "literally six hours, just sticking its head halfway in and being like 'nah' and turning around and going to the trailer."

The second day, the bear was more comfortable with both its surroundings and costars and sat for the famous photo. The team got what it needed because it worked with deadlines that prioritized the key players.

It's a philosophy that comes from the top of 6lack's record label. Studio boss McNichol tells me he sets different deadlines for different people, depending upon how they work. "As much as we would love to hit every date we seek, we also know how important the art is to the creator," McNichol says. To keeps things moving without causing anyone extra stress, management at LVRN—who recently launched the first mental health and wellness division at a record label to support their artists and employees—creates internal guidelines for how far they are willing to stray from any deadline.

SpaceX CEO Elon Musk takes a comparable approach, creating both public and private deadlines. "In order to achieve the external promised schedule," he says, "you've got to have an internal schedule that's more aggressive." By building in this "schedule margin," Musk builds in leeway that protects his team's reputation and, more likely than not, their sanity.

The smartest way to set a reasonable deadline is to make sure it's not too stressful for those involved, to tailor it individually to all players, and to also break it up. Instead of one all-consuming deadline looming over your process, set smaller deadlines within it. In the case of problem-solving, give each step its own deadline. Here's just one sample based on the artistic approach in this book:

Task	Time Needed	Date Due
Create Self-Portrait to Find Perceptual Filters		
Seek Out Other Perspectives		
Define the Problem		
Sort and Prioritize the Data Collected		
Sketch a Solution		
Execute Solution		
Measure and Follow Up		

There can be as few or as many steps and corresponding deadlines as you desire, depending on the problem you're trying to solve—whether it's completing a college essay or planning a product launch. If you're working with others, involving them in the deadline creation process can boost your overall likelihood of success because everyone will have bought into the strategy from the beginning.

You might also consider taking a page from Géricault's book and set extra deadlines just for fun.

Set Extra Deadlines

Although he was pressed for time, having determined he would exhibit *The Raft of the Medusa* at the Salon of 1819, a deadline that gave him just eighteen months to finish the room-sized masterpiece, Géricault

had another list of tasks he worked on simultaneously. His prodigious to-do list was intended not just for "self-education," but also to give him something he could complete every day. A small sample of it included:

Read and compose.

Anatomy.

Antiquity.

Italian.

Busy myself with music.

He was not the only artist to build in smaller bits of activity that had nothing directly to do with his primary project. The artist Robert Rauschenberg scheduled time every morning to watch the soap opera *The Young and the Restless.* Joan Miró left his studio every day at noon to exercise for an hour. And when she has finished her work for the day, artist Dame Paula Rego enjoys precisely one glass of champagne.

Especially when we're bogged down trying to solve a problem, it can be hard to remember to take a break, take a deep breath, and see beyond the deadline. We need to add extra tasks to help break up the monotony, bring some levity, and give us the satisfaction that comes from crossing off one item from the list every day.

This is not just an idle suggestion. I think it is an important directive. To recognize its importance, I want you to come up with a list of three things you might schedule into your own life every day that are enjoyable. They can be as big or as small as you'd like. Miró took a five-minute nap every afternoon he called "Mediterranean yoga." It can have to do with movement or meditation, food or friends, art or reality TV. Make a list, titled "Ideas for Scheduled Enjoyment."

I start every day by selecting a single work of art and posting it on my Facebook page. The act of searching for the *pièce du jour* brings me immense happiness, as do the comments I receive from friends and

followers around the globe. It engages us all in a conversation unrelated to the rest of our day, where we find common ground, simply by looking at a work of art together.

Celebrate Accomplishments along the Way

Finally, don't forget to schedule celebration. Not just for the end, but for every step in between. In problem-solving, we all too often unwittingly find ourselves stuck in drama and anxiety. Take the time to acknowledge what is going right.

Speaking of which, congratulate yourself for how far you've come in this process! We're almost at the finish line. The next step is our last: when "draft" moves from noun to verb as we take our outline of solutions and transform it into a finished work.

Just Do It

Backdoor Pipeline by Richard Serra, 2010.

O ne of the most famous corporate slogans of all time was inspired by a first lady and a serial killer.

Despite being named after the Greek goddess of victory, the American athletic manufacturer Nike was not having a good year in 1987.

Sales had dropped 18 percent; earnings had declined 40 percent. By failing to spot the popularity of aerobics and aerobic shoes, they'd all but handed competitor Reebok nearly a 50 percent market share. Nike needed a big win, and fast. They turned to a fellow Portland company, advertising agency Wieden+Kennedy.

Principal Dan Wieden thought a short, elegant slogan would do the trick. Something action-oriented and self-empowering, like Nancy Reagan's simple, three-word antidrug campaign "Just Say No." Another three-word declaration of sorts echoed in Wieden's mind. A statement from ten years earlier, uttered by a convicted murderer as he sat in front of a firing squad.

Gary Gilmore had been front-page news for months due to his unusual demand: he wanted to set a date for his own death penalty. Despite pleas from family, friends, and even the singer Johnny Cash, Gilmore requested the ACLU back off and let the state serve him the capital punishment he believed he'd earned for killing two innocent men on two subsequent nights. The country was outraged—late-night sketch television show *Saturday Night Live* did two skits on the topic— because Gilmore would be the first person executed in the United States in a decade. On the morning of January 17, 1977, Gilmore was taken to an abandoned cannery behind the Utah State Prison and sat on a chair in front of a wall of sandbags. Before they dropped a black hood over his head, he was asked for his last words. "Let's do it," he said.

Wieden found the statement to be the "ultimate act of intention." Historian Natalia Mehlman Petrzela agrees: "When are you ever less in control of your life than when you're going before the firing squad? It is an example of kind of taking agency over your own fate." Wieden merged the two phrases—"Just say no" and "let's do it"—into the instantly memorable slogan Nike still uses to great effect to this day: Just Do It.

And that is where we are in the process of problem-solving: we just have to do it. We've prepped everything, gathered all the information, and analyzed it. We've examined ourselves and the relationships surrounding us. We defined the problem, prioritized its pieces, and cre-

ated deadlines. There is nothing left to do except draft a solution. This means selecting a direction, implementing the plan, and documenting the decision. It's perhaps the hardest step, as it requires deciding on a specific action or set of actions. It's where we find out if we are capable of implementing a solution, or if we've just been dancing around the idea of the problem all this time.

This stage reminds me of both a a sculpture and a poem: Richard Serra's *Backdoor Pipeline* (pictured on page 195) and Robert Frost's "A Servant to Servants." Serra's massive arched creation, meant to be explored by visitors, was described by a museum curator as "like stepping through the threshold of a cathedral of rusted steel." To me, it is the embodiment of a line from Frost: there is "no way out but through." It is time to create a solution.

I included the story of Gary Gilmore in this section because I wanted to highlight the sheer, dogged confidence the other side frequently possesses. The side making the problems. The people or the circumstances stirring up trouble and creating obstacles for us. The ones who harass and lie, step on dignity, disrespect, tear down, cheat, kill, drain, poison, and pillage. I want you to think about those forces, killers who can sit in front of their killers and say, "Let's do it." To fix what is broken, we must exhibit the same determination as those who seek to destroy.

For this, we will tap into the determination of the artist. Take the Chinese dissident Ai Weiwei (pronounced "EYE way-way"), who uses his art to protest his government's treatment of its citizens. To bring attention to the dismal state response to the 2008 Sichuan earthquake and the shoddy engineering materials and lax regulations that contributed to the collapse of so many schools, Weiwei labeled nine thousand backpacks with the names of the children killed in the tragedy and arranged them into an installation called *Remembering*. The primary colors spelled out the sentence "She lived happily for seven years in this world," a quote from a mother whose daughter had died in the disaster. For trying to testify against the massive failures in the state-sponsored construction, Weiwei was punched so hard by Chinese police that he needed emergency surgery for a brain bleed. Two years

later, he was arrested in the Beijing airport while waiting for a flight to Hong Kong. Weiwei reflected on his confinement: "Without all the yelling, without the prison, the beatings, just what would I be?" He continues his advocacy and has no regrets. "We have only a moment to speak out or to present what little skills we have," he says. "And if everybody does that, maybe the temperature changes."

Remembering by Ai Weiwei, 2009.

We can also look to the unstoppable Iranian film director Jafar Panahi, who uses his influence to tell the world about his country's human-rights violations. After releasing several movies, including *The Circle* in 2000, a commentary on the treatment of women in Iran, Panahi was placed under house arrest and prohibited from making films for twenty years. Despite this, he continued to invent creative solutions, releasing the iPhone-shot film *This Is Not a Film* to document his struggle against suppression, which was smuggled out of the country on a flash drive stashed in a birthday cake.

Is trying to work through problems hard? Yes. Is it internal bleeding

and lifetime ban hard? Usually not. Does our solution have to be perfect? No. Do we have to do it now? Yes. We can always go back to the drawing board and try again, but we must try something now.

Just. Do. It.

Make Something from Something

Although it's a common phrase, so few of us ever have the opportunity to make something from nothing. We mostly have to make something from something.

Left: Mr. Optimistic by Julie Cockburn, 2014, hand embroidery on found photograph.
Right: The Conundrum by Julie Cockburn, 2016, hand embroidery on found photograph.

The art of Julie Cockburn (pronounced "COH-burn") might just epitomize this. She buys vintage photographs of strangers at garage

sales and auction houses and then, using a needle and thread, embroiders directly onto their surface. In doing so, she creates an entirely new image that evolves into a work of art that is greater than the sum of its parts. The embroidery and the photo are distinct yet intertwined; it is hard to see one without the other. Both sides are apparent, and yet, they can still work together. In some cases, the best solutions will be similar: not destroying the old but redefining it. Perhaps we should think of all problems as potential palimpsests, to be written over and renewed, an opportunity to bring something more beautiful into the world.

Using what you have and what you know, select your solution, and begin implementing it. Know that your solution doesn't have to be, and in many cases won't be, a permanent decision that must stand forever. Sometimes the best solutions come out of a series of multiple assays, renewed iterations aimed at fixing the same problem.

In 2015, a group of Princeton students staged a thirty-three-hour sit-in at the office of President Christopher Eisgruber to protest the university's institutional racism. One of their requests was the removal of Woodrow Wilson's name from Princeton's public and international affairs school and a residential college because of the former president and alumnus's segregationist beliefs and policies. A special committee of trustees was created, input solicited from the community and the public, and a timeline for a decision set. Five months later, the university announced that after much research and careful consideration, they had voted not to remove Wilson's name, but planned to instead publicly acknowledge his "failings and shortcomings" in a meaningful way. Additionally, the committee announced programs of educational initiatives for "underrepresented groups." Members of the Black Justice League denounced the outcome with a statement that read: "Princeton's decision today demonstrates unambiguously its commitment to symbols and legacies of anti-Blackness in the name of 'history' and 'tradition' at the expense of the needs of and in direct contravention with the daily experiences of Black students at Princeton."

The university moved forward with diversity initiatives and attempted to address the college's "complex legacy" of racism and slav-

ery by instituting educational programs, faculty appointments, and several prominent art installations. In 2017, Titus Kaphar unveiled a two-ton public sculpture, *Impressions of Liberty*, "a monument to the memory of the enslaved" on the site where a former Princeton president had sold five slaves. It was installed in front of the former official residence of the university presidents, currently home to the Alumni Association. In 2019, MacArthur Fellow Walter Hood dedicated *Double Sights* in front of Princeton's Woodrow Wilson School of Public and International Relations, a thirty-nine-foot installation intended to be "disruptive by design." It features two columns, one black and one white, inscribed with quotes from Wilson and his critics. Student leaders protested and called the sculpture "a concrete step backwards," concluding that it amounted to "yet *another* memorial on campus dedicated to avowed white supremacist Woodrow Wilson."

In June 2020, the university board of trustees announced that although they had previously conducted a "thorough, deliberate process," they were reversing their decision on key institutions bearing Wilson's name. Unlike their previous statements, this one was unequivocal: "Wilson's racism was significant and consequential even by the standards of his own time. . . . Wilson's segregationist policies make him an especially inappropriate namesake for a public policy school." President Eisgruber then took the extraordinary step of publicly admitting his previous decision was wrong, writing a piece for the *Washington Post* under the title "I Opposed Taking Woodrow Wilson's Name off Our School. Here's Why I Changed My Mind."

We can change our minds. No solution is perfect. But perhaps the process of implementing that imperfect one immediately will lead us to an even better one soon. Start now. Boldly and without fear. And if you need a last-minute gut check concerning the solution you've selected, run it through this simple filter: Is it the most humane choice?

A Princeton alumnus from the class of 1956's response to the name change underscores why it was the right decision. He wrote, "That Wilson's blatant racism was unimportant to decision-makers at the University generations ago really should not bind us to their judgment now. Especially now, as we recognize how fragile our democracy has

become, we must be vigilant in our care for the rights of all our citizens." Not everyone agreed with overwriting a hallowed tradition, but in the end, which matters more: heritage or humanity?

Set Success Metrics

To be able to monitor how well a solution addresses the problem, we need to have success metrics set in place from its implementation. What metrics work best will differ greatly across different issues, but we must choose some. We're not after the perfect monitoring system, but we do need data—data we can use to hone or pivot away from our original plan.

In the art world, methods of measurement vary. Some are concrete, such as album sales; a gold, platinum, or diamond record is a reflection of five hundred thousand, one million, or ten million sales and streams. Some are relative, such as the *New York Times* bestseller list; a book lands on the list not for how many copies it sold overall but compared to other titles sold that week. Some measurements look at finite time periods, like opening weekend; others are cumulative, like total box office. Some are by popular vote (the Oscars), some secret ballot (MacArthur Fellowships), some by committee (Nobel Prizes). The method should suit your project and provide you with some semblance of an idea of its success.

Nan Tucker is a human resources director at a General Motors assembly plant in the Midwest. She deals with dozens of problems a day, from compensation negotiations to workplace safety, but there was one she couldn't seem to solve. The employee bathroom stalls were covered in graffiti every day. No matter how many times the stalls were painted over, the markings would reappear soon after.

Tucker tried numerous things. Signs pleading for cleanliness and respect. Signs explaining the extra work that was created for the maintenance teams. Promised incentives, threatened punishments—

nothing worked. Until Tucker came across a 2009 article on a workplace improvement website that referenced a public toilets experiment conducted by a behavioral analytics professor. She decided to give his solution a try. That night, she had a new sign hung in the restrooms: "Every day these walls remain mark-free, GM will donate to the local food pantry." The scribbles stopped immediately.

Tucker was able to see the success of her solution immediately by looking at the clean walls, but in a report for upper management, she was also able to break out the cost effectiveness of posting a notice and donating to the food pantry versus buying paint and paying the extra man hours for the constant cleaning of the stalls.

There is no database for choosing the appropriate metrics; it's up to you and your team to devise them now, agree upon them, and then document their effectiveness. If you do nothing else, you can measure your success quickly and easily by answering three simple questions:

How effectively was the problem solved in your eyes?

How effectively was the problem solved in the eyes of your stakeholders?

How effectively was the problem solved in the eyes of the world?

Does it matter how others view the solution? As we discussed in the beginning of the book, since we can't successfully operate and innovate in a vacuum, yes. And since camera phones can spread information globally, wrecking reputations at the speed of light, virtually everything we do now, even in private, is up for public consumption. Post your solution to your daughter's laptop addiction on Facebook and what might seem perfectly reasonable to you—say, shooting the laptop in your backyard with your hunting rifle—might merit a visit from Child Protective Services, as one father from North Carolina found out in 2012. Instead, before executing anything—a plan or a computer—make sure you have a means to measure its success before sharing it with others.

Share Your Solution with Others

Finding a solution and determining how to measure its success isn't the end of the process. We still need to communicate what our solution will be to other people. Ideally, you want to communicate your plan in a way that will be well received.

As a Latina physician at a public hospital in Denver, Lilia Cervantes was acutely aware of the pain undocumented immigrants faced because of their limited access to medical care. As in most states, Colorado's Medicaid program would only cover emergency services. That meant Cervantes, "Dr. Lily" to her patients, could save someone's life but couldn't give them the long-term treatment they needed to stay alive. For years, she participated in a demoralizing dance with emergency room patients who would come in with kidney failure. Some of them couldn't walk. Some had multiple cardiac arrests. All of them were given dialysis, revived, and then discharged, only to show up again a week later, sicker than ever.

Cervantes was especially haunted by a patient named Hilda, an undocumented young mother who would come in once a week for life-saving dialysis. Without a transplant, a person with end-stage renal disease (ESRD) needs three sessions of dialysis a week to survive. Only getting it once a week was not enough. Hilda spent her last days trying to secure a home for her sons.

Inspired, Cervantes cut back on her clinical practice and assembled a team to research the possibility of getting Colorado to cover regular dialysis for undocumented individuals. For four years, they conducted interviews with patients and physicians and published studies that helped them engage key stakeholders. They found that patients who depended on emergency-only hemodialysis suffered a fourteen times greater mortality rate than those with regular sessions. They found the helplessness of treating these patients in an emergency-only capacity greatly contributed to physician burnout. Giving emergency medical care that could be avoided with regular treatments also strained the time and resources of emergency departments, diverting them from taking care of other life-threatening cases. To Cervantes, the answer was simple: everyone

deserved access to dialysis, regardless of their immigration status. "So many problems of health-care access lack ready policy solutions," she wrote. "This is one problem with a solution."

Simply finding the right solution, though, doesn't automatically guarantee success. The fix has to be implemented, which in many cases involves convincing others, sometimes entire organizations. Cervantes knew she could write a hundred heartfelt pleas, but in the end, it was data and dollars that would drive policy change.

Thanks in large part to her team's research, in 2018, Colorado's Department of Health Care Policy and Financing agreed to cover hemodialysis for ESRD patients. They also knew, however, that it would be a hot-button topic for taxpayers, so they announced the change by leading with the fiscal benefits. Instead of simply saying that Colorado would start covering regular hospital treatments for illegal immigrants, they purposefully crafted their communication to immediately address any potential concerns. The headline in the *Colorado Sun*: "Patients Now Can Get Regular Care at Dialysis Clinics through Medicaid, Saving Millions in Hospital Costs." No mention was made of undocumented people, and who could argue with *saving* millions of taxpayer dollars? Along with being humane, the switch would save millions since scheduled dialysis costs an average of $250, while emergency dialysis costs $2,000—eight times as much. A year after the new policy was first implemented, Colorado Medicaid is on track to save $19 million, a savings they will enjoy *annually*.

They achieved success because those involved were strategic in how they communicated their solution. Once they scored a victory in Colorado, though, Cervantes and her team didn't quit. They documented exactly how they had reframed the conversation in a way that would help health-care providers in other states. In the journal article "Moving the Needle: How Hospital-Based Research Expanded Medicaid Coverage for Undocumented Immigrants in Colorado," Cervantes highlighted two key components that factored into their win: support for research and communications, and collaboration and trust across stakeholder groups. Following suit, a senator from Texas is proposing the same plan. The headline describing it in *D Magazine*: "State Sen. Nathan Johnson's

Plan to Expand Medicaid in Texas and Save Taxpayer Dollars." Deliberately planning for how you will communicate the solution is key, but sharing the strategy ensures that it is replicable and sustainable.

Artists have been doing this for centuries. As one artist observed, "Communication is not necessarily art, but all art is communication." We can take inspiration not just from the life, mindset, and process of the artist, but also in the way they can actually work to engineer change and create solutions. One example of that arrived very close to home for me. The government of New York City tops the list of overwhelming bureaucracies. But that behemoth of red tape was no match for the artists Christo and Jeanne-Claude, who successfully created a spectacular work of art in the heart of the Big Apple, without ever descending into the rabbit hole of public funding that has halted the most ambitious projects dead in their tracks.

In February 2005, Michael Kimmelman heralded the unveiling of Christo and Jeanne-Claude's *The Gates* in New York City's Central Park as "a work of pure joy, a vast populist spectacle of good will and simple eloquence, the first great public art event of the 21st century." For two weeks, people out for a stroll in the park could wander through twenty-three miles of paths, under 7,503 steel frames supporting panels of saffron-colored fabric that floated lightly on the breeze. Having brought in over $254 million in economic activity over two weeks, the project was deemed a "stunning success."

Christo and Jeanne-Claude installed the vibrant saffron-colored gates in a park with leafless trees in winter so they were visible from every vista. Central Park belongs to everyone in New York City, natives and visitors alike, and the sense of ownership was manifest in the joyful engagement of the participants. As over four million bikers, joggers, and walkers from the five boroughs and points beyond wandered under and around the gates, there was a sense of belonging to the work of art and not viewing it from the outside. It engaged the park and its inhabitants rather than containing them. I worked across the street from Central Park during the festive installation, so I took many walks to view *The Gates,* and every visit was distinct and unique.

The Gates by Christo and Jeanne-Claude, 2005.

Yet behind the maze of saffron curtains was a massive ma-
chine that enabled Christo and Jeanne-Claude to fund the entire
project—$21 million—without a single private or public donation or
contribution. As they did with all their projects, the husband-and-wife
team successfully funded the planning, installation, maintenance,
and dismantling of *The Gates* from the sale of their artworks, at no cost
to New York or visitors to the park—a complex yearslong problem-
solving effort that the couple considers an integral part of the work
that is both a joyful high point of ephemeral sculpture and a monu-
ment to successful bureaucratic negotiation.

Problem-Solving with MESH

Following my presentations, people often reach out to tell me how
they applied their new way of looking to solve problems, both per-

sonal and professional, some of which had seemed unsolvable before they took the class. So, I should know better than anybody that the lessons can be applied in ways I'd never dreamed of. But even I was surprised when I started working with teams who specialize in planning for the worst that could happen, scenarios the rest of us would rather not contemplate.

I was in New York City on 9/11, watching the collapse of those landmark buildings, a place that was both monument and everyday workplace, so I remember what can happen when there is no contingency plan. There was chaos everywhere. And the disbelief I saw on every face lasted for months. New York was an unfortunate example of a phenomenon that is, luckily, very rare: an entire city suffering through depression all together at once.

In the aftermath of the attack, people throughout the country, really throughout the globe, reconsidered the idea of readiness. One of the most positive outcomes of that catastrophe was the establishment of collaborative organizations devoted to disaster preparedness, globally and locally. When I was invited to be a keynote speaker at the MESH National Healthcare Coalition in 2018, tailoring The Art of Perception for that audience's work, I studied what "disaster preparedness" means, starting with the term "MESH." I'd certainly never heard of it. It's an acronym for Managed Emergency Surge for Healthcare. Even the name is complex, filled with moving parts that don't seem to fit together intuitively.

Creating a meaningful presentation with actionable takeaways for these professionals involved learning the component parts of successful emergency-planning partnerships. With guidance from leaders in the field, I broke the concept into four parts: intelligence, education, planning, and policy. Professionals in each of these fields gather intelligence about potential threats, ranging from natural disasters to bioterrorism, and review their successes and failures in responding to similar crises in the past. Then they share their findings in the hope of preparatory measures to combat threats known and potential. Although their work is grounded in visual acuity, situational awareness, and resilience, the thread that binds them together is the need for ef-

fective communication of what they observe, in the moment, against the background of an ongoing disaster and its immediate aftermath. Because their collaborative work involves numerous bureaucratic agencies, the need for succinct and precise exchanges of information is paramount. I turned to abstract art and sculpture to help them practice these essential skills.

At first glance, Julie Mehretu's paintings have so many moving parts that seem to be swirling randomly. A closer look, however, reveals the underlying order in the (nearly) symmetric precision of colors, form, and line. She has contained the chaos and created a spectacular, even overwhelming representation of order. Her works are very much in motion, and that balance, of order and motion in the face of chaos, is one that every governmental agency should aspire to when disaster strikes.

In fact, Mehretu is a good model for MESH in more ways than one. Although we often think of artists working alone, Mehretu works with teams of skilled assistants, most of them artists themselves, with varying backgrounds—in furniture making, auto refinishing, graphic arts, computer layouts, and so on. The teams work together, under Mehretu's direction, to add layer after layer, with separate colors and finishes, in a virtuous circle: the efficiencies allow Mehretu to take on ever more ambitious commissions, and the size of the commissions allows her to hire more (and more talented) staff. The complexity and size of the work (*Stadia II*, from 2004, is nine by twelve feet) are part of the overwhelming impact of her work, which is certainly something that anyone in MESH can grasp.

On an entirely different scale, the series of sculptures of the model Jeannette Vaderin that Henri Matisse made from 1910 to 1913 was effective as a visual illustration of what communication should look like both within an agency and between partner organizations, and they are vastly different. In a way, the series traces the evolution of an idea from a realistic beginning, from one bust to the next, toward an increasingly more stylized abstraction. Striving for the essence of what you need to communicate is harder than it sounds. Agencies such as hospitals, EMS units, police, and social services are burdened by "al-

Stadia II by Julie Mehretu, 2014.

phabet soup," acronyms bounced around in conversation like a Hacky Sack. When agencies engage with the public or organizations not familiar with their jargon, messages should be pared down to their essence, like the later sculptures of Jeannette. The earlier iterations are certainly more realistic, but for problem-solving, not necessarily the most useful. Pretty packaging is not necessary for these organizations. The idea of less is more, of telegraphic simplicity, is imperative in both planning and implementation.

Unbeknownst to all of us, my class at the MESH conference in New Orleans in 2018 was extremely timely. It was an impressive gathering of leaders in health care, public health, emergency medical services, public safety, government, and academic, nonprofit, and private sector organizations. Their collective mission was to create a health-care infrastructure that could support communities in need of emergency management during a manmade or natural disaster.

Works of art that sparked fruitful discussion involved big pictures

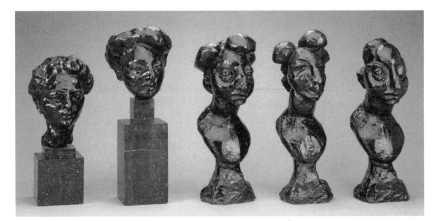

Jeannette I-V by Henri Matisse, 1910–1913, bronze.

with small details, making order out of apparent chaos in an abstract painting, all while accounting for shifting priorities and differences in observation and perception. Ideally the participants aspire to communicate with complete objectivity, stripped of irrelevant emotional elements. At the top of their list of applicable takeaways from their session was the idea that communicating in haste, without thought to economy and precision of language, could be its own disaster. Know what you want to say and, equally important, know what you *don't*— because in times of disaster, people aren't just listening to you, they are relying on you. *Festina lente*—make haste slowly, to make sure directions are communicated correctly. In emergency management of health care, clarity is a matter of life and death.

In some locations, like New Orleans, the threat of natural disasters—and their devastating impact on underserved communities—is a recurring problem, requiring assistance in the aftermath to rebuild and restore basic living conditions. The haunting photographs that went viral in the wake of Hurricane Katrina became a call to action nationwide. As a result, the three Rs—"Rescue, Recover, and Rebuild"—became the mantra for health-care coalitions thousands of miles from Louisiana. But visualization of problems doesn't have to be all gloom and doom all the time. I included Jennifer Odem's sculpture *Rising*

Tables, which was installed in the Mississippi River, with the New Orleans skyline as its backdrop. Standing sentinel against post-Katrina floodwaters, the tables symbolized hope, albeit fragile. As the artist explained, the table is an emotionally central presence both at home and in the community: when floodwaters rise, people put their valuables on the table to keep them from damage. When we can't come to an agreement, we bring our issues to the table to try to resolve them. I traipsed to the riverbank late one afternoon after speaking in New Orleans specifically to see this sculpture in situ, and I was unex-

Rising Tables by Jennifer Odem.

pectedly moved. As the water lapped at its legs, the towering structure emanated strength, solidity, and potential in the face of so many challenges, both natural and manmade. But it reminded me that we, individually and collectively, can take affirmative and collaborative steps to effect positive change. That's what MESH and its affiliates were trying to do.

In 2019, I worked with a dozen different groups on disaster preparedness and emergency planning, having absolutely no idea how soon the tools from my presentation would be put to the test, in all aspects of our lives, in the coming year. In fact, at the very last in-person session I led, in March 2020, we asked each other as we gathered over coffee if we were being prudent to even assemble considering what was unfolding in the world outside. Over the year that followed, COVID-19 had every single person at that conference working overtime.

Looking now at a Venn diagram of the successes and failures of the coronavirus pandemic response, there is one word that would be squarely situated in the overlapping center: communication. Far too often, communication about the virus's threat, symptoms, contagiousness, and quarantine and lockdown procedures failed. And the most effective responses came in places with the most effective communication. This was equally true when it came to the creation, rollout, and distribution of the vaccines. In hindsight, I am grateful that my work at the MESH conference and with state organizations after that all focused on the importance of both inter- and intra-agency communication in the midst of a crisis, as well as the creation of a communication infrastructure for the aftermath.

How Artists Fix Problems

In May 2017, to celebrate the city of Venice's international art exhibit, artist Lorenzo Quinn installed a large-scale exhibit titled *Support* in the canal next to the Ca' Sagredo Hotel. As you look at the image, consider the following questions:

What problem(s) do you think Quinn was trying to address?

What solution(s) do you think he was communicating?

Support by Lorenzo Quinn, 2017.

By using the visual of a giant pair of human hands rising out of the Grand Canal, Quinn was able to say more, perhaps more eloquently, than if he'd written a one-hundred-page research paper. People can easily refuse to read a report, but his sculpture was impossible to ignore.

If you look at the roof of the building, you can see it is sloping down to the right, where the hands arise out of the water to support it. One of the problems Quinn was highlighting was the impact of climate change on the ancient city. As temperatures rise, so do the sea levels, which threaten not just wildlife and ecosystems, but as Quinn pointed out, the exquisite historic buildings of Venice. Quinn's urgent reminder? Only humans can fix this.

Artists Christo and Jeanne-Claude first began creating their vision by wrapping ordinary objects in fabric or polyethylene. Covering ordinary things—bottles of champagne, dining room chairs—turned them into sculptures, ironically revealing more about the shape and space of an object when it was concealed. Eventually, they expanded to wrap larger items to "alter environments." In June 1995, they wrapped

the Reichstag, the historic parliament building in Berlin, in one hundred thousand square meters of silvery fabric and ten miles of blue rope. After fourteen days and throngs of visitors, the materials were removed and recycled.

Wrapped Reichstag by Christo and Jeanne-Claude, Berlin, 1971–1995.

Built in 1884, the Reichstag embodies German tradition and nationalism. It housed the German Parliament until it was set on fire in 1933 in what historians now believe was a false-flag attempt by the Nazis to rile the country against its enemies. When Christo and Jeanne-Claude first visited Berlin in 1976, the city was still divided into East and West; the Reichstag was the only building straddling both sides. It had been more or less abandoned until Germany's reunification in the 1990s. As you look at the image, *Wrapped Reichstag,* consider:

What problem(s) do you think Christo and Jeanne-Claude were trying to address?

What solution(s) do you think they were communicating?

By drastically, but temporarily, changing the appearance of a large, permanent structure—they aimed to transform either a prison or a parliament, as they believed those were the only "true public buildings"—Christo and Jeanne-Claude showed how easily perception can be altered. They noted that "years after every physical trace

Monument by Krzysztof Wodiczko, 2020, video installation.

has been removed, original visitors can still see and feel them in their minds when they return to the sites of the artworks." The politically charged *Wrapped Reichstag* project took twenty-four years to be approved, during which period Christo, a Bulgarian refugee who had escaped communism, feared on multiple occasions that he would be arrested. The artistic shrouding allowed Germans to see the building once occupied by Nazis, and then abandoned, in a new light, and came to represent a reborn, unified Germany. Soon after the *Wrapped Reichstag* came down, the design for grand renovation was approved, and by 1999, four years after the artists' installation, the German government held its first official session there since 1933. It is now the official seat of the reunited government.

Like Christo, the artist Krzysztof Wodiczko, born in Warsaw in 1943 and smuggled out of Poland as a baby during World War II, works most often in public settings. He communicates his ideas about war and injustice by projecting new images onto old statues and buildings. The bronze face of a Civil War naval admiral in New York City's Madi-

son Square Park becomes the visage of a resettled refugee. A sculpture of Abraham Lincoln that has stood silent in Union Square since 1870 comes to life as the faces and hands of veterans talking about their

Infinity Room by Yayoi Kusama.

battle scars are superimposed over it. The seated likeness of Harvard University's John Harvard transforms into current students. A pioneer of projection mapping that turns still objects into interactive displays, Wodiczko illustrates how the juxtaposition of contemporary images on static memorial structures can be used to create modern community. "Monuments can be useful for the living," he says. "Sometimes it's safer and easier for people to tell the truth in public."

Fumio Nanjo, director of Mori Art Museum in Tokyo, believes art will be the key to problem-solving in the future because it's the only field without restrictions. "When one does art, there are no frameworks, no rules to which one must adhere," he says. He notes that by seeing the contorted figures in a Picasso or entire rooms covered

in polka dots by Japanese artist Yayoi Kusama, viewers, especially children, learn to think big and not let their dreams or plans be constrained by limits.

"The more we can create a society in which people address problems without allowing existing practices to restrict them, then the sooner we can create a truly innovative society," Nanjo says.

For instance, the artist Daan Roosegaarde, who is neither a city planner nor an engineer, has been working on a project to improve transportation infrastructure by developing photoluminescent paint for road markings that could eventually replace streetlights. "Precisely because artists such as Roosegaarde don't have specialist knowledge, they can approach a problem without any preconceived notions," Nanjo notes. "Where a specialist will be working from a position of understanding logistical or technical limitations, an artist will think only of ideals—what is the best solution? That is why real innovation can occur."

What real problems can we solve? For the world or our own corner of it? What difference can we make? From a new invention or program to a simple sign on our front lawn or a chalk drawing in the street, the possibilities are endless. Drop your preconceived notions about what solutions must look like and who problems-solvers are because the truth is, we are the ones who need to find the solutions, and we don't need to follow the rules. We don't have to be artistic or creative to be inspired. We just have to do it.

Exhibit

Despite our best efforts, for any number of reasons, things don't always turn out as we planned. Like this poor glazed donut captured below by photographer Tara Wray. Don't get me wrong, I'd eat this donut in a minute. But if you were the owner of the diner, what would you do with it? Throw it away? Offer it at a discount? Pretend it was never squished?

We can't ignore when things go awry, even if it's a project we poured our heart into. In this section, we'll take all the skills we've learned in the past sections and apply them to the problems that aren't as easily solvable—the outliers and aberrations, the contradictions and failed fixes. And we'll learn how to take what seems broken and make something better from it.

Quechee, VT, 2014 by Tara Wray.

Wray took her depression and channeled it into a wildly popular photography book, *Too Tired for Sunshine,* that inspired a larger initiative that uses creative expression to help those with mental illness. If I owned this donut, I'd print out this picture, mount it next to the dome, and charge double for the privilege of enjoying this now-famous dessert. The possibilities for problem-solving don't end when we're stymied . . . in fact, in many cases, they're just beginning.

Manage Contradictions

Tower to the People
by Eron, Italy, 2018.

Our modern lives are populated with people and organizations that challenge our sanity and our conscience with contradictory demands. Jeff Marsh told me about the struggle he and his coworkers face in a factory in Dearborn, Michigan: "One day, management decides they're going to really push safety. We have this big sign that says, 'This many days since an accident,' and they added bonuses and trophies for the shift that went the longest. The next day, they posted

flyers about incentives for which team worked the fastest, who got the most parts inspected off the line. I mean, which is it? Are we supposed to work as fast as possible or as carefully? You can't do it both ways."

That paradox (more quality and more efficiency) can be documented throughout the business world. Customer service centers are asked to keep call times low and customer satisfaction high. Corporations encourage employees to have a healthy work-life balance but also require year-over-year improvements in a number of performance metrics. Health-care companies struggle with hitting efficiency goals while simultaneously providing the level of total patient care that earns a facility high scores on the patient satisfaction surveys the hospitals rely on to attract new patients.

Most medical practices and hospitals are now owned by conglomerates, with just 17 percent of physicians in solo practice, according to the Physicians Foundation. Dr. Joan Reber, a triple-board-certified pediatrician, retired early because she could no longer take the pressure of corporate bosses asking her to see as many patients as possible.

"First our 'throughput,' as it's called, was set at twenty-five patients per day," Reber recalls. "That works out to ten to fifteen minutes per patient. Then we were told we needed to up it to thirty patients. It's not enough time to provide quality care. And on top of it, we were expected to have outstanding patient satisfaction scores. It was impossible."

Teachers, law enforcement agents, and even coffee shop workers routinely face the same incompatible, contradictory requirements.

Contradiction spills out into our personal lives as well, as daily we're bombarded with antithetical opinions and "facts." While *Vox* proclaimed that "America in 2018 is a bleak and hopeless hellscape of a country, one in which the banal horror of everyday life is marked intermittently by periods of senseless cruelty and violence," the *New York Times* published a piece rejoicing at "the very best year in the long history of humanity." Tribalism has polarized almost every issue in our country, demanding that people pick a side. Buffeted by hatred and discontent on the right and the left, people are abandoning the middle.

Problem-Solving with Suicide Prevention Teams

Michael Hempseed, who wrote me after he read my first book, *Visual Intelligence*, wondered if I'd ever considered applying my work to his field, suicide prevention. Mental health professionals, he said, are like anybody else—they get caught in their own intense bubbles and fail to communicate with people outside. Or, facing so much heartache and trauma on a regular basis, they minimize their own symptoms, which they feel they somehow should be able to bear. Tragically, because of simple miscalculations like this, lives can be lost. He told me that looking at works of art from so many different angles encouraged him to see the warning signs of suicide from a different perspective. This was an inspiring letter, and since I've never been shy about reaching out to people or organizations unfamiliar with my work, I emailed New York state's suicide prevention office, offering a free training session of The Art of Perception tailored for their specialists.

Gary, the director, was busy and scheduled a call with me that was weeks away. His office was fortunate to have excellent training sessions, he said in his email, and although he could envision how my program might be helpful, he didn't want to raise expectations that they would bring me in. I'd heard it all before. Like so many others presented with this unusual offer, he wasn't really sure an "art program" would be right for his team. The official response boiled down to "Thanks, but no thanks."

When we finally did speak by phone, I explained that although I am not a specialist in suicide prevention, I work across the professional spectrum, helping individuals step out of their routines by showing them works of art to broaden their vision and demonstrate what they might be missing. I told Gary that my experiences with hostage negotiators, social workers, and critical response teams would apply directly to clinicians in suicide prevention.

And then it got personal.

I said, "I've been stuck in traffic while negotiators tried to talk someone down off the GW Bridge. I have been there sweating with the crowd on the subway while transit workers remove the body of

someone who jumped onto the tracks. And I've been barred from entering my own apartment building while EMS workers removed the body of a resident who had ended it all in the bathroom." Even I could see, I told him, that each of these scenes presented drastically different scenarios, and individuals' choices in this realm speak volumes about their thoughts about death and dying.

Gary responded with silence.

He knew I'd been thinking a lot about this topic, especially how looking in a different way, starting with turning their focus for a moment to art, might be helpful when they returned to suicide. Of course, no two cases involving individuals are ever the same, and suicide and its victims are no exception. Still, Gary showed me he was thinking about the value of a shift in perspective when he started to tell me about cops, who, as he was sure I knew, are trained to observe. In 2019, he said, more cops died by suicide than were killed in the line of duty. (Blue H.E.L.P. reports 228 police suicides in 2019, the highest total yet, according to usatoday.com.) Although there were countless similarities among the cases, one of the most striking was that, almost across the board, there were few reports of symptoms before tragedy struck. Why was it, he wondered, that when it comes to observing their colleagues, cops' skills are so diminished or absent entirely. It's almost as if they have shut down. Why, he asked again, don't cops see the signs of suicide among their own?

When he asked that question, I had to tell Gary about nurses—another group that has a hard time extending to each other the care they routinely exercise in their jobs. I told him how senior nurses often bully younger colleagues, forgetting (or, worse, consciously choosing to avoid using) the compassion, kindness, and empathy that is part of their training. This so-called lateral violence causes great harm—not only to the younger nurses, but also to their patients. But classes in The Art of Perception had been helping to buck the trend in hospitals around the country. Maybe, just maybe, it could do the same to stem the rising tide of suicides among police officers.

At last, we had found common ground. Gary began actively imag-

ining with me how to implement this training. Soon, a new session was born for first responders and clinicians working in suicide prevention for law enforcement professionals.

Recognize the Contradiction(s)

Contradictions can be jarring, their glaring contrasts almost leering at us, daring us to make a move. Others, however, are more subtle and hard to pin down. For instance, the following photograph shows a reproduction of a painting from 1881. A local artist named Julio Anaya Cabanding decided that the piece, *View of the Port of Málaga* by Emilio Ocón y Rivas, which resides in the Museum of Fine Arts of Córdoba, was better suited to the actual port of Málaga, so he painted a remarkably faithful reproduction of it on a crumbling pier.

Once I adjusted to seeing the painting in its setting, I actually liked it: the piece is calm and unobtrusive, the color palettes match, even

Emilio Ocón y Rivas—View of the Port of Málaga by Julio Anaya Cabanding, Málaga, 2018.

the horizon in the painting aligns with nature. Where, then, is the contradiction?

To start, there's the contradiction of an ornately framed work of art outside of a museum. There's also contradiction in the fact that the painting shows an imagined representation of the ocean next to the real thing. There's contradiction in the port city having boats and signs of commerce only in the painting, not in real life. There might be dozens more, but we can't fully analyze anything until we first recognize and acknowledge that contradiction is at work, and is even part of the whole point of the artwork itself.

Simon Vouet—Time Defeated by Hope and Beauty by Julio Anaya Cabanding, 2017.

Take Your Temperature

When Cabanding chooses a famous painting and "relocates" it outside of a museum, he calls it a "pictorial intervention" because it's meant to stir up conversation and emotion. Take a look at the scene above showing another of his works. The painting is a reproduction of a

famous seventeenth-century work. The location is a highway underpass.

How does this photograph make you feel?

Are your feelings more positive or negative?

Whether we're bothered, amused, or inspired by the image, it does evoke some reaction. Perhaps you're stirred up by the contrast of the classical painting over the modern graffiti. (Interesting self-examination note: Does one "ruin" the other? Which one?) Or maybe you're just perturbed by all those weeds. It doesn't matter what you're thinking, as long as you note it.

When first confronted with a contradiction, figure out whether your feelings toward it are positive or negative, and then ask yourself why. In the same way that a pilot calculates a successful landing by measuring the glide slope as the plane approaches a runway, we need to know at what angle we're flying into a contradiction so we can successfully navigate it. Checking to see if we're coming from a place of positivity or negativity toward a problem can help us solve it. This simple exercise helps engage honest self-reflection so we can identify and overcome any biases, good or bad, we might hold toward the situation.

Once we know how we feel about it, we can begin to vocalize our thoughts.

Dig In to Describe

Before we can unravel a contradiction, we must be able to explain it to another person, preferably someone not present and without access to the information, since that would ensure that our description is clear and complete. Being able to explain the situation to someone else forces us to employ our best information gathering, processing,

and objectivity. It's the difference between reading a book for school with the chance that the teacher might not ask you about it and having to present that entire novel in front of the class. In the latter case, we become the expert. We need the comprehensiveness and confidence that comes with expertise if we are to effect change—especially when the problems, like this artwork in an underpass, can be thorny.

Take another, longer look at both photographs on pages 225 and 226 and list every contradiction you can find, as if you had to present them to your supervisor, titled "Boat Painting Contradictions" and "Highway Underpass Contradictions."

Having worked at the Frick Collection in New York City, I was instantly drawn to the contradiction here with the whole idea that art is usually seen in a museum, in a carefully crafted environment designed by curators in that museum. That led me to think about the contradiction between the way artists intended their work to be displayed and how it usually appears. I wondered how often the presentation choices made by the curator conflicted with the artists' messages. Cabanding seems to have been inspired by the same thing, as he has said he chose to bring masterpieces to "decrepit" locations on purpose: "These places are inhospitable, decadent, and inappropriate to receive such a valuable object. Opposite of what a museum is."

I also thought about the contradiction between the type of person who might see these works in the outside world versus the person who would view the originals in a museum. I then considered the inherent conflict of items synonymous with wealth—gilded framed paintings—on view in a desolate, destitute environment. Others have credited Cabanding with exposing the conflict between the democratic intention of art and the perceived elitist nature of the institutions that typically present it.

This is the level of detail and context we need to consider in our assessments if we want to overcome problems successfully. We cannot stop at "something isn't right" or "that painting doesn't belong there." While those sweeping observations might help us establish the structure of the problem, we aren't finished until we use a smaller brush

to fill in details. We must get closer to the issue and look at it from different angles.

Revisit the photographs on pages 225 and 226 and delve deeper to find even more contradictions. Look at the colors and sizes of each piece and their surroundings, the materials and subjects, the perspectives, positioning, even the time of day. Note your new findings.

I found the colors in both photographs to be complementary, the sizes to be contrasting. This detail made me wonder about the size of the original paintings, and if Cabanding had painted them to scale. At this stage, I'm just collecting and cataloging information; I don't have to seek an answer to every question, just note the discrepancies.

In doing so, I stumbled upon a fascinating detail. Did you see the shadow under each of Cabanding's works? It's harder to spot in the second photo, but in the first, the shadow cast by the golden-colored frame is very apparent against the rock. Go back and look if you missed it. The conflict lies in the direction of the shadow. The frame's shadow points straight downward at 90 degrees—unlike the angle of the shadow from the rocks on the right. Is this detail important? It might be, depending on the problem we're trying to solve. For instance, if we were called in to investigate the possibility of the paintings being stolen from museums, it would be a critical detail. The mismatch of the shadows shows a truth in the photograph that our eyes might not otherwise see: the paintings by Cabanding are not, in fact, painted on canvas, framed, and hung. The entire works are instead trompe l'oeil, a "trick of the eye," painted directly on the public surfaces—even the frames and the false shadows they cast. This fact changes the conversation, since the work now moves from art into the very definition of graffiti.

Go back to the first photograph in this section on page 221 and note three contradictions that you can see in it, before you read the next paragraph.

There are many contradictions: the beauty of sculpted flowers on an otherwise nondescript road; the shape of a raised fist, a symbol of rebellion, made from roses, a symbol of love; that one side of the tower is wildly ornate while the other is bare. Did you notice the shadow at

the bottom of the rose relief? And the fact that the sky is completely overcast? If you did, it's most likely because we were just talking about shadows on the last work. Their presence here, on a cloudy day, connotes the same information as the Cabanding pieces: this work isn't a sculpture at all, but rather another trompe l'oeil. It's a completely two-dimensional image spray-painted by graffiti artist Eron on a brick tower in Santarcangelo, Italy. Did you notice the columns on either side of the fist? Or the four hearts that adorn them? Also painted.

Eron created the work to celebrate "the strength of gentleness" and "the power of nonviolence"—both contradictions in and of themselves. Or are they? Can gentleness be seen as a strength rather than a weakness? Can nonviolence be powerful? Mahatma Gandhi, Martin Luther King Jr., and Cesar Chavez all inspired systemic social and political change by employing nonviolent resistance. Their restraint proved overpowering to the forces they were up against.

Engage Others

Whether the contradiction we're facing is in the workplace or the world at large, we need allies not only to help us parse the problem, but to defend us, or better yet, join us in the actions we take to rectify it.

All too often, we feel we must face problems alone. This may seem noble but is, in fact, unwise. Humans have been designed to solve problems together. We're social creatures. Not only is there strength in numbers, but statistically speaking, there is a greater chance of success when multiple people with unique perspectives and habits of thought are involved. The process of collaboration also helps when our brains get hijacked by hardwired physiological processes.

I'm not a scientist, but let me explain this phenomenon in more detail. I'm a firm believer in trying to understand how our brains work so we can overcome automatic and, often, involuntary processes that overtake us and can ultimately work against us and our judgment.

When confronted with a problem, especially a contradictory one—like *How could my Ivy League–educated friend have voted the way he did?* or *Why does my boss, who has four kids of her own, think we should work longer hours?*—our neurochemistry can take over our reactions. Our brains are wired to make a "chemical choice" about how to best protect us, which often means making sure we're on the "right" side, since being wrong comes with shame and a loss of power—unwelcome things from an evolutionary standpoint.

Situations of stress, as well as those of fear or distrust, cause the release of the hormone cortisol that shuts down our cortex, overriding our brain's advanced executive functions including strategic thought, trust building, and even compassion. The keys are handed to our amygdala, the part of our brain that operates on instinct alone, and we lose our ability to regulate our emotions or deal with any discrepancies between our expectations and reality. The intense, unconscious takeover by the amygdala makes it hard for us to think clearly. Instead, we are presented with one of four options: fight, flight, freeze, or appease. None of these will lead to a satisfactory solution, but sociologists believe the fight response, in which we can become overwhelmed with an adrenaline-fueled bout of anger or irrationality, is the most personally and professionally damaging—and, unfortunately, the most common.

Awareness of this neurochemical process can help us overcome it and replace it with another burst of hormones that feel even better. Oxytocin, released by the pituitary gland at the base of the brain, suppresses amygdala activity, reduces anxiety, and reopens the networks in our prefrontal cortex, allowing us to make more objective decisions. The hormone, also called the "love hormone," is activated by human connection.

Practice this by showing the two photographs on pages 225 and 226 to at least one other person. Ask them how they feel about the images and what contradictions they see. Then share your findings. Pay attention to and revel in any clarity and positivity you feel kicking around in your brain as a result.

After a talk I gave at the Rijksmuseum last year, a woman, who introduced herself as Yvette, asked to speak with me privately. She

told me that my presentation about using works of art to rethink communication and problem-solving gave her the greatest sense of relief. Relief? I asked. Why relief? Over coffee, she explained that from childhood on she has suffered from depression and anxiety and that the only time she felt completely at peace was in front of a work of art in a museum. It has an inexplicably calming effect on her. On school trips to museums as a child, she was always the last one to leave the gallery, and, as a teenager, whenever angst engulfed her, she would head to a museum to catch her breath. Although she has brought her manic episodes under control with medication, she still seeks out works of art to calm her raging thoughts. She believed she was the only one to do this in such desperate times, when others might seek medical assistance, but when she heard me say what a respite art had provided for me all these years, it validated her method of self-care. She still finds great solace in looking at art but now enjoys seeing it with others. Sharing the space in front of a painting expands the sense of comfort, and connection and words are purely optional. Yvette has since founded an organization in the Netherlands that uses art to help individuals suffering from depression and anxiety.

Getting others on board is critical for problem-solving, but as discussed in the first section, it is unusual for people to look beyond their small circle of people who share their perspective. We must also seek out and include the other side. This means bringing your boss, much-loathed coworker, or cousin who acts crazy on Facebook into the conversation, being direct about what you've discovered, and helping your opposition understand where you're coming from. If we purposefully seek common ground, we can do all that without baring our teeth or brandishing weapons.

Find Common Ground

Although initially we may be hard-pressed to think of anything we have in common with those on the other side of everything we value,

there is a simple exercise to get us moving in the right direction: provide some slack.

When ships are trying to catch the wind or slide into the dock, the tension in the ropes (called "stays" in sailing) wrapped around the vessel is essential to success. Lines that are too tight can cause the sails to stay flat, negatively affecting performance; they can snap, leading to injury at worst and useless equipment at best; they can also cause stress that can break the mast or crack the hull, destroying the structural integrity of the ship. Rigging needs to be loose enough to allow some freedom of movement.

In the same way, being too rigid in beliefs or approach brings additional tension to a problem—tension that can work against us or upend the entire operation. Go back to *The Raft of the Medusa* painting on page 1 and look at the ropes. Tellingly, the stays are taut; indeed, a snapped rope flails in the wind. The raft's passengers did not work together; instead, they turned on each other. Avoid a similar fate by giving others the same leniency we desire when we fall short of our or others' expectations. Just as we are sometimes overzealous, hypocritical, or out-and-out wrong, so can our friends, coworkers, and bosses be.

Psychologists call our tendency to instantly ascribe another's actions to a character flaw rather than simply a situational trigger, while simultaneously doing the opposite for ourselves, "fundamental attribution error." When someone cuts us off in traffic, we are quick to think it's because she is an inconsiderate jerk; when we do it, it's only because we're rushing home for a legitimate reason, like to care for a sick pet. The guy in the restaurant who's rude to the waiter is an inexcusable elitist snob, but when we bark at the barista for getting our coffee order wrong, it's only because we're overwhelmed on a really bad day.

This innate flaw in thinking is easily reversed once we recognize it. When you find yourself attaching an action to someone's *personality*, try to look for a *situation* that might have prompted it instead. Rather than settling on the idea that your boss supported the pension plan cuts because she is heartless, look for other reasons she might have conceded;

maybe she talked the board out of personnel cuts she can't discuss for confidentiality reasons; maybe she was dealing with a personal crisis at home and dropped the ball. Everyone succumbs to external pressures sometimes. Doing so doesn't automatically make anyone a bad person.

Instead of making assumptions, or accepting them from someone else, examine the situations around your "opponent." Ask questions to get a more complete picture of how they came to their opinion or decision. Offer to help rather than just criticize or judge.

Once the situation has been studied from a more objective perspective, common ground can usually be found through a query. What is your ideal outcome? What is theirs? What can you live with? What can they? What is something you both want?

You and your boss both want the company to be profitable. You and the school board both want successful students and dedicated teachers. You and almost everyone else in the world, with a few extreme exceptions, want to live in peace and prosperity. Instead of trying to gain ground on others, we should concentrate on increasing the total area of our common ground.

Finding common ground doesn't mean solving a problem completely. It simply moves us out of our concrete bunkers and toward a solution. Focusing on shared goals or principles also doesn't mean completely agreeing with the other side. Engaging in productive dialogue is not the same as endorsing someone else's beliefs; it's a strategic decision en route to an end goal. A study of negotiation found that those who brokered successful deals referred to areas of agreement with the other party three times more often than unsuccessful negotiators. We're more likely to come out of a situation feeling triumphant if we've gone in with a positive mindset looking for commonality.

We're also more likely to get the resolution we desire if we give the other side an out. Recognize that no one wants to lose face or leave a meeting feeling defeated. Plan to give your opponent an escape hatch, one that makes them feel comfortable conceding. A great illustration of finding common ground to see your way out of a problem is a series of portraits by the photographer Irving Penn entitled *Portraits in a Corner*. Penn invited famous subjects to pose between two converging

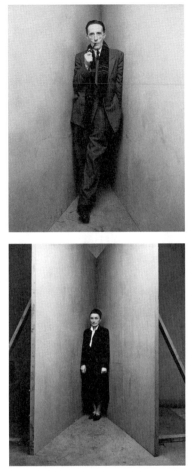

Marcel Duchamp by Irving Penn, New York, 1948.

Georgia O'Keeffe by Irving Penn, New York, 1948.

walls that formed a corner. Space was tight, but rather than complain about the confinement, the subjects found new ways to use the limited space not only to express themselves but also to help Penn create an extraordinary portrait.

Paula Carr, a blogger and mother of three, told me giving somebody an out was her biggest parenting secret. "Kids, at least my kids anyway, have a tendency to dig themselves into a hole. You scold them for not doing their homework and somehow the situation escalates into a full-blown war. Tempers flare, they say something disrespectful or mean, and instead of apologizing, they panic and double down." She shakes her head as if trying to erase the memory of a tantrum

gone wild. "I know lots of parents that stand by and watch their kids self-destruct," she continues, "or even throw them a shovel. What they need is a ladder!"

Carr explains that she gave all her children a phrase to use when they felt backed into a corner. "What seemed to work best was 'do-over.' They knew that they always had this magic word at their disposal. If they simply said, 'I need a do-over,' no matter what had transpired or where we were in the argument, my husband and I would drop everything, give them a hug, and let them press the reset button."

In all our relationships—personal, professional, and even political—we need to give the other side room to surrender. If they don't feel they have it, they might panic and jump off the edge, taking us and everyone around us down with them.

A Quick Descent into Hell

The abandoned passengers of the *Medusa* descended into murder, mayhem, and cannibalism surprisingly quickly—in fewer than two weeks. The cascade of bad decisions that landed them on the raft in the first place might have been stymied if the original problem with the captain's ignorance and abdication of duty had been addressed and resolved.

According to the detailed reports culled after the event, almost immediately upon setting sail, the crew noticed that Captain Hugues Duroy de Chaumareys did not seem to understand or adhere to the basics of sailing. In an effort to reach Senegal as soon as possible, he steered the frigate dangerously close to the shore. He also gave a random passenger, a philosopher called Richefort who'd spent the previous decade in prison, authority over the ship's navigation.

There is an inherent conflict (which turned into a fatal flaw) in the fact that the most highly ranked official on the ship, the person with explicit and undisputed power, with absolute authority over all souls

and cargo on board, had the least practical seafaring and leadership experience.

As many of us do when faced with conflict—perceive it as a result of bad decisions—the crew let their emotions rule them. Many officers argued openly with the captain, publicly questioning his skill. One called Richefort an "imposter" and was subsequently put in the brig by the captain. Eventually, the crew began whispering among themselves, lying to their captain, and withholding important information from him. This, along with the fact that his officers seemed to shun him from the moment he took command, drove de Chaumareys into the confidence of a stranger. The more his underlings disrespected him, the more he dug in his heels and relied on the advice of Richefort alone.

What if, instead of undermining their leader, ineffective as he was, the crew of the *Medusa* had used the five steps outlined above to address the underlying issues? They acknowledged the captain's inexperience to one another and to his face repeatedly, but their plan of action ended there. None of the other officers stepped forward to take charge.

What if they had met and noted their mood? Most likely they were not happy to be under the command of the poster boy of royal cronyism—especially those officers with more experience who deserved the promotion. Recognizing that they were predisposed to thinking about the captain in a negative light, they could have consciously worked to overcome those internal biases and keep them out of any decision-making.

What if they had taken the time to craft an approach to describe the issue to the captain without insulting him?

What if they had engaged other crew members and perhaps even passengers to see if anyone had been in a similar situation on another ship, asking what they did and what the outcome was? What if they had looked for common ground, like how they all wanted the ship to get to its destination as expediently and safely as possible? The captain might have been persuaded to change course farther away from the

shore if those speaking with him had offered him an out, a way to make the decision and still save face.

It's impossible to know how the situation might have turned out had different people with different communication styles been on the *Medusa*. We can't change the past, but we can do better in the future by actively practicing conflict negotiation skills.

Putting It into Practice

The ability to successfully work through contradiction isn't something most of us are born with; it comes with experience. So, let's practice, using the two photographs we've been studying in this section.

Say we're on the city council of the town where the works appeared, and we're responsible for quality-of-life decisions. Both works by Cabanding have been met with much public and media support, but graffiti—defined as unsanctioned writings or drawings made on public surfaces—is illegal in our town. The police chief has publicly threatened to arrest the artist and is asking us to remove and formally condemn his works.

How should we handle it? By using the five steps we've learned for tackling contradictions:

1. Recognize the Contradiction

2. Take Your Temperature

3. Dig In to Describe

4. Engage Others

5. Find Common Ground

First, we must recognize the contradictions at play. The work is well-liked, but it is unlawful. Even if we side with public opinion about the works, we have to abide by the city's laws. There is also a contradiction in the nature of the work, as it is a fine line that separates street art and graffiti. Random scribbles, threats, and vulgarity fall firmly into the latter camp, but even beautiful, artistic works are generally considered graffiti if they are executed on property without the explicit permission of the owner. The Cabanding works in question are not random or threatening or vulgar and seem to enhance the environment, but they were not commissioned.

Does that mean they should be removed no matter what value they hold?

Second, we should take our temperature. Let's assume for this exercise that we like Cabanding's message about the democratization of art and are strongly opposed to his being arrested. Our consideration could be biased if we think of people we know who could just as easily be reprimanded for skateboarding where they shouldn't or someone close to us who is passionate about freedom of expression. Bear in mind these personal experiences and make sure they don't cloud our objective judgment. We can be pro-artist, but still try to keep an open mind when speaking with those, like the police chief, who aren't. Speaking of the chief, we reflect on how much we personally don't like him and didn't support his appointment. He knows this. It's important to remember to set our feelings aside when meeting with him, and to know he's probably going to come in to the discussion predisposed to disagree.

Next, to dig in and describe the conflict, we could prepare a fact sheet for distribution to the press. Whether we use it or not, researching for it and writing our findings down will help us get a firm handle on the facts and force us to look at the situation from multiple angles. To do this, we should visit the two locations in person with a camera to document what we find and a means to record our observations. Our visit should not just be a drive-by; we should get out, walk around the artwork, and talk to anyone nearby.

Now we should engage others. We've already interviewed people in the artwork's proximity, but we can and should cast the net wider. We can talk to other members of the city council and other citizens as well. It might also be helpful to research where and how other municipalities have handled similar situations. A detailed internet search uncovers that some cities have indeed arrested artists for graffiti. There was pushback, however, when the artist was popular or well-known, with responses ranging from Change.org petitions to retaliatory graffiti attacks. None of those reactions strikes anyone as ideal for the community. In the case of celebrated pieces, some cities have decided to protect the works with plexiglass coverings or, ironically enough, graffiti-proof varnish. Other cities have invited graffiti artists indoors to showcase their works or commissioned them to work on other areas of the city after covering their original "crimes."

Armed with this information, we now need to seek common ground with the police chief. We know that he firmly believes graffiti leads to more crime. We suspect he also feels graffiti sends a message that the police aren't patrolling in a certain area. We might not agree, but we're also not police chiefs. As much as we dislike him, we must concede he has a tough job. We remind ourselves that our lives aren't on the line every day and that the success of our job doesn't hinge on graffiti as much as he believes his job does.

We also need to find an out for the chief. We don't want Cabanding arrested, but we don't want to make the chief look dishonest or incompetent for his public declaration to do so.

At our meeting with the chief, our distaste for practically everything about him instantly bubbles to the surface. We swallow it. We begin with a compliment and a positive attitude. We bring up how we both want the best for the city. We all want lower crime rates and for people to feel safe. We share the same frustration of budget cuts and not being able to fix certain blighted areas.

In speaking with the chief, we find he wants to make an example of Cabanding to discourage future taggers. We'd also like to capitalize on Cabanding's fame and discourage future vandalism and wonder aloud if there isn't a way to do so in which everyone wins. A way that

doesn't incite his supporters. A way that includes his willing participation. So far, Cabanding's work has brought the city positive press. Can we somehow keep it that way?

What if—we're just thinking out loud—we pay Cabanding for the existing works? Just a small amount, but doing so would make his works official. He did, after all, beautify some rather unsightly areas. In exchange, we get Cabanding to join us, perhaps in creating an urban art renewal project. We have him help us educate the public about why vandalism is anathema to the city and reiterate that it is a crime and will be prosecuted vigorously. At the same time, we can help direct the creative energy of people like Cabanding by designating certain public spaces—the empty canal, for instance—as public art zones. The police chief agrees, we dodge his hug, and head back to our office to tackle the next crisis.

I'd be willing to bet that at the beginning of this book you didn't believe that rethinking graffiti would help you learn so much about yourself and your ability to conquer contradiction. I knew, though, because I see it every day. I watch nurses and FBI agents, CEOs and customer service reps, light up as they discover their strengths, differences, vulnerabilities, and communication expertise. Art permits us to step outside of ourselves and turn a "what now?" into a "what else you got?"

Repair Mistakes with Gold

Kintsugi bowl.

I n 1443, Ashikaga Yoshimasa was only eight years old when his older
brother fell off a horse and died, making him the next *shōgun* of
Japan. Raised by a miserably cruel father, Yoshimasa had no taste for
war and was considered one of the country's worst military generals.

Instead, he was enamored with art and became a patron of every kind, filling his court with painters, poets, and dancers. He ushered in the Higashiyama culture of the fifteenth century, a golden age of Zen gardens, tatami mats, and tea ceremonies.

Tea had only recently been brought to Japan by traveling Buddhist monks. The *Camellia sinensis* plant did not grow easily in Japan (as it did in China), so tea powder was rare and reserved for nobility. Japanese leaders used tea in bonding rituals, and a unique, very formal ceremony for its preparation and consumption evolved. The traditions surrounding the tea ceremony placed much emphasis on praising and passing around delicate treasures like the small *tenmoku* bowls used to hold the tea. They were imported from China and were very precious, as Japan had not yet mastered the art of ceramics.

One day, according to legend, Yoshimasa accidentally dropped a teacup, and it shattered on the palace floor. It was the leader's favorite, so it was immediately sent to China for repair, but when it came back held together by metal stitches—the customary way Chinese masters repaired pottery—Yoshimasa was deeply unhappy. Some of his own artisans took the cup and attempted to fix it. They pried out the staples and glued the pieces back together using sap from the urushi tree, a very shiny, bondable, and toxic natural lacquer that Japanese Buddhist monks would drink for years to start a live mummification process that would end with the advanced monk being entombed in the lotus position. In this new and less macabre application, craftsmen painted gold dust over the glue while it was still wet; in doing so, the fractured lines were highlighted rather than concealed. Yoshimasa was delighted at the result and a new art form for correcting mistakes, *kintsugi*, was born.

Kintsugi, which is roughly translated as "to join with gold," is a philosophy of healing that many now embrace around the world. American artist Rachel Sussman gilded the concrete cracks in streets with gold filling to "draw attention to the wear and tear while reminding us that the space is more beautiful for having been lived in." Victor Solomon used the same technique on deteriorating basketball courts

in Los Angeles. Berlin-based artist Jan Vormann repairs crumbling architecture with colorful patches made from LEGO bricks.

Kintsugi Court by Victor Solomon.

Vormann encourages others to join him in "fixing the world in color" on his interactive website, Dispatchwork.Info, where projects from Kuala Lumpur to Cape Town have been documented. Polish outdoor artist NeSpoon fills rotting tree stumps and gaping potholes with delicate lace patterns. Barcelona-based artist Pejac transformed broken windows in an abandoned power plant in Croatia into a mosaic of flying birds. Tokyo artist Tomomi Kamoshita took the broken pieces of glass and ceramic she found when cleaning up her local beaches and, using the traditional golden *kintsugi* method, crafted them into unique chopstick rests she exhibited at an event supporting the Japan Earthquake Relief Fund.

In every case, the repair revitalized the object or space and resulted in a compelling new creation—perhaps even more beautiful than when it was new. Many call *kintsugi* "the art of precious scars."

Dispatch work, from the Venti Eventi in Bocchignano, Italy, by Jan Vormann, 2007.

Pejac, Camouflage Year: 2016.

It's an idea that many women today have embraced literally as they transform their C-section and mastectomy scars into elaborate tattoos, most of which don't hide the wound, but enhance it. I'm one of them. I recently got a tattoo of Ruth Bader Ginsburg's dissent collar to "close" my chemo port scar. It's my way to remember that we should always pursue justice no matter the obstacles. Others use their scars as the limbs of flowering tree branches, blossoming zippers, heartbeats on an EKG, bear tracks, and inspirational words ("Now I'm a Warrior" is one of my personal favorites). A new body positivity trend on social media is inspiring young women to paint their stretch marks with glitter. The message: imperfection is beauty.

Perhaps most important, *kintsugi* fixes without camouflaging. Each result owns its history of brokenness.

Own It

Problem-solving often doesn't stick because we don't include an acknowledgment of the problem itself in our solution. The best solutions recognize the failures of the past and address how they will make amends.

As Speaker of the House of Delegates for the American Association of Colleges of Pharmacy, Dr. Bradley Cannon knows the importance of correctly addressing mistakes because in his profession, they can be deadly. When we think of frontline health-care workers, we usually picture doctors and nurses, EMTs, and ambulance drivers, but not necessarily pharmacists, even though their job is one of the most critical, as they are the last health-care provider a patient sees.

One of the biggest problems that pharmacists face is adherence miscommunication. If a patient doesn't adhere to instructions about their medication, taking the right medicine at the right time in the right way, the outcome could be costly, in terms of both money and lives. This is especially true, Dr. Cannon tells me, in our age of global pandemics, the opioid crisis, and complicated modern medication regimens. Adherence communication involves the doctor and the patient, the doctor and the pharmacy, and the pharmacy and the customer—a lengthy chain that, like the schoolyard game of telephone, can easily break down. Over the years, Dr. Cannon has come to rely on three invaluable problem-solving phrases: "I don't know," "I was wrong," and "I need help."

If we are to make lasting changes, we cannot pretend the problem never existed, a mistake wasn't made, or something was never wrong. Seph Rodney, the art scholar who wrote about his unfortunate stay at the *Hopper Hotel Experience* we looked at on page 81, doesn't only turn his critical eye toward others; he publicly reflects on his own mistakes. After working for art and culture website *Hyperallergic* for four years, Rodney published an article ruminating on "what he may have gotten wrong and why," including not-so-small errors of omission, misattribution, and inattention. "I want to keep myself honest," he wrote in

the May 2020 article. "The truth is that I've sometimes missed the import of an artwork or an argument because I have my own blind spots and I can't predict when they will obscure my vision."

Rodney's editor in chief, Hrag Vartanian, invited other celebrated art historians to do the same, noting, "Sometimes recognizing our mistakes teaches us more than what we get right because they jostle us into questioning orthodoxies that may no longer be useful." Rodney says he now asks "better questions. And then I try to quiet myself and listen carefully for the answers."

Kintsugi reminds us that there is no deadline for healing or forgiveness. Some of our remedies will come at the last minute. It wasn't until after *The Raft of the Medusa* was hung on the wall at the Paris Salon that Géricault realized his human pyramid would be physically unstable in the real world, so he had it taken down and added two more full figures to the work on the spot. Some of our remedies will come much later.

It's Never Too Late to Fix Something

Things can be fixed now, four days from now, in four years, or in four decades. *Kintsugi* reminds us to keep going, keep trying to solve our thorniest problems, because it's never too late.

The first time the artist Faith Ringgold was called the n-word was at the Whitney Museum in New York. It was 1968, and she and a few other women had gathered outside with signs protesting an exhibit about American sculpture that didn't include a single Black artist. Two years later, they infiltrated the Whitney's annual sculpture invitational opening wearing red armbands with a placard that read "Women Now." They staged a peaceful, five-minute sit-in to demand equal representation for women artists in a museum that was founded by a woman. Stephen E. Weil, the museum's administrator, told the *New York Times* at the time, "We have been bending over backwards not to ignore requests from women." He noted that of the 103 exhibi-

tors, 22 were women sculptors, up from only 8 the previous year. One of them, Louise Bourgeois, wore a red armband to the black-tie event in solidarity.

Ringgold would not be appeased. She'd been raised surrounded by art and music during the Harlem Renaissance. In 1950, she'd enrolled in the City College of New York to major in art but was told women weren't allowed liberal arts degrees. She found a loophole, studying art history for a teaching degree, and became an artist anyway. Through the 1970s, Ringgold continued making art and protesting with and for it. After gallery owner Stephen Radich was arrested for showing Marc Morrel's art, which incorporated the American flag to protest the Vietnam War, Ringgold hosted a show of protest-themed flags. In 2007, Ringgold made her own: a painting resembling the Confederate flag with white words in place of stars that read "Hate Is a Sin." Around the image she inscribed her story of being disrespected outside the Whitney. ("I was passing out flyers about the Whitney's discrimination against Black artists when a white man told his daughter: Don't go near that NIGGER.")

Although Ringgold's work has been on display at the Museum of Modern Art and the Guggenheim—and decorates the walls of New York City and Los Angeles subway stations—the Whitney never bought anything. Until 2018. Exactly fifty years after her unsettling experience outside the museum, which took place in front of her daughters, Ringgold's "Hate Is a Sin" piece was purchased by the Whitney and included in its "Incomplete History of Protest" exhibit.

"I cannot cease to be amazed that the Whitney bought the print all these years later," she said. "And that they would tell that story."

Would it have been better had the Whitney reached out to Ringgold earlier, had not waited fifty years to invite her in? Of course. Too often, though, the weight of how much time has passed keeps us rooted in our wrongs. There is no statute of limitations on righting wrongs, and it is imperative to continue to try to work our way out of problems, even old, entrenched, embarrassing ones.

Use Everything

Kintsugi gives meaning to the broken and the burdensome. It teaches us that when something breaks, it isn't useless but can become even more useful. As we saw on page 121 with artist Jean Shin with her canopy of umbrella fabric and on page 122 with Amanda Schachter and Alexander Levi with their floating orb of discarded umbrella skeletons, trash can be turned into treasure. The Portuguese artist known as Bordalo II takes this concept one step further, drawing attention to our global waste problem by using garbage to construct giant murals of the animals threatened by it. Instead of just creating an image of a baby seal somewhere in the world, Bordalo II chooses specific sites to feature a local animal threatened by local debris, such as this elephant in Thailand. In doing so, the street artist provides a visual reminder about problem-solving: we have a responsibility to fix our own problems with our own resources, and not simply pass them along to someone else.

Increased focus on the threats of climate change has heightened scrutiny on conservation, and the disposal of trash has emerged as

Elephant by
Bordalo II, 2016.

a dire problem in need of immediate attention. For many citizens in industrialized countries, the environmental consequences of garbage aren't as apparent because their trash is shipped somewhere else. Every year, more than five million tons of waste—ten *billion* pounds— from places like the United States, Germany, and Japan are exported to Southeast Asia.

The average American produces 4.5 pounds of trash per day, far more than the global average of 1.6 pounds. For an average American family, that's 6,570 pounds of trash per year or the equivalent of twenty-one barrels. Per house, per year. Most of us in the industrialized world do not have to store our own garbage in our own backyard, but if we did, we'd be acutely more conscious of our consumption, especially if our children played around it, as many do in India. The mountain of trash in the Ghazipur landfill outside New Delhi, where children as young as four help their parents pick through scraps, is taller than the Taj Mahal.

Not every Western community ships their trash somewhere else. Some keep it and celebrate it as a point of civic pride.

Driving up I-75 into the heavily wooded suburbs of Michigan's Oakland County, you'll find the terrain quite flat. As the road curves past where the Palace, once home to the Detroit Pistons basketball team, used to stand, a single slope rises to the right. At 1,215 feet, it's taller than the local ski slope ten miles north. It's neither a small mountain nor a natural hill. It's the town's garbage dump.

"Landfill!" a resident corrects me.

The Eagle Valley Landfill doesn't look like any dump or landfill I've ever seen. It's covered in green grass and emits no foul odor, at least from nearby. The only giveaways are the dozen or so birds circling at the top and the bulldozers winding up dirt roads along its sides. I'm told it's grown twenty-five feet in height in the last twenty years. The local elementary schools take yearly field trips to it, and in 2011, then president Obama stopped by for a tour.

President Obama brought South Korean president Lee Myung-bak to visit the General Motors Orion Assembly plant next door to see how the facility was using captured methane gas from the landfill to power

its operations. The factory, where Chevrolet's Bolt electric vehicle is built, gets 66 percent of its electricity from gas captured and converted at the landfill, making it the eighth-largest user of green power generated on-site of all the US Environmental Protection Agency's (EPA) Green Power Partners. The landfill's gas conversion system also provides electricity for three thousand local homes.

The environmentally conscious solution to waste also helped the plant avoid an unforeseen economic catastrophe. The green energy initiatives—which eliminated the need for burning coal and save the GM Orion Assembly plant more than $1 million a year—helped spare the location from the widespread auto industry shutdowns in 2008. The plant is currently producing the company's first EUV, an electric-powered sport utility vehicle with an expected range of 259 miles and zero CO_2 emissions. Although both Orion and the Fort Wayne Assembly plants meet their electricity needs with gas from local landfills, General Motors is committed to keeping its facilities from contributing to them. The company currently has 142 landfill-free facilities around the world that produce zero waste by recycling, reusing, or converting any leftovers. This means everything from composting food waste to turning employees' plastic water bottles into noise-reducing engine insulation fabric.

"To us, waste is simply a resource out of place," says John Bradburn, GM's global waste reduction manager.

Using GM as a model, how can we rethink what others have overlooked or thrown away that we can repurpose to solve a problem?

Lewis Miller is one of the most sought-after floral artists in New York City. He creates colorful, natural fantasy-scapes for clients like Bulgari, Versace, and Bergdorf Goodman. After the gala or fashion show or board meeting, however, he was not satisfied dismantling and then redistributing the displays. Most were taken home by participants or donated to hospitals or charities, but Miller wanted to do more. He wanted to reuse the flowers to spread joy in a new, unexpected way that could reach thousands of people. So, he and his team began building displays in the middle of the night. His guerilla

Flower Flash
by Lewis Miller.

floristry beautified street corners, abandoned storefronts, and even trash cans.

The art of *kintsugi* allows us to reframe how we see our surroundings and resources, inspiring us to reuse, remake, and re-create.

Don't Be Afraid to Break Things

Finding the beauty in scars sometimes requires us to break things purposefully: expectations, traditions, the way it's always been done.

When classical figure sculptor Paige Bradley first moved to Manhattan in the early 2000s, she was startled by the reaction she got from curators and critics. Figurative art was over, they told her. As she noticed exhibitions in museums and galleries, it seemed they were right. Representational, realistic sculptures had all but disappeared.

Expansion by Paige Bradley, bronze with electricity.

She didn't want to adopt a new, more contemporary style just because it was popular. And she refused to quit creating and just start teaching, as many of her peers had. Instead, she took a wax sculpture of a woman meditating in the lotus position that she had worked on diligently for months . . . and dropped it.

"It shattered into so many pieces," she recalls. "My first feeling was, 'What have I done?'"

Bradley knew she had to somehow destroy what she'd made and the way she had been working to remake herself commercially and artistically. She had the pieces cast in bronze and then mounted so they were floating slightly apart. She then had to let go of her process and her ego and hired a lighting artist to help execute her vision of a statue that glowed from within. The result, *Expansion*, brought Bradley international recognition and acclaim. By breaking out of her dated mold, Bradley discovered a new creation that propelled her forward.

Troubleshooting

What if you can't find an answer at all? What if, after employing every artistic process in every section in this book, doing all the prep work, looking at the problem from every angle, you just can't see a single solution? There are a few creative maneuvers that can help you break through.

Time to Check Out

The immediacy and intensity of responsibilities, tasks, and projects take a toll on creativity, problem-solving skills, and even our ability to be empathetic. When it seems like the roadblock is insurmountable, when the dissenting opinions are bubbling up from our own minds, it's time to check out. Perhaps just for you, perhaps for everyone working on the problem. Regardless of any set deadline, we are humans. Humans who can be easily overextended and overwhelmed. Schedule a small break from the stress. It might just be the missing piece to your solution.

Scientific American published research on how the mental breaks used by successful artists and athletes—everything from naps and nature walks to meditation and mojitos with friends—increased their productivity, replenished their attention, and stoked their creativity.

Writer Tim Kreider notes, "The space and quiet that idleness provides is a necessary condition for standing back from life and seeing it whole, for making unexpected connections and waiting for the wild summer lightning strikes of inspiration—it is, paradoxically, necessary to getting any work done."

Just take a break. Not just from the problem you're pursuing, but from the relentless stream of problems and information overflowing from all manner of electronics. Consider a digital diet, if only for an hour, to give your mind a chance to be still. I read about a man who decided to join meditating monks in the mountains for a month. One full month with no phone, no laptop, no news. How will you know if something huge happens in the world? he asked. The monks assured him, if something huge happens, someone will tell us. Very little of the "news" we consume is of huge importance, but it's taking a huge

toll on our psyches. It's making us stressed and depressed, angry, confused, hopeless, lather, rinse, repeat. And we forget that it's a completely voluntary position. Kreider reminds us, "The present hysteria is not a necessary or inevitable condition of life."

I have a suggestion for what to do instead of "doom scrolling" on your phone, tablet, or watch: look at art. Anything and everything. A child's drawing, a billboard, the cover of a novel, the art at your local museum. Go where the crowds aren't. Looking at art, even the difficult pieces, can allow us to step outside of ourselves, see things from a new perspective, and maybe, just maybe, even open our eyes to find what we've been looking for.

Reverse the Problem

Try a notan study, as we learned on page 139, only this time, instead of looking at the pieces of the problem, sketch out its opposite. If you can't figure how to increase sales, try finding a strategy for decreasing sales. Then do the opposite. Don't know how to motivate your customer service reps? How would you demotivate them? Can't get your kids to understand respect? How would you teach them about disrespect?

It seems counterintuitive to turn a problem inside out, but viewing it from the opposite direction can help uncover the obvious answer that is sometimes, frustratingly, otherwise obscured.

In World War II, the Royal Air Force (RAF) tried to counter the problem of losing so many of their aircraft to German antiaircraft guns by adding extra armor to the most embattled places on the planes. When the planes would return, riddled with bullet holes, the engineers would study the places on the fuselage that were most damaged. A pattern quickly became clear, as heavy-bomber Halifax and Lancaster planes touched down after missions with gaping holes in their sides, tails half blown off, and craters in their wings. Reinforcements were added to the areas that were most often hit, but it didn't help. The number of planes returning decreased rather than increased. Why?

A mathematician had the answer. Hungarian-born Abraham Wald, who'd been brought in to help improve the odds, pointed out that ev-

eryone was looking at the problem backward. Planes that came back with giant holes in their fuselage, wings, and tails *came back*. It was the ones that didn't that were failing. Statistically, planes should be hit by bullets all over. Where were the planes that had shattered cockpit screens or blown-out nose cones or several propellers? Not back on base. Planes that were hit in those areas went down. Wald pointed out that instead of studying where the bullets had hit the returning planes—since that damage didn't stop the planes from flying home— they should study where the bullets luckily *hadn't* hit and increase protection in those areas. It worked.

If you're stymied, try turning the problem on its head. Instead of figuring out what would make your team win, everyone happy, and costs go down, find out what would make your team lose, everyone miserable, and costs go up. While it may sound counterintuitive to analyze what isn't there, you'd be surprised how often this simple mirroring can reflect an answer that had previously eluded you.

Find an Opposite Fix

Sometimes we're stuck because what we've determined would be a perfect solution is unattainable. The crisis would be over if we had five extra employees, but the budget won't allow for any new hires. We could serve more customers in the coffee shop if we had more tables, but there's no room. Instead of hitting a wall, make a window.

Brazilian visual artist Tatiane Freitas fixes old wooden chairs. She doesn't use old or new wood, however. Instead, she patches them with modern, translucent acrylic. The repair materials are opposite in every way: they are harder, colorless, transparent, and smoother. They are alike in the most important way: they provide functionality. If she held out for the perfect wooden complement, the chair would not be usable. Instead, Freitas drops the idea of a perfect fix and focuses, instead, on a workable one. The result is perhaps even better this way, as the chair is now art and a conversation starter.

When the Frick Collection in New York City had to close for long-overdue renovations in 2020, there was no decisive plan about how

My Old New Chair by
Tatiane Freitas, 2010,
acrylic and wood.

or even whether to stay open during the construction. The Frick is be-
loved and unique among museums in New York City, so the loss of ac-
cess was a grim prospect to native New Yorkers and tourists alike. And
for the museum, the lost revenue was no small consideration. Anyone
familiar with the masterpieces there knows that the former mansion of
Henry Clay Frick—which houses the museum—is integral to the expe-
rience of visiting the collection. The atmosphere—with its gilded stair-
case, sumptuous rugs, and indoor courtyards—is almost as grand as the
works of art themselves. So, the question was: Could visitors somehow
experience the Frick Collection anyplace but its original home?

For decades, the Upper East Side has been home to many of New
York's most famous museums. In 2015, when the Whitney Museum of
American Art reopened downtown, leaving its longtime uptown lo-
cation in the iconic Breuer building, the Metropolitan Museum of Art
seized upon the vacancy, purchased the building, and used the space as
a venue for its modern and contemporary exhibitions. That expensive
gamble didn't pay off in visitors or revenue, and after the pandemic
the Met decided not to reopen the space. At the same time, the Frick
received approval to expand the historic mansion on East 70th Street.
The two museums—the Met, with all that pricey real estate, and the
Frick, with no place to show its spectacular art—solved two problems

at once, when they hatched the plan to relocate the Frick to the Breuer building until the renovations were complete. The Frick gets a whole new spread and the Met saves tens of millions of dollars.

Is the relocation of the Frick to the Breuer building a perfect solution? Not by a long shot. Does the conspicuous absence of the Frick's domestic atmosphere dilute the experience of viewing the founder's collections? Perhaps. But as we have seen throughout this book, art is compelling and can fix so many problems for which solutions seem unattainable. The Frick's magnificent collections now stand on their own, in a new light, surrounded by fresh air in a decidedly modern atmosphere. Some like the new digs and others don't, but this is not a permanent solution and, more important, the new installation affords thousands of art lovers uninterrupted access to one of the greatest art collections in the world. Problem solved. If your original solution stopped working, look for its opposite.

Make a Tower of Blue Horses

In 1914, German artist Franz Marc, a member of an avant-garde modern-art movement called Der Blaue Reiter (The Blue Rider), was drafted as a cavalryman into World War I. Recognizing his artistic talent, the Imperial German Army began using him for military camouflaging. He wrote to his wife that he enjoyed painting the canvases that would hide artillery from aircraft with styles that paid homage to his friends "from Manet to Kandinsky." In 1916, the German Army began identifying notable artists who were serving and removed them from combat for their safety. Marc was listed, but before the reassignment order reached him, he was killed by a shell during the Battle of Verdun.

After his death, the Berlin National Gallery acquired a large-scale painting Marc had completed in 1913, *The Tower of Blue Horses*, which featured four "almost life-sized" vibrant blue horses in a dreamy landscape. It became a national icon and was widely reproduced on books, postcards, and posters. In 1937, however, it fell into disfavor with the Nazis, who labeled Marc, along with many of his contemporary colleagues, a "degenerate artist." *The Tower of Blue Horses* was removed from the museum and placed into the "care" of Hermann Göring, the

The Tower of Blue Horses
by Franz Marc, 1913, oil on canvas.
(Lost since 1945.)

notorious president of the Reichstag. Although eyewitnesses claimed to have seen the painting over the years, and theories abound regarding what happened to it—*it was destroyed in a bombing, it was lost in a youth hostel, it was transferred to a Swiss bank vault*—it was lost to the public and has not been seen since.

A few years ago, I was in Munich and stumbled upon the exhibition *Missing: Franz Marc's The Tower of Blue Horses*. The Staatliche Graphische Sammlung (National Graphic Arts Collection) along with the Haus am Waldsee in Berlin had invited twenty contemporary artists to commemorate the probable loss of the icon but also to create a whole new body of work that celebrates the painting and, hopefully, renews interest in the search for it. The reimaginings ranged from paintings and sculptures to photography and literature. The results were stunning, as was the fact that something monumental was created by many different people with the *absence* of something as the inspiration. The creators of the exhibition tried to "solve" the mystery by unlocking the creativity of others to explore ideas that the original investigators might have missed.

Embracing the Unfixable

One reason the philosophy of *kintsugi* originated and flourished in Japan was because it aligned closely with another popular school of thought: wabi-sabi. Originating in Taoism and Chinese Zen Buddhism as an appreciation for a humble lifestyle, wabi-sabi spread across Japan with the popularity of the tea ceremony. According to legend, a young man named Sen no Rikyū sought to learn the secrets of a famous tea master, who instructed him to clean a garden to perfection. When he was done, the plot was flawless, free of weeds and leaves, raked beautifully, with not a blade of grass out of place. Before Rikyū fetched the master for approval, though, he reached out and shook the branch of a flowering tree, sending petals flying. This is the essence of wabi-sabi: that we shouldn't even strive for perfection because in our changeable, inconstant world, it doesn't exist. Instead, wabi-sabi says to embrace the imperfect, the impermanent, and the incomplete.

Even the unfixable.

Some complex problems refuse remedy. There are certain things we cannot replace. Time cannot be reversed. Wrongs cannot always be righted. In these instances, we turn again to the art world for the lesson of embracing the unfinished.

The Winged Victory of Samothrace sculpture in the Louvre is no less extraordinary without a head. The grace of motion and the depiction of flight are compelling to viewers even with the conspicuous absence of its head, which has never been found. The sculpture remains iconic and has inspired so many reproductions in spite of its imperfection.

This isn't about lowering our own expectations; it's about shifting them. Striving for perfection, or even completion, can set us up for failure and disappointment. We demand black and white, but the world isn't binary. Instead, we must learn how to embrace the gray when we need to.

Perhaps we didn't solve an issue, but we made progress toward its resolution, filled in gaps, and raised awareness. These might be the

Winged Victory of
Samothrace,
3rd–2nd centuries
BCE.

very things someone else needs to fix it. If you applied the principles of
wabi-sabi to most complex problems, the realization that they might
not be solvable—at least right now—is enough to keep going.

Artists have approached intractable problems that don't seem to
have an easy resolution in the hope of casting light on a particular is-
sue to motivate others to find solutions. In 2016, Ai Weiwei, discussed
on page 197, wrapped the stately columns of the Berlin Konzerthaus
with fourteen thousand brightly colored life vests, all salvaged from
refugees who tried to cross the Mediterranean Sea into Europe. Wei-
wei himself was a child refugee, forced to live in camps that he says
"robbed" him of his humanity. In 2017, he released a documentary
about the global refugee crisis, *Human Flow*, and another, *The Rest*,
in 2019. Weiwei's life jackets installation and movies didn't solve the

refugee crisis, but they kept the issue in the limelight, ensuring that they wouldn't be ignored.

In 2015, prior to so many world-changing events occurring later in the decade, leadership expert Margie Warrell wrote that in "our fast-changing, unpredictable and accelerated workplace and world . . . it is impossible to chart a certain path through uncertain waters." She called embracing uncertainty "critical" to success.

We can embrace uncertainty as a cauldron of creativity. Théodore Géricault wrote, "The truly gifted individual does not fear obstacles, because he knows that he can surmount them; indeed they often are an additional asset; the fever they are able to excite in his soul is not lost; it even often becomes the cause of the most astonishing productions." At best, it might ignite our imagination and lead us, or others, to a solution. At worst, there is a great consolation prize: resilience.

Rejoice in Your Resilience

There's an old saying: "Experience is what you get when you didn't get what you want." Mistakes, hardships, and failures build resilience, which becomes a keenly sharpened arrow in the problem-solving quiver.

The artist Chuck Close created art for more than sixty years and knew quite a bit about resilience. In 1988, at the age of forty-eight, he suffered a spinal stroke and was instantly paralyzed. It didn't stop him. In the hospital, he told friends if he could never move more than his head, he'd still work with a brush in his teeth and spit paint on the canvas. With years of therapy, Close was able to regain some movement in his arms and transition to a wheelchair. In the last years of his life, he also ate with a fork strapped to his hand and painted with a brush strapped to his wrist.

When I was writing my first book, *Visual Intelligence*, in 2014, life was pretty perfect. My business was booming, my son was thriving,

and I was doing work I truly loved all over the world. Then, following a routine doctor visit, I was diagnosed with early but aggressive cancer. Disbelief turned quickly to resolve because there really was no choice. There was work to be done, a son to raise, bills to pay, and dying simply was not an option, which is exactly what I told my oncologist. She replied confidently, "We'll treat you aggressively, but you will be fine." Five surgeries, sixteen sessions of chemotherapy, nine months of baldness, and five sessions of radiation later, I am better than I was before.

Gratitude for survival has imbued my daily problem-solving abilities with a determination that did not exist before. That tenacity cannot make everything perfect, but as I tell my son, repeatedly and unequivocally, if no one is dying, we can fix the problem at hand.

I worked throughout my illness and treatment and wear my scars proudly as a reminder of my own *kintsugi*. Surviving cancer and all its associated side effects was no picnic, but it equipped me with so many more brushes and a much more vivid palette to paint over, camouflage, and even incorporate the missteps and imperfections into the bigger picture.

In retrospect, I believe that it was resilience that saved my life and sanity.

Both *kintsugi* and wabi-sabi are visual illustrations of resilience, reminders that hope can bloom even when the branch is broken. When we realize that the traumatic, the negative, and even the unsolvable offer the gift of resilience, they are no longer unwelcome events. In trying to make sense of his experiences in Nazi concentration camps during World War II, Viktor Frankl wrote, "In some ways suffering ceases to be suffering at the moment it finds a meaning."

Embracing the Unfamiliar (Part Three)

My problem trying to settle on the right approach to help this shadowy government agency I was calling Cyclone was turning into one

of the toughest challenges I'd faced since I started talking about art and problem-solving. I wondered if I'd reached the limit of what I could take on, using only art and the open-ended questions it provokes. Then I realized that my problems figuring out what to do with them were a mirror of the critical issues they faced in the field (thankfully without the risk of catastrophic loss of life!). For me, too, there were more unknowns than knowns, and I had to learn to operate in that environment—and to project confidence in the process, just as they do.

With every new group I meet, I try to remind them that we all have two ears and one mouth for a reason, and we should use them proportionally. Now it was time for me to take my own advice. I replayed Caroline's conversation in my head and the word that came up most often was "unfamiliar": unfamiliar environments, unfamiliar actors, unfamiliar terrain, unfamiliar sounds, and unfamiliar cultural behaviors. Coming in a close second and third behind "unfamiliar" were "communication" and "extreme." Each of those is a broad topic, but they're all favorite subjects for artists, whether they're working in abstract or representational styles. I like to minimize the art-world jargon and try to adapt my language to what I know of my audience. Here was my key.

From other sessions I'd had with law enforcement and Department of Defense groups, I thought we should begin by thinking of art as data. What tools do they already use that could help them deal with this new set of unfamiliar inputs? Next, I wanted to help them establish their sense of visual acuity—asking them about details they would consider relevant, and how they would communicate their judgments to others on their team. I decided to start with representational art and immediately follow up with more challenging abstract works that would throw them into assessments outside their normal frame of reference. One approach that consistently provokes new strategies: pairing art objects (photographs, paintings, sculptures, installations) with no apparent narrative or visual connection between them and asking them to look for patterns in both form and narrative. I cut my choices down to twenty slides, called my contact, and asked to do a run-through with her of my curated images to verify that 1) I included

the critical issues and 2) I was on the track that she'd envisioned for the presentation when she first called. Green light on the dry run and the first presentation was scheduled.

During the dry run, I picked up two new bits of intel, both unrelated to the narrative of the presentation, that would help fine-tune my approach. First, I could not add to the team's plate, which was full enough. Whatever skills I wanted to introduce or challenges I planned to place in front of them, they had to become automatic before they left the class. I could reinforce new concepts with indelible visual images, so they could be recalled readily, but I couldn't leave them with loose ends or a sense of incompletion. Second, I had to make sure that new concepts and skills were connected to situational awareness. In highly changeable environments, it helps for them to share a memorable visual reference, one that gives them a shorthand they can use to communicate with other team members. Once I knew I had to fit everything into one of these two categories, selecting the right images became much easier.

I'm not usually nervous before my sessions, but when the morning came to face Cyclone, I had butterflies in my stomach. I knew the sequence of images I'd planned inside out, but communication is a two-way street. It's not only what you have to say; you have to pay attention to how your message is being heard. Three hours and two hundred slides later, I exhaled. While Zoom obscures full body language, I could still see each face focusing intently on each of the images. I didn't permit them to take notes, hoping they'd have a sharper recall if they were fully engaged with the works of art. After all, I was pretty sure they weren't taking notes on their missions. In our collective debrief, each member of the team offered his or her top takeaways, and to my delight and relief, their interpretations matched the ideas I'd laid out in my initial sketch for Caroline, who was visibly pleased with the team's interaction and participation. Later that day, she called me back to schedule more sessions and add new issues to take on.

I had a debrief with myself to check on my own expectations and to assess whether I'd realized my self-imposed goals. My presentation

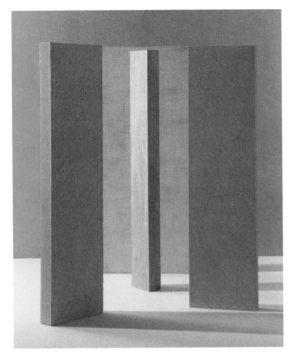

Built Work #17
by Erin O'Keefe, 2018.

was not a perfect solution to my own problem or theirs, but given their positive response, I trusted that with each iteration of the program, I'd grow more attuned to immediate reactions, helping me see how they were internalizing my points. At the conclusion of the first session, each participant told me that they found my emphasis on the necessity of self-perception *and* self-assessment valuable.

The artworks in their third session are designed to fool with perception, present a visual conundrum, and do their best to distract. Erin O'Keefe's photographs, which are easily mistaken for paintings, force viewers to examine assumptions about situational awareness—a paramount consideration for the Cyclone team. O'Keefe creates sculptures and then she places these creations in front or behind painted boards in precise positions, and then photographs the entire arrangement. When her setup is viewed in a single glance, or more specifically, from a carefully choreographed camera angle, the viewer is tricked into thinking that they're seeing a two-dimensional painting. The setup is painstaking, but not quite exact—on purpose. The clues

*Four Bicycles
(There Is Always One
Direction)* by Gabriel
Orozco, 1994.

she has planted are more precise than people are used to. Whenever
the setup (the entire premise, in a sense, of her work) is revealed to
viewers, they have to reorient themselves to the photograph and re-
consider it with new information.

The artist Gabriel Orozco creates a contradiction, and in some ways
a portrait of a place, in his sculptural installation *Four Bicycles (There Is
Always One Direction)*. In the piece, five or six bicycles appear together,
all balanced on a single kickstand. They seem to be perfectly, albeit pre-
cariously, dependent on each other. One gust of wind, the slightest jig-
gle on one set of handlebars, and the whole structure could topple. The
single structure seems to contain motion, stillness, internal harmony,
and the potential for sudden chaos at the same time. Orozco made the
work just days before the opening of his show, after arriving in Am-
sterdam (where of course bikes are everywhere) with no plan ahead of
time. Cyclone teams also dispatch to unfamiliar settings under severe
time constraints and must adapt in a hurry. I included this piece to pro-
voke a new take on the timely responsiveness that they prize.

Finally, the work of Mary Weatherford warrants inclusion because
her paintings are just so big, you have to focus on them deliberately.

Blue Cut Fire by
Mary Weatherford,
2017.

Her brushstrokes are broad, the colors intense, and there's even marble dust in the ground to create more texture and luminosity on the canvas. But it is her use of neon that punctuates the paintings and sets her work apart. Does it distract or accentuate aspects of the work? Does it help viewers focus on the elements of the whole or does it capture the gaze entirely? The reflections of the neon on the walls, the surface of the painting, and the floor are also elements of its situation and should be included in discussion. Each of these works focuses on deceptive or complex form with interpretation relegated to secondary importance.

I enjoy gnawing on the problems presented by Cyclone as our dialogue progresses. However, as I choose to fine-tune my work to help them, the overarching goal is to augment perception and human performance. Although they are an elite squad, chosen from the best to perform in uniquely challenging settings, I'm trying to present them with familiar problems—sharpening their visual acuity in a series of unusual, complex, or destabilized settings—so they can test themselves and, almost without recognizing it, improve their performance on the outer limits of their comfort and knowledge.

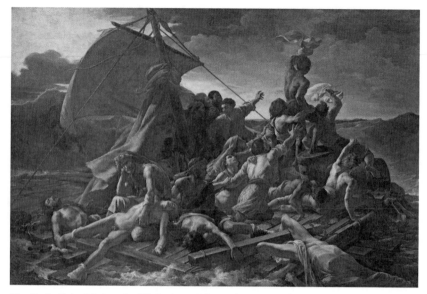

The Raft of the Medusa by Théodore Géricault, 1819, oil on canvas.

I'd like to return now to the place where we started: on the raft in turbulent water.

Upon seeing Géricault's painting, French historian Jules Michelet declared, "Our whole society is aboard the raft of the *Medusa*." It seems truer now than ever. We're all, in some respects, on the raft. With a ragged crew of people both achingly similar to and vastly different from ourselves.

As I did on the very first page (page 1), I'm going to ask you to look at the painting again.

How has it changed? How has your interpretation of it changed? When you first saw it, did you notice the wave menacing to the left, about to crash over the raft? Did you see the tiny speck of salvation on the horizon to the right? Which seems more important now?

If you had to choose one person to represent you on the raft, who would it be? Has that person changed from the first time you saw the painting?

Has your overall feeling toward the image changed? Toward the people on the raft?

Part of the magic of art is that it's never the same twice. Every time we look at a work, we can see something different, see it differently, and, ultimately, see ourselves changing with it.

When I selected this piece to represent the process of problem-solving, I'll admit, I was drawn to the complexity and carnage of it, as that's how problems can seem—huge, horrible, and messy. I could easily relate to the feelings of despair and desperation as I watched what felt like our world on fire. After delving into the mind and the process of the artist, though, I see it differently. It's no longer just a seething mass of chaos; it now represents hope. The entire painting seems to have shifted to highlight the figure hoisted up on others' shoulders, waving hopefully toward the future.

It's still a perfect metaphor, not just for problems, but for problem-*solving*, as it highlights the answer: when in doubt, we must default to our humanity. Because when we support each other, and lift each other up as high as we can, we're all rescued.

Géricault faced monumental hurdles in his journey to paint *The Raft of the Medusa*. The tragic subject, scale of the painting, gathering of materials, and risk of offending the king all were obstacles he overcame to produce what many consider to be the defining work of French Romantic painting. But it was so much more.

Géricault's masterpiece laid the groundwork for Romantic painting—with all its emotion, gore, and passion—to be widely accepted in the decades after the *Raft* was first seen at the Salon in 1819. Géricault's contemporary and one of his models for a figure on the raft, Eugène Delacroix, caused a similar stir at the Salon of 1830 with his painting *Liberty Leading the People, 1830*. Delacroix's entry received a mixed reception when shown, even as it basked in the light of the *Raft*, which had been acquired by the Louvre just six years before and was finally recognized to be the masterpiece it is. Still, questions about (and contradictions within) Delacroix's work abounded. Who was the bare-breasted woman, her face in profile, charging into view? Smoke and the crowd follow her as she, waving the tricolor, strides forward over bodies and barricades—leading the masses, although she is not of them. Larger than life with a body that echoes a winged Greek

sculpture, Liberty wears a Phrygian cap, a working-class symbol of freedom. She is an amalgam of allegory and revolution. Her profile reflects classical sculpture, but her body is dirty, her armpits are hairy, and her arms are those of a muscled gladiator. These paradoxes notwithstanding, she symbolized France, filling viewers with hope that she would lead the people to establish a republic.

Those hopes were dashed. By 1865, France was still a deeply divided nation, still holding on to the same antagonism that brought on their revolution more than half a century before. On one side were those who backed the repressive monarchy; on the other, those who supported Enlightenment ideals, grounded in a constitutional government advocating tolerance and progress toward a better future. Seeking to inspire the French to align with these ideals, the abolitionist and political thinker Edouard de Laboulaye proposed building a monument as a gift to the United States to commemorate the centennial of its democracy, selecting Frédéric-Auguste Bartholdi as its sculptor. Neither man wanted the monument to represent the turmoil of revolution but preferred a subject that harked back to a neoclassicist aesthetic devoid of frivolity and ornamentation. Numerous logistical, financial, and political obstacles took years to overcome; but finally, in 1886, more than fifty years after Delacroix's painting of Liberty debuted at the Salon in Paris, France officially presented Bartholdi's sculpture, its spiritual offspring, Liberty Enlightening the World, to the United States. The monument was installed on Bedloe's Island in New York Harbor.

At 151 feet tall with a torch in her right hand and broken shackles at her feet, the sculptural figure of Liberty, unlike Delacroix's painted version, is stoic and stands straight, her light held aloft. An iconic symbol of democracy, she also is a poignant vision of freedom for those fleeing persecution. Although neither Bartholdi's nor Delacroix's Liberty depicts a specific person, the similarities in representation underscored the two countries' shared reverence for democracy. Battles for freedom were hard-won on both sides of the Atlantic, but as we know all too well, the struggles persist, and governments still grapple with untenable solutions.

Although the existing canon is shifting as diversity in art history manifests itself, Géricault's *Raft of the Medusa* and Delacroix's *Liberty Leading the People* still hold an indisputable place within it. But the influence of Géricault, whose work was an instrument of change, has far surpassed the confines of the canon—and even those of French art—as we can see in the contemporary work of Ethiopian American artist Julie Mehretu. Her most recent works, as seen in her mid-career retrospective at the Whitney Museum of American Art, force viewers to confront big issues head-on: the chaotic rhythms of war, the inhumanity of genocide, and the destructive paths of climate change. Underlying the dynamism and obsessive detail of her work are social forces too forthright to ignore, making it almost impossible to see her art as purely painterly. More than monumental in their scale, Mehretu's works display her spectacular command of the distinct media she uses to communicate her message—a message she hopes, ultimately, will inspire social change.

In this exhibition, a single work of art hangs in the last gallery, a fifth-floor space outfitted with floor-to-ceiling windows that accentuate dazzling light and offer an unobstructed view of the Hudson River. At this point, Mehretu's works are highly sought after, and prohibitively expensive to all but the most deep-pocketed collectors and institutions, and no lenders to the exhibition wanted their painting installed here for fear that the light, albeit spectacular, would damage the work's surface. So, Mehretu solved this problem herself, by creating a painting just for this space. Entitled *Ghosthymn (After the Raft)*, the gallery's sole painting pays homage to Géricault's *The Raft of the Medusa*.

The painting's scale—twelve feet by fifteen feet—is immense, and as the exhibition's curator noted, in relation to Géricault's *Raft*, Mehretu "imagines turning the history in th[at] painting upside down." As the artist further explains, "Instead of the destitute of Europe trying to go to the colonies to further their lives in a colonial project, you have the reversal."

To create the underpainting, she cut up blurred photographs of anti-immigration rallies from the United States, United Kingdom,

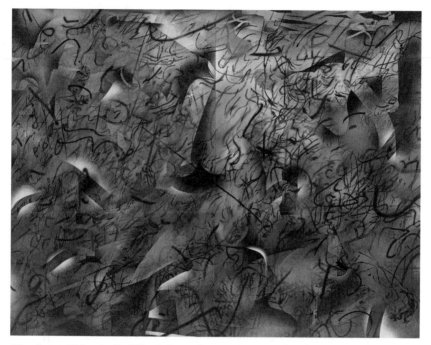

Ghosthymn (After the Raft) by Julie Mehretu, 2019–2021, ink and acrylic on canvas.

and Germany. By focusing on the plight of immigrants and the difficulties they faced fleeing persecution, Mehretu shifts the *Medusa's* narrative. Although completely abstract, the work re-creates the pyramidal structure of Géricault's raft while the upward motion of the brushstrokes and ink echoes the undulating waves of the turbulent waters. In the upper-right-hand corner of her painting, Mehretu positioned the smallest patch of green to suggest the horizon, the place where hope could be seen in Géricault's original, in the form of the rescue ship.

Like most problems, *Ghosthymn* is multilayered. Mehretu not only had to fill the final gallery with a work befitting a coda but also had to address the difficult conditions of the room itself. By recalling a work of art that exposed racial and political turmoil scandalously, Mehretu paid tribute to Géricault's vision and emulated his desire to institute social change. Rather than minimizing the light from the windows,

she incorporated it, and the outward view, all to underscore connectivity to the painting's subject.

Upon entering the gallery, even before they realize a painting hangs behind them, viewers are captivated by the Hudson's sparkling waters. From the windows, they can glimpse the Statue of Liberty, her arm raised, torch aloft, still, to welcome newcomers to New York City. Mehretu's *Ghosthymn* is an abstract visual statement, encompassing the potential and the plight of individuals and families willing to uproot their lives for opportunity and freedom. The painting not only solves the problem of ending her exhibition with an emphatic work that captures its own sense of place, but, in the spirit of her predecessors, also creates, as Mehretu herself notes, "space for possibility and for invention."

In one very real sense, Mehretu has solved her immediate problem. But in a more profound and lasting one, she is contributing in the best way she knows to solving a problem that artists have been con-

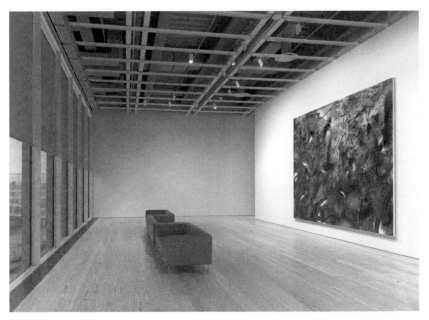

Ghosthymn (After the Raft) by Julie Mehretu, 2019-2021, Installation view at the Whitney Museum of American Art, New York, 2021.

fronting for centuries. We have come full circle, along with her, from Géricault's depiction of the French frigate sailing to Africa to colonize a nation to Mehretu's call to action. In each of these attempts to address a contemporary injustice, artists have used the most compelling visual means at hand to focus the attention of the world on a crisis and to inspire us, the viewers, to find the best solutions with them.

Acknowledgments

I offer immeasurable gratitude to my father, Robert Herman, and my sister, Jane E. Herman, who encourage me daily to paint my canvas brightly and embrace the world with wide-open eyes. My late mother, Diana S. Herman, laid the groundwork for me to see the world for all it has to offer, and I believe she would be proud that her visual intelligence continues to guide me. My family's collective wisdom informs my work, and when all else disappoints, they still cheer me on.

Mary Pantoga, my cherished friend and colleague, has provided the tape, glue, spit, sweat, staples, and gold to hold The Art of Perception and the pages of this book together, even when both were splitting at the seams. Her deep understanding of our work and her belief in the power of art form the primer on every one of my canvases. My dearest friend, Christine Butler, an unending source of creative inspiration, has shared her joy in looking at art with me for years, and her insights keep me searching for answers to seemingly unsolvable problems. Our friendship is, indeed, a joyous work of art.

My editor at HarperWave, Karen Rinaldi, had the vision to see this book through its many iterations and to coax its beauty forth, shepherding it from initial inspiration to a truly polished work of art . She never gave up on it or me. Kevin Conley, wordsmith, editor extraordinaire, and lover of art, chiseled away at this manuscript, smoothed its rough edges, and buffed its patina to a resplendent shine. I am in-

debted to Heather Maclean who gathered all the materials, primed the canvas, mixed the pigments, and prepared the sketches that made this work possible.

Susan Ginsburg, my agent at Writers House and also my friend, is a consummate fixer of problems who repeatedly makes me the beneficiary of her ability to see every situation in its best light. I am beyond fortunate to have her in my corner. Fates conspired the day I flew on a plane with Robin Rue, also at Writers House, to whom I will be eternally grateful. Chatting with her on that flight literally changed everything about how I see my work in the world. Heartfelt thanks, too, to Catherine Bradshaw, also at Writers House, for her belief in me and my work and her keen eye for detail.

Rebecca Holland, Leah Carlson-Stanisic, Milan Bozic, Brian Perrin, Penny Makras, Sophia Lauriello, and Kirby Sandmeyer at HarperWave have my deepest appreciation for their gracious, creative, and stalwart support of this book from its first days in the studio through to the final exhibition—and as the show will continue to travel to each new venue.

There are so many people to whom I owe gratitude, not only for their advocacy of this book and The Art of Perception but also for their willingness to help me see solutions that weren't always apparent. You all have broadened my views and intensified the palette with which I work. Each of your names should be affixed to the label that accompanies this work of art: Bob Mattison, Marshall R. Metzgar Professor of Art History at Lafayette College; the Lehrer Family, who critiqued countless slides, fed my soul, and agreed to be my test audience too many times to count; Lisa Barré-Quick, my brilliant legal eagle who taught me to fly and how to dream like a dog; Wilma Bulkin Siegel for being the extraordinary Wilma; my friend and nurse extraordinaire, Rachele Khadjehturian, and, Chris and Donna Costa, for sharing their gift of patriotism and friendship; and these colleagues and friends, among countless others too numerous to mention: the late Charles Ryskamp, Sam Sachs II, Colin Bailey, Rebecca Brooke, Richard Barsam, the late Edgar Munhall, Susan Galassi, Peggy Iacono, Sean Famoso McNichol, Jennifer Belt, Julie Mehretu, Kumi

Yamashita, Colton Seale, Ralph Cilento, Kathryn Roche, Mitch Albala, Marilyn Kushner, Donna Cohen Ross, Tara Wray, Maggie Holyoke, Amy Hamlin, Robin Wachtler, Michael Morgan, Jacob Eastham, Nyssa Straatveit, Lisa Grant, Ellen Friedman, and Chari LeMasters. A special and heartfelt thanks to the late Louise Fishman, who did not know that her work would illuminate these pages and that posthumously, she saved the day. Deepest appreciation to the many artists who granted permission to include their works herein. I am honored to have your voices among this prose.

Most important, I thank the greatest muse in my life, Ian Carter, for sharing the world he sees through his exquisite green eyes and whose very presence assures me that any problem, no matter how large or looming, can always be Fixed.

Notes

Introduction

4 But a discouraged Géricault: Rupert Christiansen, *The Victorian Visitors: Culture Shock in Nineteenth-Century Britain* (New York: Grove Books, 2002).

5 It's an age-old idea: Arthur Bloch, *Murphy's Law, and Other Reasons Why Things Go Wrong* (New York: Price Stern Sloan Publishers, 1978).

6 When the project's lead: *Essays on the History of Rocketry and Astronautics: Proceedings of the Third through the Sixth History Symposia of the International Academy of Astronautics*, Volume 1, National Aeronautics and Space Administration, Scientific and Technical Information Office, 1977; Craig Ryan, *Sonic Wind: The Story of John Paul Stapp and How a Renegade Doctor Became the Fastest Man on Earth* (New York: Liveright, 2015).

Prep

13 According to the publishers: Artists Network Staff, "8 Beginner Painting Mistakes and How to Conquer Them," *Artists Magazine*, April 10, 2018.

Step #1: Clean Your Lenses

15 In 1569, doctor: Elena Fabietti, "A Body of Glass: The Case of El licenciado Vidriera," *symploke*, vol. 23, 2015.

17 The fear of being made of glass: Fabietti, "A Body of Glass."

17 A 2013 study of prisoners: Constantine Sedikides et al., "Behind Bars but above the Bar: Prisoners Consider Themselves More Prosocial than Non-prisoners," *British Journal of Social Psychology*, vol. 53, June 2014.

17 Psychologist Tasha Eurich: Tasha Eurich, *Insight: Why We're Not as Self-Aware as We Think, and How Seeing Ourselves Clearly Helps Us Succeed at Work and in Life* (New York: Crown Business, 2017).

17 After studying the: John Baldoni, "Few Executives Are Self-Aware, but Women Have the Edge," *Harvard Business Review*, May 9, 2013.

18 "If that's the trend": Nicholas Kristof, "The Daily Me," *New York Times*, March 3, 2009.

18 Researchers at the University of Kansas: Brendan M. Lynch, "Study Finds Our Desire for 'Like Minded Others' Is Hard-wired," University of Kansas, February 23, 2016.

20 "Complacency sets in": Harry Kraemer, "How Ford CEO Alan Mullaly Turned a Broken Company into the Industry's Comeback Kid," *Quartz*, June 18, 2015.

20 In his prescient book: Bill Bishop, *The Big Sort: Why the Clustering of Like-Minded America Is Tearing Us Apart* (Boston: Mariner Books, 2009).

20 While we can easily see: Kristof, "The Daily Me."

20 A study of Yale students: Leonid Rozenblit and Frank Keil, "The Misunderstood Limits of Folk Science: An Illusion of Explanatory Depth," *Cognitive Science*, September 2002.

21 For instance, in their book: Steven Sloman and Philip Fernbach, *The Knowledge Illusion: Why We Never Think Alone* (New York: Riverhead Books, 2017).

22 As of January 2020: Simon Kemp, "Digital 2020: Digital Global Overview," *DataReportal*, January 30, 2020.

31 Many people don't like: Russell Smith, "Why I Don't Like Picasso," *Globe and Mail*, May 2, 2012.

31 This habit, which is known as "psychological projection": Jeff Schimel, Jeff Greenberg, and Andy Martens, "Evidence That Projection of a Feared Trait Can Serve a Defensive Function," *Personality and Social Psychology Bulletin*, August 1, 2003, https://doi.org/10.1177/0146167203252969.

31 According to Jung: Carl G. Jung, "The Relations between Ego and Unconscious," *Collected Works of C.G. Jung, Volume 7: Two Essays in Analytical Psychology 2nd ed.* (Princeton, NJ: Princeton University Press, 1972).

32 Hidden in the shadows: Carl G. Jung, "Aion: Researches into the Phenomenology of the Self," *Collected Works of C.G. Jung, Volume 9, Part 2* (Princeton, NJ: Princeton University Press, 1979).

32 Doing so is known as: Jung, "The Relations between Ego and Unconscious."

35 "I was thinking": "Lick and Lather: Janine Antoni," *Art21.org*, November 2011.

35 "There's not a lot of time": Robin Cembalest, "Self-Portrait of the Artist as a Self-Destructing Chocolate Head," *ARTnews*, February 21, 2013.

36 "The brown and white": "Lick and Lather," *Art21.org*, November 2011.

37 In 1770, future American president: "Adams' Argument for the Defense: 3–4 December 1770," *The Adams Papers: Legal Papers of John Adams, vol. 3, Cases 63 and 64: The Boston Massacre Trials*, ed. L. Kinvin Wroth and Hiller B. Zobel (Cambridge, MA: Harvard University Press, 1965); Patrick J. Kiger, "8 Things We Know about Crispus Attucks," History.com, February 3, 2020.

37 His goal was: "Adams' Argument for the Defense," *The Adams Papers*.

37 In the 2018 policy report: Norman Vasu et al., *Fake News: National Security in the Post-truth Era*, Report, S. Rajaratnam School of International Studies, 2018, http://www.jstor.org/stable/resrep17648.7.

37 The report concluded: Vasu et al., *Fake News*.

37 As in Attucks's case: *The Adams Papers*; Amy Forliti, "Ex-officer Charged in George Floyd's Death Freed on $1M bond," AP News, October 9, 2020; Amy Forliti, "Judge Dismisses 1 Charge against Former Cop in Floyd's Death," AP News, October 22, 2020.

37 While almost everyone agreed: Davey Alba, "Misinformation about George Floyd Protests Surges on Social Media," *New York Times*, June 1, 2020.

37 Others wondered what: Richard Read, "Attorney for Minneapolis Police Of-
 ficer Says He'll Argue George Floyd Died of an Overdose and a Heart Condi-
 tion," *Los Angeles Times*, August 20, 202037

37 The medical: Amy Forliti and Steve Karnowski, "Medical Examiner: Floyd's
 Heart Stopped While Restrained," AP News, June 1, 2020.

37 The word "while": Bill Hutchinson, "Officer Charged in George Floyd's Death
 Argues Drug Overdose Killed Him, Not Knee on Neck," *ABC News*, August 30,
 2020.

39 Nutrition and wellness coach: Adam Chaim, "Reframe How You Think,
 Speak, and Eat with Rebecca Clements," *Plant Trainers* podcast #336, Decem-
 ber 24, 2019.

39 "The phrase is a cop-out": Rebecca Clements, "Why 'I don't know' is NOT an
 Answer: Manage Your Mind to Learn to Decide," *Simply Whimsical*, Medium
 .com, June 10, 2019.

39 "Do you know what happens": Clements, "Why 'I don't know' is NOT an An-
 swer."

40 Cadets are instructed: United States Naval Institute, *Reef Points 2016–2017*,
 United States Naval Institute, 2016.

40 Clements offers: Clements, "Why 'I don't know' is NOT an Answer."

40 "The point is": Clements, "Why 'I don't know' is NOT an Answer."

47 In American public schools: Kendra Yoshinaga, "Babies of Color Are Now the
 Majority, Census Says," *NPR*, July 1, 2016.

47 The US Census Bureau: Yoshinaga, "Babies of Color Are Now the Majority."

48 He quickly realized: Joseph Choi, "Rep. Phillips Says He Did Not Truly Under-
 stand White Privilege until the Capitol Riot," *The Hill*, February 4, 2021.

50 Seeking to understand: T. H. Chi Michelene and Kurt A. VanLehn, "The Con-
 tent of Physics Self-Explanations," *Journal of the Learning Sciences*, 1:1, 69–105.

50 Their conclusions were: Alexander Salle, "Analyzing Self-Explanations in
 Mathematics: Gestures and Written Notes Do Matter," *Frontiers in Psychology*,
 November 23, 2020; Jia-Wei Chang et al., "Effects of Using Self-Explanation on
 a Web-Based Chinese Sentence-Learning System," *Computer Assisted Language
 Learning* 30, nos. 1–2 (2016): 44–63; Helga Noice and Tony Noice, "An Example
 of Role Preparation by a Professional Actor: A Think-Aloud Protocol," *Dis-
 course Processes* 18, no. 3 (1994): 345–69.

50 "Why?" is so instrumental: Art Markman, "The Importance of Creating a Cul-
 ture of Why," *Fast Company*, December 11, 201452

52 I told the man: "The Story Behind the Chains, the Mohawk, the Earrings,"
 Harvard Crimson, October 7, 1993.

55 The outrage reached: Jessica Chasmar, "Barack Obama's Portrait Artist Ke-
 hinde Wiley Painted Black Women Beheading White Women," *Washington
 Post*, February 13, 201855

55 He'd answered the question: Kehinde Wiley, *Officer of the Hussars*, 2007, *Detroit
 Institute of Arts* website, dia.org.

56 In numerous studies: Emily Pronin, Daniel Y. Lin, and Lee Ross, "The Bias
 Blind Spot: Perceptions of Bias in Self versus Others," *Personality and Social Psy-
 chology Bulletin*, March 2002; Joyce Ehrlinger, Thomas Gilovich, and Lee Ross,
 "Peering into the Bias Blind Spot: People's Assessments of Bias in Themselves
 and Others," *Personality and Social Psychology Bulletin*, May 2005.

56 They call this phenomenon: Erik Luis Uhlmann and Geoffrey L. Cohen, "'I Think It, Therefore It's True': Effects of Self-Perceived Objectivity on Hiring Discrimination," *Organizational Behavior and Human Decision Processes*, November 2007.

57 Unlike previous CEO: Matthew Stevens, "BHP chairman Jac Nasser Reflects on 30 Years in Management," *Australian Financial Review Magazine*, May 25, 2017.

57 "It's so important": "In Focus: Former Ford CEO on Leadership and Inspiring Others [Video]," *Georgetown University School of Continuing Studies*, December 15, 2016.

58 Bryce G. Hoffman: Bryce G. Hoffman, "Nine Things I Learned from Alan Mulally," *Change This*, April 11, 2012.

58 "I used to run from it": Alex Wong, "Jeremy Lin, 'Reppin' Asians with Everything I Have,' Is Bigger Than an N.B.A. Title," *New York Times*, June 18, 2019.

59 Lin, then a player: Jessica Prois and Lilly Workneh, "Jeremy Lin's Dreads and Kenyon Martin's Chinese Tattoo Are a False Equivalency," *Huffington Post*, October 11, 2017.

59 "Do I need to remind": Matt Bonesteel, "After Kenyon Martin Rips His Dreads, Jeremy Lin Kills Him with Kindness," *Washington Post*, October 6, 2017.

59 While Martin thought: Yao Ming with Ric Bucher, *YAO: A Life in Two Worlds* (Los Angeles: Miramax, 2004).

59 "Hey man, it's all good": Bonesteel, "After Kenyon Martin Rips His Dreads."

59 In an essay: Jeremy Lin, "So . . . about My Hair," *Players' Tribune*, October 3, 2017.

60 Writer Cameron Wolf: Cameron Wolf, "A Timeline of All of Jeremy Lin's Ridiculous Hairstyles," *Complex*, July 21, 2016.

60 "Maybe one day": Lin, "So . . . about My Hair."

60 "He might have": Brian Lewis, "Jeremy Lin Turns Hair Criticism into Plea for Tolerance," *New York Post*, October 6, 2017.

Step #2: Change Your Shoes

63 In 1873: *Lonely Planet*, "Budapest, History," August 8, 2019, https://www .lonelyplanet.com/hungary/budapest/background/destination-today/a/nar /bb5701d1-d6bf-4ea8-8d09-200cb986eaff/359522.

65 The shoes were sculpted: Sheryl Silver Ochayon, "The Shoes on the Danube Promenade—Commemoration of the Tragedy," Yad Vashem, yadvashem.org.

65 Tommy Dick was one: "Escaping Death on the Danube," The Holocaust Survivor Memoirs Program, March 22, 2017, https://medium.com/@azrielimem oirs/suddenly-the-shadow-fell-4ca42a36e9b1.

65 Five-year-old Eva Meisels: "Escaping Death on the Danube," Holocaust Survivor Memoirs Program.

65 It was these shoes: Gyula Pauer, "Shoes on the Danube Bank," Gyula Pauer homepage, http://www.pauergyula.hu/emlekmuvek/cipok.html.

65 Author Sheryl Silver Ochayon: Ochayon, "The Shoes on the Danube Promenade."

69 One of the rescuers: "Constable to Delacroix: British Art and the French Romantics: Room Guide: Room 8: 'The Raft of Medusa,'" Tate, https://www .tate.org.uk/whats-on/tate-britain/exhibition/constable-delacroix-british-art -and-french-romantics/constable-7.

70 Art historians believe: Mary Slavkin, "*The Raft of the Medusa, The Fatal Raft* and the Art of Critique," *Kritikos*, vol. 9, January–June 2012.

71 The painting was created: "Slavery and Portraiture in 18th-Century Atlantic Britain," *Elihu Yale, the Second Duke of Devonshire, Lord James Cavendish, Mr. Tunstal, and a Page*, Yale Center for British Art, http://interactive.britishart .yale.edu/slavery-and-portraiture/266/elihu-yale-the-second-duke-of-devon shire-lord-james-cavendish-mr-tunstal-and-a-page.

71 More recent research centered: "New Light on the Group Portrait of Elihu Yale, His Family, and an Enslaved Child," Yale Center for British Art, https://british art.yale.edu/new-light-group-portrait-elihu-yale-his-family-and-enslaved-child.

71 When the artist Titus Kaphar: Terence Trouillot, "Titus Kaphar on Putting Black Figures Back into Art History and His Solution for the Problem of Confederate Monuments," *ArtNet*, March 27, 2019.

72 Kaphar explains: Trouillot, "Titus Kaphar on Putting Black Figures Back into Art History."

73 "But," Kaphar said: Titus Kaphar, "Can Art Amend History?," TED Talks, August 1, 2017, https://www.ted.com/talks/titus_kaphar_can_art_amend_his tory/discussion?utm_content.

74 "This is not about eradication": Kaphar, "Can Art Amend History?"

76 "I am overwhelmed by white figure representations": "Kerry James Marshall at Secession," *Contemporary Art Daily*, November 20, 2012.

79 According to his own autobiographical writings: Peter Schjeldahl, "Hitler as Artist," *New Yorker*, August 12, 2002.

80 Sotheby's reports that: Sotheby's Institute of Art, "The Business Model of the Nonprofit Museum," *Sotheby's Institute of Art*, https://www.sothebysinstitute .com/news-and-events/news/the-business-model-of-the-nonprofit-museum.

80 The popular twentieth-century American artist: "Edward Hopper and the American Hotel," VMFA, https://www.vmfa.museum/exhibitions/exhibi tions/edward-hopper-american-hotel/.

80 The museum faithfully: "Hopper Hotel Experience," VMFA, https://www .vmfa.museum/calendar/events/hopper-hotel-experience/.

81 He likened it: Seph Rodney, "How Does a Black Man Fit into an Edward Hopper Painting?," *Hyperallergic*, January 10, 2020.

82 He recalled: Rodney, "How Does a Black Man Fit into an Edward Hopper Painting?"

82 Rodney wrote about: Mary Louise Schumacher, "Hyperallergic, at Age 9, Rivals the Arts Journalism of Legacy Media," *NiemanReports*, May 24, 2018.

82 There are three iron signs: Ochayon, "The Shoes on the Danube Promenade."

84 It's actually a satirical etching: William Dent, "Object: Abolition of the Slave Trade, or the Man the Master," 1789, British Museum, https://www.britishmu seum.org/collection/object/P_1948-0214-538.

85 For women, this image: "Man as Object: Reversing the Gaze," Northern California Women's Caucus for Art, https://www.ncwca.org/mao-reversing-the -gaze.html.

90 Her father boasted: Alexxa Gotthardt, "Behind the Fierce, Assertive Paintings of Baroque Master Artemisia Gentileschi," *Artsy*, June 8, 2018.

91 One art journalist notes: Gotthardt, "Behind the Fierce, Assertive Paintings of Baroque Master Artemisia Gentileschi."

92 Instructors, like artist Sophia Dawson: Hakim Bishara, "Minor Offenders Can Substitute Jail Time with an Art Class at the Brooklyn Museum," *Hyperallergic*, October 24, 2019.

92 A study by the Center for Court Innovation: Kimberly Dalve and Becca Cadoff, "Project Reset: An Evaluation of a Pre-arraignment Diversion Program in New York City," Center for Court Innovation, January 2019, https://www.courtinnovation.org/sites/default/files/media/document/2019/projectreset_eval_2019.pdf.

92 Many called for: Dalve and Cadoff, "Project Reset."

93 Now, Luzzi is a celebrated author: Joseph Luzzi, *In a Dark Wood: What Dante Taught Me about Grief, Healing, and the Mysteries of Love* (New York: Harper Wave, 2015).

93 "posttraumatic growth": Scott Barry Kaufman, "Post-traumatic Growth: Finding Meaning and Creativity in Adversity," *Scientific American*, April 20, 2020.

93 The *New Yorker* notes: Alexandra Schwartz, "The Artist JR Lifts a Mexican Child over the Border Wall," *New Yorker*, September 11, 2017.

94 "JR sees things": Carole Cadwalladr, "JR: 'I Realised I Was Giving People a Voice,'" *Guardian*, October 11, 2015.

94 A reporter who followed JR: Cadwalladr, "JR."

94 She agreed: Schwartz, "The Artist JR Lifts a Mexican Child over the Border Wall."

95 JR says he hoped people: Schwartz, "The Artist JR Lifts a Mexican Child over the Border Wall."

95 JR posted a photo: JR, Instagram, September 6, 2017, https://www.instagram.com/p/BYto6YrjovS/?taken-by=jr.

95 JR notes that his installation: Schwartz, "The Artist JR Lifts a Mexican Child over the Border Wall."

95 Researchers at the University of California, Davis: Gregory M. Herek, John P. Capitanio, and Keith F. Widaman, "HIV-Related Stigma and Knowledge in the United States: Prevalence and Trends, 1991–1999," *American Journal of Public Health*, March 2002, https://www.ncbi.nlm.nih.gov/pmc/articles/PMC1447082/.

95 Such prejudices are an impediment: Ronald O. Valdiserri, "HIV/AIDS Stigma: An Impediment to Public Health," *American Journal of Public Health*, March 2002, https://www.ncbi.nlm.nih.gov/pmc/articles/PMC1447072/.

95 Having grown up in a fairly homogenous town: Stacy Lambe, "How 'The Real World' Star Pedro Zamora Humanized AIDS," *Entertainment Tonight*, June 21, 2018; Stacy Lambe, "EXCLUSIVE: 'Real World' Creator Jonathan Murray on Show's Changes, Remembering Diem Brown," *Entertainment Tonight*, December 15, 2014.

96 Ryan, however, got the virus: "Who Was Ryan White?," HIV/AIDS Bureau, November 14, 2017, https://hab.hrsa.gov/about-ryan-white-hivaids-program/who-was-ryan-white; Jeffry J. Iovannone, "Pedro Zamora: Real World Activist," *Medium*, June 21, 2018.

96 Then-president Bill Clinton: Iovannone, "Pedro Zamora."

96 His former roommate: Laura Franco, "Pedro Zamora of 'Real World: San Francisco' Remembered 20 Years Later," *MTV News*, November 11, 2014.

96 Michael Sidibé, executive director: Michael Sidibé, "Giving Power to Couples to End the AIDS Epidemic," *Huffington Post*, May 7, 2012.

96 Titus Kaphar knows: Titus Kaphar, "Can Beauty Open Our Hearts to Diffi-
 cult Conversations?," TED, July 24, 2020, https://www.ted.com/talks/titus_ka
 phar_can_beauty_open_our_hearts_to_difficult_conversations/transcript.

96 He's delighted, though: Kaphar, "Can Beauty Open Our Hearts?"

97 professor Beth Bechky: Beth A. Bechky et al., "Sharing Meaning across Occu-
 pational Communities: The Transformation of Understanding on a Produc-
 tion Floor," *Organization Science*, May 1, 2003, https://dl.acm.org/doi/10.1287
 /orsc.14.3.312.15162.

98 "It enhanced the individual's understanding": Bechky et al., "Sharing Meaning
 across Occupational Communities."

98 In the early 1970s: Joel Magalnick, "Growing Up in an Oasis," *JT News*, June 11,
 2004, https://wasns.org/growing-up-in-an-oasis.

98 the goal was not assimilation: Grace Feuerverger, *Oasis of Dreams: Teaching
 and Learning Peace in a Jewish-Palestinian Village in Israel* (Oxfordshire, England:
 Routledge, 2001).

98 Half a century later: Daniel Gavron, "Living Together," *Holy Land Mosaic:
 Stories of Cooperation and Coexistence between Israelis and Palestinians* (Lanham,
 MD: Rowman & Littlefield, 2007).

98 Organizers Dafna Karte-Schwartz and: "Art as a Language of Communica-
 tion" workshop, August 1998: http://wasns.org/village/updates/artwork.htm.

99 Karte-Schwartz and Shalufi-Rizek note: "Art as a Language of Communica-
 tion" workshop.

99 Success is measured by participant feedback: "Art as a Language of Communi-
 cation" workshop.

101 British sculptor Barbara Hepworth: Barbara Hepworth, "Approach to Sculp-
 ture," *Studio*, vol. 132, no. 643, October 1946.

101 As the *Harvard Business Review* notes: Art Markman, "How You Define the Prob-
 lem Determines Whether You Solve It," *Harvard Business Review*, June 6, 2017.

101 One of my favorite problem-solving mantras: "Atomic Education Urged by
 Einstein: Scientists in Plea for $200,000 to Promote New Type of Essential
 Thinking," *New York Times*, May 25, 1946, 13.

Step #3: Define the Project

104 Rather than a conscious, personal decision: Sam Eifling, "Think Slow and
 Other Tricks for Better Problem-Solving," *Success*, October 6, 2016.

104 Even our brains are programmed: Herbert A. Simon, *Models of Man: Social and
 Rational—Mathematical Essays on Rational Human Behavior in a Social Setting*
 (Hoboken, NJ: Wiley, 1957); Daniel Kahneman, *Thinking, Fast and Slow* (New
 York: Farrar, Straus and Giroux, 2013).

104 Sherlock Holmes alludes to this tendency: Sir Arthur Conan Doyle, *The Adven-
 tures of Sherlock Holmes* (London, George Newnes Ltd., 1892).

105 To combat this: Kahneman, *Thinking, Fast and Slow.*

105 "People usually go to a museum": Trent Morse, "Slow Down, You Look Too
 Fast," *ARTNews*, April 1, 2011.

105 To share his newfound appreciation: Slow Art Day official website, www.slow
 artday.com.

105 Ironically, Terry finds: Morse, "Slow Down, You Look Too Fast."

109 Due to a declining birth rate: Julie Mack, "78 Michigan School Districts with Enrollment Drops of 25% or More since 2009," *MLive*, October 29, 2019.

109 Like many others, St. Mary's: Frank Witsil, "All-Boys St. Mary's Prep to Accept Girls as Michigan Enrollment Drops," *Detroit Free Press*, October 15, 2019.

109 They ran a projection: James David Dickson and Jennifer Chambers, "Lady-wood High Closing at End of School Year," *Detroit News*, December 12, 2017.

110 John Keane, Professor of Politics: John Keane, "Post-truth Politics and Why the Antidote Isn't Simply 'Fact-Checking' and Truth," *The Conversation*, March 22, 2018.

111 "If he refuses": "England Forward Raheem Sterling Defends Gun Tattoo," *BBC News*, May 29, 2018.

111 Cope, founder of the nonprofit group Mothers Against Guns: Stephen Moyes and Alex Diaz, "England Ace Raheem Sterling Sparks Fury by Unveiling M16 Assault Rifle Tattoo," *Sun*, May 29, 2018.

111 The headlines I'd read had made it clear: Jessica Glenza, "Trump's Decision to Allow Plastic Bottle Sales in National Parks Condemned," *Guardian*, August 20, 2017.

111 The *Washington Post* explained it this way: Darryl Fears, "National Parks Put a Ban on Bottled Water to Ease Pollution. Trump Just Sided with the Lobby That Fought It," *Washington Post*, August 17, 2017.

112 The increase in consumption of soda: Sandy Bauers, "Which Is Greener: Glass Bottles, Plastic Bottles, or Aluminum Cans?," *Philadelphia Inquirer*, July 23, 2012.

112 On February 1, 1968: Jennifer Peltz, "In an Instant, Vietnam Execution Photo Framed a View of War," Associated Press, January 29, 2018.

112 Many scholars believe: "Eddie Adams' Iconic Vietnam War Photo: What Happened Next," *BBC News*, January 29, 2018.

113 "Pictures don't tell the whole story": Peltz, "In an Instant." AP Images / Eddie Adams.

114 Adams himself assumed the shooter: "Eddie Adams' Iconic Vietnam War Photo," *BBC News*.

114 Adams came to believe: "Eddie Adams' Iconic Vietnam War Photo," *BBC News*.

114 "Two people died in that photograph": "Eddie Adams' Iconic Vietnam War Photo," *BBC News*.

116 The image on the left: *James Joyce*, Berenice Abbott/Masters via Getty Images.

116 Abbott was known: Clare Davies, "Diane Arbus' Best Photographs," *Sleek Magazine*, April 20, 2017.

117 To me, it was obvious: Alec Soth, "Josh, Joelton, TN, 2004," *The Last Days of W* (St. Paul, MN: Little Brown Mushroom, 2008).

121 The exhibit is called *Untitled (One Hundred Spaces)*: Rachel Whiteread, *Untitled (One Hundred Spaces)*, 1995, Tate Britain Exhibition 2017, https://www.tate.org.uk/whats-on/tate-britain/exhibition/rachel-whiteread.

121 Called *Penumbra*: Jean Shin, *Penumbra*, 2003, https://jeanshin.com/penumbra.

122 They used the metal skeletons: Justine Testado, "Harvest Dome 2.0 Is Finally Afloat," *Archinect*, August 5, 2013.

123 By the death rate: "Prostitution in the United States," HG.org, https://www.hg.org/legal-articles/prostitution-in-the-united-states-30997.

123 A&E television network's 2016 documentary series: Ellen Killoran, "Why So Many Sex Worker Murders Go Unsolved," *Rolling Stone*, November 11, 2016.

123 In November 2020: Eric Leonard and Andrew Blankstein, "LAPD's 'SVU' That Investigates Complicated Sex Crimes Shuttered in Initial Budget Cuts," *NBC Los Angeles*, November 10, 2020.

125 Mexican artist Jorge Méndez Blake: Katie Sierzputowski, "A Single Book Disrupts the Foundation of a Brick Wall by Jorge Méndez Blake," *Colossal*, February 14, 2018.

126 "Just saw your news report": Johnny Diaz, "A Viewer Spotted a Lump on Her Neck. Now, She's Having a Tumor Removed," *New York Times*, July 25, 2020.

126 In an update: Maura Hohman, "TV Reporter Shares Health Update after Viewer Spots Her Thyroid Cancer," *Today*, August 4, 2020.

127 J. R. R. Tolkien told a friend: J. R. R. Tolkien, "Letter 163 to W.H. Auden (1955)," J. R. R. Tolkien Estate, https://www.tolkienestate.com/en/writing/letters/letter-163-to-wh-auden.html.

127 When Japanese printmaker: Richard Lane, *Images from the Floating World, The Japanese Print* (Oxford: Oxford University Press, 1978). Although many scholars cite Suzuki Harunobu as the inventor of *nishiki-e*, the art of multicolored woodblock printing, others suggest he merely perfected it thanks to wealthy patrons. Some name engraver Kinroku as the actual inventor of the technology, but as a prolific printmaker, Harunobu did popularize it.

127 Vincent Van Gogh: "Meet Vincent: Inspiration from Japan," Vincent Van Gogh Museum, Amsterdam, https://www.vangoghmuseum.nl/en/stories/inspiration-from-japan#0.

128 One major magazine: Caitlin Flanagan, "The Media Botched the Covington Catholic Story," *Atlantic*, January 23, 2019.

128 Political commentator: Flanagan, "The Media Botched the Covington Catholic Story."

128 Actress Alyssa Milano: Katherine Hignett, "'The Red MAGA Hat Is the New White Hood' Says Alyssa Milano in Twitter Storm," *Newsweek*, January 22, 2019.

128 He was labeled: Flanagan, "The Media Botched the Covington Catholic Story."

128 He and his family: Karma Allen, "Teen Accused of Taunting Native American Protesters in Viral Video Says He's Receiving Death Threats," *ABC News*, January 20, 2019.

129 The students were documented: Flanagan, "The Media Botched the Covington Catholic Story."

129 A writer for the *Atlantic*: Flanagan, "The Media Botched the Covington Catholic Story."

129 He stated he'd remained: Scott Wartman, "Covington Catholic Student from Incident at the Indigenous Peoples March Issues Statement with His Side of the Story," *Cincinnati Enquirer*, January 20, 2019.

129 They were from a small town in Kentucky: Deloitte, Datawheel, and Cesar Hidalgo, "Covington, KY," Data USA, https://datausa.io/profile/geo/covington-ky; Jessica Semega, "Income and Poverty in the United States: 2018," Census.gov, September 10, 2019.

129 Milano, for one: Alyssa Milano, "Red MAGA Hats Are the New White Hoods—Let's Take a Stand (Commentary)," *The Wrap*, February 13, 2019.

130 sued by the young man: Ebony Bowden, "*Washington Post* Settles $250M Suit with Covington Teen," *New York Post*, July 24, 2020.

130 CNN and the *Washington Post*: Flanagan, "The Media Botched the Covington Catholic Story."

130 Flanagan notes that: Flanagan, "The Media Botched the Covington Catholic Story."

131 When the Renaissance Philadelphia Downtown Hotel: Marriott International, "Renaissance Hotels Brings High Design to Historic 'Old City' Philadelphia," *PR Newswire*, June 28, 2018.

132 After just a few weeks: AnneWestChester_PA, "Who Designed This Hotel????," TripAdvisor, July 2019; Steven O, "Great Location and Modern, Clean Hotel," TripAdvisor, March 2019.

Draft
136 Still, his rationale was: Dan Scott, "How to Analyze Art," *Draw Paint Academy*, October 15, 2018.

138 Scott's folksy approach: Scott, "How to Analyze Art."

139 the word is: Barry John Raybould, "A Guide to Notan: The What, Why, and How," Virtual Art Academy, n.d., https://www.virtualartacademy.com/notan/.

140 "Similarly, if the underlying notan": Mitchell Albala, *The Landscape Painter's Workbook: Essential Studies in Shape, Composition, and Color* (Beverly, MA: Rockport Publishers, forthcoming 2021).

141 As of 2019: "Number of User Reviews and Opinions on TripAdvisor Worldwide from 2014 to 2019," *Statista*, February 2020, https://www.statista.com/statistics/684862/tripadvisor-number-of-reviews/.

141 Ninety-eight percent of: Linda Fox, "Extreme Comments Ignored and Few Focus on Negative Reviews Says Tripadvisor," PhocusWire, November 15, 2012.

141 Ninety percent of: Sophia Soltani, "90% of Travellers Avoid Booking a Hotel If Labelled 'Dirty' Online Says FCS," *Hotel News ME*, November 22, 2016.

141 A single negative review: "Hotel Online Reputation Research, Statistics, and Quotes." ReviewPro, January 25, 2016.

141 Furthermore, guest satisfaction: "Hotel Online Reputation Research, Statistics, and Quotes."

141 Since, on average: "Hotel Online Reputation Research, Statistics, and Quotes."

Step #4: Break It into Bite-Sized Pieces
145 "I am disorientated": Christiansen, *The Victorian Visitors*.

145 Alexandrine-Modeste gave birth: Christiansen, *The Victorian Visitors*.

146 A young artist: Alexander McKee, *Wreck of the Medusa: The Tragic Story of the Death Raft* (New York: Skyhorse Publishing, 2007).

146 Sarri Gilman: Sarri Gilman, *Naming and Taming Overwhelm: For Healthcare & Human Service Providers* (Healthy Gen Media and Island Bound Publishing, 2017).

146 Health educator Melanie Gillespie: Gilman, *Naming and Taming Overwhelm*.

147 Ancient Egyptians used: Gay Robins, *Proportion and Style in Ancient Egyptian Art* (Austin: University of Texas Press, 1994).

147 A fellow artist: McKee, *Wreck of the Medusa*.

148 I sometimes show: Kumi Yamashita, *Building Blocks, 2014*, Permanent Collection Otsuma Women's University, Tokyo, Japan.

148 Hugo Glendinning, Cold Dark Matter Shed before explosion, 1991,© Hugo Glendinning. All Rights Reserved, DACS/Artimage 2021; Hugo Glendinning, Cold Dark Matter Explosion, 1991© Hugo Glendinning. All Rights Reserved, DACS/Artimage 2021.

148 While the mangled pieces: "The Story of *Cold Dark Matter*," Tate, https://www .tate.org.uk/art/artworks/parker-cold-dark-matter-an-exploded-view-t06949 /story-cold-dark-matter.

149 *Cold Dark Matter*: Cornelia Parker, *Cold Dark Matter: An Exploded View*, 1991, Tate, © Cornelia Parker.

152 The piece, titled: Salvador Dalí, *Retrospective Bust of a Woman*, 1933 (some elements reconstructed 1970).

153 Two centuries after Goya's painting: Grace Ebert, "Human Figures Removed from Classic Paintings by Artist José Manuel Ballester," *Colossal*, March 23, 2020.

153 Take a look at Ballester's: José Manuel Ballester, *3 de Mayo*, 2008, https://www .josemanuelballester.com.

153 you can see that, *The Raft of the Medusa*: José Manuel Ballester, *La balsa de la Medusa*, 2010, https://www.josemanuelballester.com.

Step #5: Recognize Relationships and Red Herrings

158 but, the writer Ovid tells us: Ovid, *Metamorphoses*, trans. Rolfe Humphries (Bloomington: Indiana University Press, 1961), 241–43.

158 Wonder Woman is sculpted: Anthony Lane, "Top Ten Things about Wonder Woman," *New Yorker*, June 5, 2017.

158 *The Umbrella Academy*: Elizabeth Pashley, "The Transformation and Adaptation of Ovid's Pygmalion," ArtsEmerson, October 26, 2012; Emma Nolan, "The Umbrella Academy Cast: Who Is Dolores in 'The Umbrella Academy?,'" *Daily Express*, April 2, 2019.

158 The story has universal appeal: Editors, "Tawfīq al-Ḥakīm," *Encyclopedia Britannica*, July 22, 2020.

158 Relationships can determine: Society for Personality and Social Psychology, "Meaningful Relationships Can Help You Thrive," *ScienceDaily*, August 2014.

160 "Even when I pass": Kate Lemery, "Awakening to Art," *After the Art*, December 4, 2018.

160 "a touching image of love": Lemery, "Awakening to Art."

160 at the 2016: Lauren Cowling, "Gwen Stefani Says Blake Shelton Kissed Her Back to Life after Divorce," *One Country*, November 21, 2016.

160 Amanda Lampel, an: Amanda Lampel, "Pygmalion and Galatea," *Sartle*, https://www.sartle.com/artwork/pygmalion-and-galatea-jean-leon-gerome.

161 Bostick wrote, "Trivializing": Dani Bostick, "Dear National Junior Classical League, Don't Have Children Dress Up like Galatea & Pygmalion at Your Convention," *Medium*, February 19, 2020.

161 Lampel has written: "Amanda Lampel," *Sartle*, https://www.sartle.com/pro file/amanda-lampel?page=1.

161 Additionally, she's a counselor: "About Me," DaniBostick.net, https://www .danibostick.net/about-me--contact.html.

162 Having worked at the Met: "Amanda Lampel," *Sartle*.

162 His marriage is: "Lot 43: Jean-Léon Gérôme," *Bonhams*, https://www.bon hams.com/auctions/24213/lot/43/.

162 Dupont arrived in Paris: Susan Waller, "Jean-Léon Gérôme's Nude (Emma Dupont): The Pose as Praxis," *Nineteenth Century Art Worldwide*, vol. 13, issue 1, Spring 2014.

162 She features not just in: Photograph: Anonymous or Louis Bonnard, Jean-Léon Gérôme with a model in frontal view, posing for *Omphale*, plaster seen in frontal view, c. 1885. Albumen silver print. Département des Estampes et de la Photographie, Bibliothèque Nationale de France, Paris.

162 A journalist: Waller, "Jean-Léon Gérôme's Nude."

163 Firsthand accounts: "Jean-Léon Gérôme—Biography and Legacy," *The Art Story*, https://www.theartstory.org/artist/gerome-jean-leon/life-and-legacy/.

163 Gérôme engaged: Scott Allan and Mary Morton, *Reconsidering Gérôme* (Los Angeles: J. Paul Getty Museum, 2010).

163 Thanks to advances: Emily Beeny, "Blood Spectacle: Gérôme in the Arena," in Allan and Morton, *Reconsidering Gérôme*.

165 *Truth Coming from the Well*: Bogdan Migulski, "Inspiration: 'Truth Coming Out of Her Well to Shame Mankind,' by Jean-Léon Gerôme," *The Art Bog*, February 13, 2005.

165 during the quarantine of 2020, the image: Gavia Baker-Whitelaw, "How a 19th Century Nude Painting Became a Feminist Meme," *Daily Dot*, July 31, 2017; "Truth Coming Out of Her Well to Shame Mankind," Know Your Meme, https://knowyourmeme.com/memes/truth-coming-out-of-her-well-to-shame-mankind; Jo Perry, "Jo Perry," Facebook, April 20, 2020, https://www.facebook.com/joperryauthor/posts/moodzoom-background-of-the-daytruth-coming-from-the-well-armed-with-her-whip-to-/1420449328142800/.

165 Some historians have interpreted: Emily Bedard, "Pygmalion and Galatea," *Artery: The Art History Journal of Students*, Lyme Academy College of Fine Arts, April 23, 2006.

166 On its website: Amy Johnson, "Chromosomes," *The Tech Interactive*, Stanford University, April 5, 2012, https://genetics.thetech.org/ask-a-geneticist/which-parent-decides-whether-baby-will-be-boy-or-girl.

166 Classics scholar Geoffrey Miles: Geoffrey Miles, *Classical Mythology in English Literature: A Critical Anthology* (London: Routledge, 1999).

166 The Latin word: Bostick, "Dear National Junior Classical League."

166 can also mean to blush "with modesty": Caroline Perkins and Denise Davis-Henry, *Ovid: A Legamus Transitional Reader* (Mundelein, IL: Bolchazy-Carducci Publishers, 2009).

166 Love story proponents: Bedard, "Pygmalion and Galatea."

166 Lust story proponents: Ian Lockey, "Not a 'Charming Little Tale': Teaching the Pygmalion Myth Ethically," *Medium*, February 26, 2020.

166 Some critics call: Perkins and Davis-Henry, *Ovid*; Lockey, "Not a 'Charming Little Tale.'"

167 One even surmises: Lockey, "Not a 'Charming Little Tale'"; Mark D. Griffiths, "Love Sculpture," *Psychology Today*, November 1, 2013.

167 Others mention the sculptor: Bedard, "Pygmalion and Galatea."

167 One classics teacher: Lockey, "Not a 'Charming Little Tale.'"

167 The story has been hailed: Bedard, "Pygmalion and Galatea."

167 In the introduction: Ovid, *Ars Amatoria,* trans. B. P. Moore (London: The Folio Society, 1965).

170 The Latin teacher Ian Lockey: Ian Lockey, "Not a 'Charming Little Tale.'"

174 British philosopher and mathematician: Alfred North Whitehead, *Dialogues of Alfred North Whitehead as Recorded by Lucien Price* (Boston: David R. Godine, 2008).

175 The Writing Center: "Art History," The Writing Center, University of North Carolina at Chapel Hill, https://writingcenter.unc.edu/tips-and-tools/art-history/.

177 Upon closer inspection: Study for *The Raft of the Medusa* by Théodore Géricault, oil on canvas, 36 x 48 cm, Musée du Louvre, Paris. Wikimedia Commons.

179 There was only one Black man: McKee, *Wreck of the Medusa*.

181 Artist Aengus Dewar: Aengus Dewar, "Under the Hood: What's Going On in Famous Paintings—*The Raft of the Medusa*: Theodore Géricault," *Medium*, August 4, 2020.

180 He writes that: Dewar, "Under the Hood."

Step #6: Set a Deadline

186 The first arrivals: "Prisoner Shelters," Andersonville: National Historic Site, Georgia, National Parks Service, https://www.nps.gov/ande/learn/history culture/prisoner-shelter.htm?fullweb=1.

187 McElroy later wrote: John McElroy, *Andersonville: A Story of Rebel Military Prisons* (Toledo: D.R. Rock, 1879).

187 McElroy, a printer's apprentice: McElroy, *Andersonville*.

187 McElroy understood the rules: McElroy, *Andersonville*.

187 "There was never": McElroy, *Andersonville*.

187 McElroy survived his: Richard Saeurs, ed., *The National Tribune Civil War Index: A Guide to the Weekly Newspaper Dedicated to Civil War Veterans, 1877–1943, Volume 1: 1877–1903* (El Dorado Hills, CA: Savas Beati, 2019).

187 It is perhaps not a coincidence: "Origin of the 'Deadline,'" *Today I Found Out*, January 6, 2014.

188 Leonardo da Vinci: Tia Ghose, "Lurking beneath the 'Mona Lisa' May Be the Real One," *Live Science*, December 9, 2015.

189 When *Bridges to Babylon* graphic designer: Simon Plant, "Stefan Sagmeister's the Man for Rolling Stones Covers," *Herald Sun*, May 4, 2009.

189 "The kind of snap decisions": Shane Mehling, "Are Deadlines Good for Creativity? Of Course They Are," *Creative Live*, March 6, 2015.

189 In an interview: Joe Fig, *Inside the Painter's Studio* (Princeton, NJ: Princeton Architectural Press, 2009).

190 A 2019 poll: "2019 Jobs Rated Report on Stress," *CareerCast*, April 18, 2019, https://www.careercast.com/jobs-rated/2019-jobs-rated-stress.

190 "I feel like as big": Jacob Moore, "The Story behind One of the Best Album Covers of the Year, 6lack's 'Free 6lack,'" *Complex*, November 15, 2016.

190 "People always think it's CGI": Moore, "The Story behind One of the Best Album Covers of the Year."

191 "You can't *make* a bear": Moore, "The Story behind One of the Best Album Covers of the Year."

191 "He would walk in": Moore, "The Story behind One of the Best Album Covers of the Year."

191 "In order to achieve": Ashlee Vance, *Elon Musk: Tesla, SpaceX, and the Quest for a Fantastic Future* (New York: Ecco, 2017).

193 A small sample: McKee, *Wreck of the Medusa.*

193 The artist Robert Rauschenberg: Abigail Cain, "The Morning Routines of Famous Artists, from Andy Warhol to Louise Bourgeois," Artsy.net, August 15, 2018.

193 Joan Miró left his studio: Cain, "The Morning Routines of Famous Artists."

193 And when she has finished: Dame Paula Rego, "Where I Work: Artist Paula Rego's North London Studio," *Guardian*, December 17, 2014.

193 Miró took a five-minute nap: Cain, "The Morning Routines of Famous Artists."

Step #7: Just Do It

195 Despite being named: Christopher Hooton, "Nike Is Pronounced Nikey, Confirms Guy Who Ought to Know," *Independent*, June 2, 2014.

196 Sales had dropped: Martin Kessler, "The Story behind Nike's 'Just Do It' Slogan," WBUR.org, November 23, 2018.

196 Something action-oriented: Kessler, "The Story behind Nike's 'Just Do It' Slogan."

196 Despite pleas from: Norman Mailer, *The Executioner's Song* (New York: Little, Brown and Company, 1979).

196 The country was outraged: Jef Rouner, "Gary Gilmore: 5 Songs for a Famous Executionee," *Houston Press*, January 17, 2012.

196 "Let's do it": Joan Didion, "'I Want to Go Ahead and Do It,'" *New York Times*, October 7, 1979.

196 Wieden found the statement: Kessler, "The Story behind Nike's 'Just Do It' Slogan."

196 Historian Natalia Mehlman Petrzela: Kessler, "The Story behind Nike's 'Just Do It' Slogan."

197 Serra's massive arched creation: Melanie Vandenbrouch, "Impossible Balance: Richard Serra's Sculptures at Gagosian Gallery," *Apollo: The International Art Magazine*, November 6, 2014.

197 To me, it is the embodiment: Robert Frost, "A Servant to Servants," *North of Boston* (New York: Henry Holt and Company, 1915).

197 The primary colors: JP McMahon, "Ai Weiwei, 'Remembering' and the Politics of Dissent," *Khan Academy*, https://www.khanacademy.org/humanities /global-culture/concepts-in-art-1980-to-now/appropriation-and-ideological -critique/a/ai-weiwei-remembering-and-the-politics-of-dissent.

198 Weiwei reflected: Xan Brooks, "Ai Weiwei: 'Without the Prison, the Beatings, What Would I Be?,'" *Guardian*, September 17, 2017.

198 He continues his advocacy: Brooks, "Ai Weiwei: 'Without the Prison, the Beatings, What Would I Be?'"

198 After releasing several movies: Helen Armitage, "11 Dissident Artists Who Aren't Ai Weiwei," *Culture Trip*, January 11, 2017.

198 Despite this, he continued to invent: Mojtaba Mirtahmasb and Jafar Panahi, *This Is Not a Film*, Palisades Tartan, March 13, 2013.

199 She buys vintage photographs: Julie Cockburn official website, http://www .juliecockburn.com; "Julie Cockburn," Artsy.net, https://www.artsy.net/artist /julie-cockburn.

200 In 2015, a group: Susan Svrluga, "Princeton Protesters Occupy President's Of-

fice, Demand 'Racist' Woodrow Wilson's Name Be Removed," *Washington Post*, November 18, 2015.

200 Five months later: W. Raymond Ollwerther, "University Won't Rename Wilson School or Wilson College," *Princeton Alumni Weekly*, April 5, 2016.

200 Additionally, the committee: Ollwerther, "University Won't Rename Wilson School."

200 Members of the Black Justice League: Ollwerther, "University Won't Rename Wilson School."

201 In 2017, Titus Kaphar: Artsy Editors, "At Princeton, Titus Kaphar Reckons with the University's History of Slavery," Artsy.net, November 14, 2017.

201 In 2019, MacArthur Fellow: Denise Valenti, "University Dedicates Marker Addressing the Complex Legacy of Woodrow Wilson," Princeton University, Office of Communications, October 10, 2019.

201 Student leaders protested: Kiki Gilbert and Nathan Poland, "A Concrete Step Backwards," *Daily Princetonian*, October 4, 2019.

201 In June 2020: Office of Communications, "Board of Trustees' Decision on Removing Woodrow Wilson's Name from Public Policy School and Residential College," Princeton University, June 27, 2020.

201 Unlike their previous statements: Office of Communications, "President Eisgruber's Message to Community on Removal of Woodrow Wilson Name from Public Policy School and Wilson College," Princeton University, June 27, 2020; Office of Communications, "Board of Trustees' Decision on Removing Woodrow Wilson's Name."

201 President Eisgruber then: Christopher L. Eisgruber, "I Opposed Taking Woodrow Wilson's Name off Our School. Here's Why I Changed My Mind," *Washington Post*, June 27, 2020.

201 A Princeton alumnus: Joe Illick, "On Respectful Listening and Change," *Princeton Alumni Weekly*, September 10, 2020.

202 Until Tucker came across: Robby Slaughter, "Graffiti and Good Behavior," *AccelaWork*, October 28, 2009.

203 Post your solution: Chris Matyszczyk, "Police Visit Facebook Dad Who Shot Daughter's Laptop," *CNET*, February 13, 2012.

204 As a Latina physician: Lilia Cervantes, MD, "Dialysis in the Undocumented: Driving Policy Change with Data," *Journal of Hospital Medicine*, August 2020.

204 For four years: Cervantes, "Dialysis in the Undocumented."

204 They found that patients: Lilia Cervantes, MD, et al., "Association of Emergency-Only vs Standard Hemodialysis with Mortality and Health Care Use among Undocumented Immigrants with End-Stage Renal Disease," *JAMA Internal Medicine*, February 2018, doi:10.1001/jamainternmed.2017.7039.

204 They found the helplessness: Cervantes, "Dialysis in the Undocumented."

204 Giving emergency medical care: Jeff Lagasse, "Thousands of Uninsured Kidney Disease Patients Strain Texas Emergency Departments," *Healthcare Finance*, February 21, 2020.

205 "So many problems": Lilia Cervantes, MD, and Nancy Berlinger, PhD, "Moving the Needle: How Hospital-Based Research Expanded Medicaid Coverage for Undocumented Immigrants in Colorado," *Health Progress, Journal of the Catholic Health Association of the United States*, March–April 2020.

205 Thanks in large: Cervantes, "Dialysis in the Undocumented."

205 The headline in the *Colorado Sun*: Jennifer Brown, "Immigrants Here Illegally Were Waiting until Near Death to Get Dialysis. A New Colorado Policy Changes That," *Colorado Sun*, February 25, 2019.

205 Along with being humane: Lagasse, "Thousands of Uninsured Kidney Disease Patients."

205 A year after the new policy: May Ortega, "Colorado Changed Its Rules So Undocumented People Can Get Regular Dialysis. It's Saved Lives and Dollars," *CPR News*, March 4, 2020.

205 In the journal article: Cervantes and Berlinger, "Moving the Needle."

206 The headline describing: Will Maddox, "State Sen. Nathan Johnson's Plan to Expand Medicaid in Texas and Save Taxpayer Dollars," *D Magazine*, October 27, 2020.

206 As one artist observed: Rex Crockett, "Art and Communication," *Art & Perception*, November 18, 2006.

213 In May 2017: Christopher Jobson, "Support: Monumental Hands Rise from the Water in Venice to Highlight Climate Change," *Colossal*, May 12, 2017.

214 Eventually, they expanded: "Frequently Asked Questions," Christo and Jeanne-Claude official website, estate of Christo V. Javacheff, https://christojeanneclaude.net/faq.

214 In June 1995: "Wrapped Reichstag," Christo and Jeanne-Claude official website, estate of Christo V. Javacheff, https://christojeanneclaude.net.

214 Built in 1884: Digby Warde-Aldam, "Understanding Christo and Jeanne-Claude through 6 Pivotal Artworks," Artsy.net, June 19, 2018.

215 When Christo and Jeanne-Claude: Oliver Wainwright, "Interview: How We Made the Wrapped Reichstag," *Guardian*, February 7, 2017.

215 By drastically, but temporarily: Wainwright, "Interview: How We Made the Wrapped Reichstag."

216 They noted that: "Frequently Asked Questions," Christo and Jeanne-Claude official website.

216 The politically charged: Wainwright, "Interview: How We Made the Wrapped Reichstag."

216 The artistic shrouding: Warde-Aldam, "Understanding Christo and Jeanne-Claude through 6 Pivotal Artworks."

216 Like Christo: Hilarie M. Sheets, "A Monument Man Gives Memorials New Stories to Tell," *New York Times*, January 23, 2020.

217 "Monuments can be useful": Sheets, "A Monument Man."

217 "When one does art": "Art May Hold the Key to Solving the Problems of the Future," *Japan Times*, September 17, 2013.

218 "The more we can create": "Art May Hold the Key to Solving the Problems of the Future."

218 "Precisely because artists": "Art May Hold the Key to Solving the Problems of the Future."

Exhibit

220 Wray took her depression: Tara Wray official website, https://www.tarawray.net; Tara Wray, *Too Tired for Sunshine* (New York: Yoffy Press, 2018), http://

www.yoffypress.com/too-tired-for-sunshine/; Too Tired Project, https://www.tarawray.net/tootiredproject.

Step #8: Manage Contradictions

222 Most medical practices: Nikitta Foston, "Considering Private Practice? Here Are 6 Things to Think About," *The Do*, American Osteopathic Association, November 8, 2017.

222 While *Vox* proclaimed: Constance Grady, "*The Heathers* TV Show Was Pulled Following a Mass Shooting—for the Third Time This Year," Vox.com, October 29, 2018; Nicholas Kristof, "Why 2017 Was the Best Year in Human History," *New York Times*, January 6, 2018.

224 Blue H.E.L.P. reports: Joel Shannon, "At Least 228 Police Officers Died by Suicide in 2019, Blue H.E.L.P. Says," *USA Today*, January 2, 2020.

228 Cabanding seems to: Sasha Bogojev, "Uncanny Trompe L'oeil Replicas of Classic Masterpieces Painted in Humble Outdoor Locations," *Colossal*, November 6, 2018.

228 Others have credited: Sasha Bogojev, "Julio Anaya Cabanding Displays Museum-Worthy Masterpieces in Public Space," *Juxtapoz*, January 4, 2019.

230 Eron created the work: Sasha Bogojev, "A Fist of Flowers Presents a Message of Unity on the Streets of Santarcangelo," *Colossal*, October 12, 2018.

231 Our brains are wired: Judith E. Glaser, "Your Brain Is Hooked on Being Right," *Harvard Business Review*, February 28, 2013.

231 None of these will lead: Vicki Webster, Paula Brough, and Kathleen Daly, "Fight, Flight or Freeze: Common Responses for Follower Coping with Toxic Leadership," *Stress & Health*, October 2016, https://doi.org/10.1002/smi.2626.

231 Oxytocin, released by: Rosanna Sobota et al., "Oxytocin Reduces Amygdala Activity, Increases Social Interactions, and Reduces Anxiety-like Behavior Irrespective of NMDAR Antagonism," *Behavioral Neuroscience,* August 2015, http://dx.doi.org/10.1037/bne0000074.

233 Psychologists call our tendency: Mark Sherman, "Why We Don't Give Each Other a Break," *Psychology Today*, June 20, 2014.

234 A study of negotiation: Roger J. Volkema, *The Negotiation Toolkit: How to Get Exactly What You Want in Any Business or Personal Situation* (New York: AMACOM, 1999).

236 He also gave: Jonathan Miles, *The Wreck of the Medusa* New York: Atlantic Monthly Press, 2007).

237 One called Richefort: McKee, *Wreck of the Medusa.*

Step #9: Repair Mistakes with Gold

243 In 1443, Ashikaga Yoshimasa: Editors of Encyclopaedia Britannica, "Ashikaga Yoshimasa: Japanese Shōgun," *Encyclopaedia Britannica*.

243 Raised by a: Michael Hoffman, "Fifteenth Century Shogun Ashikaga Yoshimasa: Impotent or Indifferent?," *Japan Times*, October 15, 2016.

244 He ushered in: Kevin Shau, "Higashiyama Culture and Quintessential Japanese Aesthetics," *Medium*, March 20, 2019.

244 Tea had only recently: "What Is a Chinese Tea Ceremony?," Red Blossom Tea Company, June 25, 2019.

244 One day, according: Kelly Richman-Abdou, "Kintsugi: The Centuries-Old Art of Repairing Broken Pottery with Gold," *My Modern Met*, September 5, 2019.

244 They pried out: "'Urushi,' the Beautiful and Dangerous Art of Japanese Lacquerware," *Japan Info*, August 2, 2016.

244 American artist Rachel Sussman: "The Space Between," MASS MoCA, https://massmoca.org/event/the-space-between/.

244 Victor Solomon used: Grace Ebert, "Opulent Kintsugi Installation by Artist Victor Solomon Gilds Dilapidated Basketball Court in Los Angeles," *Colossal*, August 4, 2020.

245 Berlin-based artist: Katie Sierzputowski, "Jan Vormann Invites Playful Interaction by Patching Crumbling Walls with LEGO Bricks," *Colossal*, October 3, 2018.

245 Vormann encourages others: Jan Vormann, *Dispatch Work*, https://www.dispatchwork.info.

245 Polish outdoor artist: Pinar Noorata, "Artist Beautifies Public Spaces with Ornate Lace Patterns," *My Modern Met*, February 18, 2013.

245 Barcelona-based artist: Booooooom.com Staff, "Broken Window Installation by Artist Pejac," Booooooom.com, October 31, 2016.

245 Tokyo artist Tomomi: Johnny Waldman, "Broken Ceramics Found on the Beach, Turned into Chopstick Rests Using Kintsugi," *Colossal*, June 13, 2016.

245 Many call *kintsugi*: "Kintsugi Bowl: The Art of Precious Scars," The Course at the Centre, https://www.thecourseatthecentre.com/the-kintsugi-bowl-art-of-precious-scars; Eric D. Zelsdorf, "Kintsugi: The Art of Precious Scars," *Psychology Today*, June 27, 2020.

247 After working for: Seph Rodney, "Reflecting on the Mistakes I've Made as an Art Critic," *Hyperallergic*, May 29, 2020.

247 "I want to keep myself": Rodney, "Reflecting on the Mistakes I've Made."

248 Rodney's editor in chief: Hrag Vartanian, "Sunday Edition, Mistakes: From Oversights to Missteps," *Hyperallergic*, August 30, 2020.

248 "And then I try": Rodney, "Reflecting on the Mistakes I've Made."

248 It wasn't until: McKee, *Wreck of the Medusa*.

248 The first time: Regina F. Graham, "50 Years after She Was Called a N***** outside the Whitney, Artist Faith Ringgold's Work—Inspired by That Day—Hangs in the New York Gallery That Once Refused to Show Her Paintings," *Daily Mail*, February 13, 2018.

248 Stephen E. Weil: Grace Glueck, "Women Artists Demonstrate at Whitney," *New York Times*, December 12, 1970.

249 In 1950, she'd enrolled: Andrew Russeth, "The Storyteller: At 85, Her Star Still Rising, Faith Ringgold Looks Back on Her Life in Art, Activism, and Education," *ARTNews*, March 1, 2016.

249 After gallery owner: Russeth, "The Storyteller."

249 Exactly fifty years: Faith Ringgold, *Hate Is a Sin Flag*, 2007, Whitney Museum of American Art, https://whitney.org/collection/works/55835.

249 "I cannot cease": Graham, "50 Years after She Was Called a N*****."

250 The Portuguese artist: Jessica Stewart, "Artist Turns Discarded Trash into Fantastical Animal Sculptures," *My Modern Met*, September 28, 2016.

251 Every year, more than: Ann Koh and Anuradha Raghu, "The World's 2-Billion-Ton Trash Problem Just Got More Alarming," *Bloomberg*, July 11, 2019.

251 The average American: Juliana Lytkowski, "Curbing America's Trash Production: Statistics and Solutions," Dumpsters.com, April 29, 2020.

251 The mountain of trash: Lauren Frayer, "A Day's Work on Delhi's Mountain of Trash," *NPR*, July 6, 2019; Ariel Min, "In World's Poorest Slums, Landfills and Polluted Rivers Become a Child's Playground," *PBS*, February 12, 2015.

251 President Obama brought: Jen Anesi, "Obama Visit Likely to Delay Lake Orion Schools Buses, Snarl Local Traffic," *Orion Patch*, October 13, 2011.

252 The factory, where Chevrolet's: Megan Greenwalt, "GM Plant Using Landfill Gas to Produce 54% of Its Electricity," *Waste 360*, August 2, 2016; "GM Greener Vehicles," Corporate Newsroom, General Motors, July 10, 2015.

252 The landfill's gas: Eagle Valley Landfill, Waste Management, https://eaglevalley landfill.wm.com/index.jsp.

252 The green energy initiatives: Eagle Valley Landfill, Waste Management; "GM Greener Vehicles."

252 The plant is currently producing: Wendy Johnson, "Suddenly, the Chevrolet Bolt Is an SUV?," *Motor Biscuit*, October 24, 2020; Energy Efficiency & Renewable Energy, US Department of Energy, FuelEconomy.gov.

252 The company currently has: "General Motors Expands Landfill-Free Efforts Globally," Corporate Newsroom, General Motors, February 28, 2018, https:// media.gm.com/media/us/en/gm/news.detail.html/content/Pages/news/us /en/2018/feb/0228-landfill-free.html.

252 This means everything from: "General Motors Expands Landfill-Free Efforts Globally"; "GM Turns Recycled Water Bottles into Engine Insulation," Environmental Protection, May 9, 2016.

252 "To us, waste": "General Motors Expands Landfill-Free Efforts Globally."

252 He creates colorful: Christopher Jobson, "Guerilla Flower Installations on the Streets of NYC by Lewis Miller Design," *Colossal*, December 13, 2017; "Lewis Miller—Not Your Grandmother's Florist," Phaidon.com.

254 "It shattered into": Alice Yoo, "Riveting Story behind that Striking Sculpture," *My Modern Met*, June 30, 2011.

255 *Scientific American* published: Ferris Jabr, "Why Your Brain Needs More Downtime," *Scientific American*, October 15, 2013.

255 Writer Tim Kreider: Tim Kreider, "The 'Busy' Trap," *New York Times*, June 30, 2012.

256 Kreider reminds us: Kreider, "The 'Busy' Trap."

256 In World War II: Kevin Drum, "The Counterintuitive World," *Mother Jones*, September 30, 2010.

257 Brazilian visual artist: Christopher Jobson, "My New Old Chair: Artist 'Fixes' Broken Wood Furniture with Opposing Materials," *Colossal*, November 16, 2016.

259 He wrote to his wife: Tim Newark, *Camouflage* (London: Thames and Hudson, 2007).

259 In 1916, the German Army: Michele Dantini, *Modern & Contemporary Art* (New York: Sterling Publishing, 2008).

259 After his death: Susanna Partsch, *Franz Marc, 1880–1916* (Cologne: Taschen, 2001).

261 According to legend: Robyn Griggs Lawrence, "Wabi-Sabi: The Art of Imperfection," *Utne*, September–October 2001.

262 In 2016, Ai Weiwei: Kate Sierzputowski, "Ai Weiwei Wraps the Columns of

Berlin's Konzerthaus with 14,000 Salvaged Refugee Life Vests," *Colossal*, February 16, 2016.

262 Weiwei himself was: Ai Weiwei, "The Refugee Crisis Isn't about Refugees. It's about Us," *Guardian*, February 2, 2018.

263 In 2015: Margie Warrell, "Why Embracing Uncertainty Is Critical to Your Success," *Forbes*, July 21, 2015.

263 Théodore Géricault wrote: "Théodore Géricault," *The Art Story*, https://www.theartstory.org/artist/gericault-theodore/.

263 In the hospital: Todd Farley, "Disabilities Are at the Heart of Chuck Close's Art," *Brain & Life*, American Academy of Neurology, August/September 2011.

264 In trying to make sense: Viktor Frankl, *Man's Search for Meaning* (Boston: Beacon Press, 2006).

270 Upon seeing Géricault's: *The Raft of the Medusa*, Louvre, https://www.louvre.fr/en/oeuvre-notices/raft-medusa.

273 As the artist further explains: Interview with JM, audio guide, accompanying her exhibition at the Whitney Museum of American Art, January 2020.

Credits and Permissions

page 26: Paul Pfeiffer, *Caryatid (De La Hoya)*, 2016 digital video loop, chromed 12-inch colour television with embedded media player 24.1 x 26.7 x 36.8 cm. 91/2x101/2x141/2in. © Paul Pfeiffer. Courtesy of the artist, Thomas Dane Gallery, and Paula Cooper Gallery.

page 28: Pablo Picasso, *Girl before a Mirror*. Boisgeloup, March 1932. Oil on canvas, 64 x 51 1/4" (162.3 x 130.2 cm). Gift of Mrs. Simon Guggenheim. The Museum of Modern Art, New York, NY, USA. © 2021 Estate of Pablo Picasso / Artists Rights Society (ARS) Digital Image © The Museum of Modern Art/ Licensed by SCALA / Art Resource, NY.

page 28: *Woman Holding a Mirror*, from the series "Eight Views of Tea-stalls in Celebrated Places" ("Meisho koshikake hakkei"), 1790–1801. Clarence Buckingham Collection. The Art Institute of Chicago.

page 29: *Top left: Egon Schiele, Drawing a Nude Model in front of a Mirror (1910)* © The Albertina Museum, Vienna. *Top right:* Magritte, René (1898–1967) © ARS, NY. *La Reproduction interdite (Portrait d'Edward James)*. 1937. Oil on canvas, 81 x 65 cm. Museum Boijmans van Beuningen, Rotterdam, The Netherlands © 2021 C. Herscovici / Artists Rights Society (ARS), New York Banque d'Images, ADAGP / Art Resource, NY. *Bottom:* Elizabeth Colomba, *Narcissus*, 2008, © 2021 Elizabeth Colomba / Artists Rights Society (ARS), New York.

page 33: *Alice Neel Self-Portrait*, Alice Neel, 1980. Oil on canvas. National Portrait Gallery, Smithsonian Institution © The Estate of Alice Neel. Courtesy The Estate of Alice Neel and David Zwirner.

page 48: *Synecdoche* by Byron Kim. © Byron Kim 2021. Image courtesy of the artist and James Cohan, New York.

page 49: *Officer of the Hussars*, 2007 (oil on canvas), Wiley, Kehinde (b. 1977) / Detroit Institute of Arts, USA / © Detroit Institute of Arts / Bridgeman Images.

page 53: Géricault, Théodore (1791–1824). *Officer of the Chasseurs (Imperial Guard) on Horseback* Oil on canvas. 349.0 x 266.0 cm. Inv4885. Photo: Franck Raux. Musée du Louvre, Paris, France © RMN-Grand Palais / Art Resource, NY.

page 54: Cristofano Allori (1577–1621), *Judith with the Head of Holofernes*, 1613 (signed and dated 1613). Oil on canvas. Royal Collection Trust / © Her Majesty Queen Elizabeth II 2021.

page 63: Panorama view on Budapest city from Fisherman Bastion. Hungary. Vital-Edush/istockphoto.com. Stock photo ID:537333836.

page 64: *The Shoes on the Danube Bank*: Dr. Borgovan / Shutterstock.com ID: 1535291591/ Shutterstock.

page 69 *Elihu Yale; William Cavendish, the second Duke of Devonshire; Lord James Cavendish; Mr. Tunstal; and an Enslaved Servant*, Unknown artist, 1708, Oil on canvas, 79 1/4 x 92 3/4 inches (201.3 x 235.6 cm). Yale Center for British Art, Gift of Andrew Cavendish, eleventh Duke of Devonshire Object Number: B1970.1.

page 74: Frans Hals, *Family Group in a Landscape*, 1645–1648, oil on canvas. 202 x 285 cm. Copyright Museo Nacional Thyssen-Bornemisza, Madrid.

page 76: *Top:* Hans Holbein the Younger (1497-1543), *Jean de Dinteville and Georges de Selve ('The Ambassadors')*, 1533. © National Gallery, London / Art Resource, NY. *Bottom:* Hans Holbein the Younger (1497-1543), *Jean de Dinteville and Georges de Selve ('The Ambassadors')*, 1533. Detail of the skull. © National Gallery, London / Art Resource, NY.

page 119: Colton Seale, *Perspectives*, Peterborough, NH.

page 120: Installation photograph of Rachel Whiteread's "Untitled (One Hundred Spaces)," 1995, Tate Britain, during the Whiteread exhibition.

page 121: Jean Shin, *Penumbra*, 2003, Courtesy of the Artist and Socrates Sculpture Park.

page 122: *Harvest Dome, 2.0.* SLO Architechture, 2013. Photo: Andreas Symietz.

page 125: Jorge Méndez Blake, *Amerika, 2019 Bricks*, edition of "Amerika" by Franz Kafka, 185.1 x 30.2 x 1016 cm. Installation view at the exhibition Borders at James Cohan, New York, 2019. Images courtesy of the artist.

page 136: Magritte, René (1898-1967), *La Clairvoyance*. 1936. Private Collection © 2021 C. Herscovici / Artists Rights Society (ARS), New York Herscovici / Art Resource, NY.

page 137 Dan Scott, Childe Hassam, *The Sea*, 1892, focal points, 2018. www.drawpaint academy.com, 2018.

page 138 Dan Scott, Claude Monet, *The Thames Below Westminster*, 1871, focal points, 2018. www.drawpaintacademy.com.

page 139: Yin and Yang Symbol © teono4ka / Fotosearch LBRF / agefotostock.

page 140: *Left:* Ilya Repin, *Girl with Flowers, Daughter of the Artist*, 1878, Artefact / Alamy Stock Photo. *Right:* Dan Scott, *Notan of Ilya Repin, Girl with Flowers, Daughter of the Artist*, 1878, www.drawpaintacademy.com, 2018.

page 142: Mitchell Albala, *Cascade Dusk*.

page 142 Mitchell Albala, notan study, *Cascade Dusk*, marker on paper, 2.5 " x 5.5 ", 6.3 x 12.7 cm.

page 143: Maggie Holyoke, *Expanding the Square*, 2021.

page 148: *Left:* Hugo Glendinning, Cold Dark Matter Shed before explosion,1991, © Hugo Gledinning. All Rights Reserved, DACS/Artimage 2021.
Right: Hugo Glendinning, Cold Dark Matter Explosion, 1991, © Hugo Glendinning. All Rights Reserved, DACS/Artimage 2021.

page 149: Cornelia Parker. *Cold Dark Matter: An Exploded View*, as displayed in Duveen Gallery, Tate Britain.

page 150: Kumi Yamashita, "Warp & Weft, Mother No. 2."

page 151: Dalí, Salvador (1904–1989), *Retrospective Bust of a Woman*. 1933 (some elements reconstructed 1970). Painted porcelain, bread, corn, feathers, paint on paper, beads, ink stand, sand, and two pens, 29 x 27 1/4 x 12 5/8". The Museum of Modern Art, New York, NY, USA. Digital Image © The Museum of Modern Art/Licensed by SCALA / Art Resource, NY © 2021 Salvador Dalí, Fundacio Gala-Salvador Dalí, Artists Rights Society; MoMA, https://www.moma.org/collection/works/81329.

page 153: Francisco Goya. *The Third of May 1808 in Madrid or "The Executions."* 1814. Oil on canvas. © Photographic Archive, Museo National del Prado.

page 154: *Top:* José Manuel Ballester, *3 de mayo*, 2008. Photographic print on canvas 269.2 x 351 cm. Edition 1/2 + 1 A.P. Guggenheim Bilbao Museoa Photo: Guggenheim Bilbao Museoa © FMGB Guggenheim Bilbao Museoa, photo by Erika Barahona Ede. *Bottom:* José Manuel Ballester, *La balsa de la Medusa*, 2010. Photographic print on canvas 491 x 717 cm. Unique edition Guggenheim Bilbao Museoa. Photo: Guggenheim Bilbao Museoa © FMGB Guggenheim Bilbao Museoa, photo by Erika Barahona Ede.

page 207: Christo and Jeanne-Claude, *The Gates*, Project for Central Park, New York City, USA, Credit: Wolfgang Volz/laif/Redux.

page 210: Julie Mehretu, American, b. 1970, *Stadia II*, 2004 ink and acrylic on canvas, H: 107 3/8 in. x W: 140 1/8 in. x D: 2 1/4 in. (272.73 x 355.92 x 5.71 cm). Carnegie Museum of Art, Pittsburgh: Gift of Jeanne Greenberg Rohatyn and Nicolas Rohatyn and A. W. Mellon Acquisition Endowment Fund, 2004.50 © Julie Mehretu. By permission.

page 211: Henri Matisse, *Jeanette I-V*, 1910–13. © 2021 Succession H. Matisse / Artists Rights Society (ARS), New York Gift of the Art Museum Council in memory of Penelope Rigby (68.3.1-.2 and M.68.48.1-.3). Photo © M . . . Matisse, Henri (1869-1954) © Copyright Digital Image © (2021) Museum Associates / LACMA. Licensed by Art Resource, NY.

page 212: Jennifer Odem, *Rising Tables*, Sunset Photo: Kevin Kline.

page 213: Lorenzo Quinn, *Support*, 2017, © 2021 Artists Rights Society (ARS), New York / VEGAP, Madrid.

page 215: Christo and Jeanne-Claude, *Wrapped Reichstag*, Berlin 1971–95, Germany. Credit: Wolfgang Volz/laif/Redux.

page 216: Krzysztof Wodiczko, *Monument*, 2020. Video installation, dimensions variable. Collection Krzysztof Wodiczko, courtesy of Galerie Lelong & Co., New York. © Krzysztof Wodiczko. Photograph by Andy Romer/Madison Square Park Conservancy. This exhibition was organized by Madison Square Park Conservancy, New York, and was on view from January 16 through May 10, 2020.

page 217: Yayoi Kusama, *Infinity Mirrored Room—The Souls Of Millions Of Light Years Away*, 2013. Wood, metal, glass mirrors, plastic, acrylic panel, rubber, LED lighting system, acrylic balls, and water. 113 1/4 x 163 1/2 x 163 1/2 inches, 287.7 x 415.3 x 415.3 cm. © YAYOI KUSAMA. Courtesy David Zwirner, New York; Ota Fine Arts, Tokyo/Singapore/Shanghai.

page 219: Tara Wray, *Quechee, VT, 2014*, from the book *Too Tired for Sunshine* (UK: Yoffy Press, 2018).

page 221: Eron, *Tower to the People*, spray paint on wall, Santarcangelo di Romagna, Rimini, (Italy) 2018.

page 225: Julio Anaya Cabanding, "Emilio Ocón y Rivas, 'Vista del puerto de Málaga.' " Intervención pictórica, 2018.

page 226: Julio Anaya Cabanding, "Simón Vouet, 'El tiempo vencido por el amor, la belleza y la esperanza.' " Intervención pictórica/pictorial intervention, 2017.

page 235: *Top: Marcel Duchamp*, New York, 1948 © The Irving Penn Foundation. *Bottom: Georgia O'Keeffe*, New York, 1948 © The Irving Penn Foundation.

page 243: Kintsugi Bowl: Marco Montalti/ Shutterstock.com ID:1799987551/Shutterstock.

page 245: Victor Solomon, *Kintsugi Court.* studio@victorsolomon.com, LiterallyBalling.com. Photo Credit: Shafik Kadi- @Shafik.

page 246: *Top:* Jan Vormann, *Dispatch work,* from the Venti Eventi in Bocchignano, Italy, 2007. © 2021 Artists Rights Society (ARS), New York / VG Bild-Kunst, Bonn. *Bottom:* Camouflage Year: 2016. Location: Rijeka, Croatia. Photos: PEJAC, @pejac_art.

page 250: Bordalo II, *Elephant*, 2016. Parody Art Museum, Pattaya, Thailand. Photo credit: Bordalo II.

page 253: *Flower Flash* by Lewis Miller. Photo credit: Irini Arakas Greenbaum.

Index

About the Author

Amy Herman is the founder and president of The Art of Perception, Inc., a New York–based organization that conducts professional development courses for leaders around the world including at the FBI, NATO, Scotland Yard, and the Peace Corps. Herman was also the director of educational development at Thirteen/WNET, the educational public television station serving New York and New Jersey, and, for more than ten years, the head of education at the Frick Collection, where she oversaw the collection's educational collaborations and community initiatives.

An art historian and attorney, Herman holds a BA in international affairs from Lafayette College, a JD from the National Law Center at George Washington University, and an MA in art history from Hunter College. She is a member of the New Jersey and Pennsylvania Bar Associations. Herman channeled her dual degrees in art and law to create the successful Art of Perception program and now trains thousands of professionals from Secret Service agents to prison wardens. Herman is a world-renowned speaker who frequently presents at national and international conventions. She has been featured on the *CBS Evening News*, the BBC, and in countless print publications including the *New York Times*, the *Wall Street Journal*, the *Daily Telegraph*, the *New York Daily News*, *Smithsonian Magazine*, and the *Philadelphia Inquirer*.